Modern Mythmakers:

35 Interviews with Horror & Science Fiction Writers and Filmmakers

Michael McCarty

Foreword by Alan Dean Foster
Afterword by The Amazing Kreskin

Edited by Joe Mynhardt
Proofread by Hasse Chacon, Joshua Hood, Paula
Limbaugh, Chad Lutzke, and Nancy Scuri

Crystal Lake Publishing
www.CrystalLakePub.com

Modern Mythmakers: 35 Interviews with Horror, Science Fiction and Fantasy Writers and Filmmakers is dedicated to the Mythmakers who have since passed away:

Forrest J. Ackerman

Ray Bradbury

Dan Curtis

George Clayton Johnson

Richard Matheson

Ingrid Pitt

Ben Baldwin for the awesome cover!

Also to my friends and collaborators Mark McLaughlin, Cristopher DeRose, Amy Grech and Holly Zaldivar who helped me with the lion's share of interviews in this book.

And the Source Book Store in Davenport, Iowa and The Book Rack in Moline, Illinois and Davenport, Iowa.

Lastly to Svengoolie who always keeps me laughing in the dark.

Modern Mythmakers: Interviews with Science Fiction, Horror and Fantasy Writers and Filmmakers, 2008 (McFarland & Company), *Modern Mythmakers: 33 Interviews With Horror and Science Fiction and Fantasy Writers and Filmmakers*, 2011 (BearManor Media) and *Modern Mythmakers: 35 Interviews With Horror, Science Fiction and Fantasy Writers and Filmmakers*, 2015 (Crystal Lake Publishing)

Previously unpublished work:

Ray Bradbury included 25% new material

Joe McKinney included 50% new and unpublished

Christopher Moore included 50% new material

William Nolan included 50% new material

David Snell Interview 100% unpublished material

Previously published, but not in any *Mythmakers* books:

Graham Masterton (*Giants of the Genre*, 2003, *More Giants of the Genre*, 2005 and previously unpublished material 2015)

C. Dean Andersson (*Masters of Imagination*, 2011)

"Foreword" by Alan Dean Foster (2011 and 2015)

"Afterword" by The Amazing Kreskin (2008 and 2015)

"Preface" by Michael McCarty (2008, 2011 and 2015)

PRAISE FOR MODERN MYTHMAKERS

"*These people are bizarre yet normal. They are just like us, but they are somehow different. These are the people that can see into that place, interpret it, and hand us back some of our most frightening nightmares . . . Highly recommended.*"
— Alex Scully — Hellnotes

"*Ranging as they do from genre giants to semi-obscure cult figures, all of Michael McCarty's interview subjects in Modern Mythmakers are fascinating artists and engaging speakers. The erstwhile stand-up comedic, music and entertainment journalist casts his net wide, serving up candid chats with an eclectic group of players in the horror, sci-fi and fantasy fields. And it's clear from the get-go that McCarty is a thoughtful, workman-like interviewer who knows and loves his subject matter*"
— *Rue Morgue* Magazine, John W. Bowen

" *. . . McCarty's flowing interviews delve deep into the hearts of our favorite fright masters. With knowledgeable enquires that will entice newcomers and bedazzle hardcore fans, McCarty offers an inside look at the dark world we horror-hounds keep barking for.*"
— Kristopher Triana
author of *Growing Dark*
and head of *Tavern of Terror*

TABLE OF CONTENTS

ACKNOWLEDGEMENTS

Greetings and salutations, genre fans!

I'd like to thank all thirty-five interviewees for taking time out of their very busy schedules to do the interviews in the first place and providing whatever assistance, photos and additional material needed for this book.

I'd like to thank editors Scott Edelman, James J. J. Wilson, David Silva, Pitch Black, Garrett Peck, Judi Rohling, Tony Lee, Lin Stein, Sharon Dodge, Romie Stout, Michael Romkey, John Betancourt, Dominick Salemi and Joe Mynhardt.

Also Alan Dean Foster for writing the introduction, The Amazing Kreskin for writing the afterword, and Charlee Jacob.

Thanks also goes to The Midwest Writing Center, the Rock Island and Davenport libraries, Joan Mauch, Mel Piff, Chef Steph, Michael Faun, Eric Beebe, Lyle Ernst, Sherry Decker, Janet Clark, Bonnie Lou, Connie Sherwood, Bradley Heden, Ben Eads, Donald Pierce, Jean Brandt, Dave & Julie, Greg Smith, Terrie Leigh Relf, Janet Clark, Brian Kronfeld, Kimberly Cole Zemke, Christopher & Val, Latte The Bunny, and the memory of Kitty The Bunny.

Michael McCarty

Finally, I'd also like to thank Joe Mynhardt and the rest of Crystal Lake Publishing for making this book possible. Also thanks to McFarland & Company and BearManor Media for publishing the previous editions and letting me publish this one. And I'm so blessed to have Cindy McCarty, my beautiful and brilliant wife, who traveled with me on this journey, helping with the difficult task of transcribing, proofreading, going to book signings, and believing in me again.

PREFACE

I AM CONSTANTLY asked, "Why would you want to interview horror and science fiction writers?"

When newspaper reporters ask me this question, I feel as though I've been consigned to the literary ghetto: horror, science fiction, fantasy. Those are the bad places. Why would you want to go there?

I have no simple answer, no handy sound bite. My answer is that this is who I am. When I was a kid, I thought science fiction writers actually lived on other planets and sent their stories to earth via rocket ships.

It wasn't until college that I even met a real writer. The first professional writer I met was David Morrell, the author of *First Blood* and literary father of Rambo, whom I met at a party at the University of Iowa. I told him how I loved his book and I wanted to be a writer, too. He smiled and gave me some great advice I still keep close to my heart: "This is a tough profession. Not for the faint of heart. Keep up the good fight." Then he asked me when the last time I had written anything was and I told him, "Fifteen minutes before coming to this party." I told him I write every day. I still do.

A year later I would see Morrell at a writers' conference in my hometown. He was teaching a class

on writing horror. There were only a few students in attendance. Across the hall was a class on writing poetry; the poetry class was full. Morrell looked across the hall and said, "People don't make money from writing poetry these days," then began his class. I wouldn't interview him for an article until fifteen years later.

The next writer I met was Kurt Vonnegut. He did a lecture at the college I was attending. Vonnegut was one of my favorite writers in college. He's still one of my favorite writers. During his lecture he took questions from the audience. I raised my hand and asked him about his novel *Bluebeard*. He liked my question and gave it a long and thoughtful answer. After the lecture, I sneaked backstage and had Vonnegut sign my copy of *Galapagos*. He was signing books and he recognized me as the person who had asked the *Bluebeard* question. After he signed his book, he asked me to step over to the table so we could talk a little more as he signed books. I told him I wanted to be a writer, too. He asked me what I was studying and I told him English and Journalism. I added I had just gotten a B+ in a Kurt Vonnegut class. I read articles he had written when he was a student in college. He smiled and said, "That is a pity."

Each interview is like putting thousands of ideas into a few words.

Each interview is like walking on a tightrope without a net, with a strong wind blowing as you try to keep your balance.

Each interview is crawling into the writer's or filmmaker's inner brain to see what makes his creative mind tick.

Each interview is a luncheon featuring food with a good friend.

Each interview is like a favorite song you could listen to forever.

I see myself as a scribe for speculative fiction writers. I record their thoughts, let them offer their advice and insight for the readers. I don't try to do fluff pieces or overly critical pieces. I try to present the author in a fair and objective manner. I have been a freelance writer for over two decades now.

After I graduated from Marycrest College with my Bachelor of Arts in English and Journalism, I moved to the suburbs of Chicago to try to get a job writing for a newspaper. I didn't land a newspaper job. I did, however, land an interview with one of my literary idols, Frederik Pohl. I knew that if I were going to write articles for professional magazines, they'd better concern subjects I knew something about. I knew about science fiction and horror writers and their writing. I wrote to Fred Pohl and asked if I could do an interview with him; he wrote back, saying it would be okay. The reason I picked Fred was simple. He lived only about a half-hour away, and I had read several dozen of his books, starting with *Gateway*, which I'd read as a teenager.

Pohl's place was everything I'd imagined a writer's residence should be. The entire living room was lined with books, and his office was a work-in-progress.

[The Frederik Pohl interview is the "Bonus Material" of the eBook only]

There is a story behind each interview. This is one of my favorites. The first time I met Peter Straub was at the dealers' room at the World Horror Convention

in Denver. I was leafing through some rare books and when I looked up, standing next to me was Peter Straub. I introduced myself and told him I was a huge fan, all the usual fan-boy fanfare. We talked briefly and that was it. The rest of the convention I was kicking myself for not asking him to do an interview. But the truth of the matter is: I was terrified. We're talking about Peter Straub, a living legend. My insides had turned to Jell-O just saying hello. I met up with Peter Straub two years later at the World Horror Convention in Chicago outside the dealers' room. It was in the latter part of the morning. I asked him to do an interview, and, of course, he said yes. After we finished, he thanked me for doing the interview, and said they were good questions.

The day *Giants of the Genre*, my first book, arrived at my home was the same day The Amazing Kreskin (who is also in this book) was performing in my hometown at Circa 21. Before intermission, Kreskin talked about *Giants*. He introduced me from the stage and had me stand up to take a bow. Kreskin clapped, and everyone in the audience clapped. I felt like I had just won an Oscar. I do interviews. This is my job. No need for applause.

Since that time, The Amazing Kreskin and I wrote a nonfiction book together called *Conversations with Kreskin* which is available as a hardcover book and eBook. One of the highlights in my writing career was when Kreskin was on Late Night with Jimmy Fallon and Jimmy Fallon held my book to the camera. It will be a moment I will never forget.

How do you sum up four decades of writing nonfiction? It is hard to do. Starting in grade school

and continuing through college I worked for various papers. I interviewed various people: a police officer, a military recruiter, a DJ, local merchants, a movie critic, yada yada yada.

My freelance writing years were like a roller coaster ride, highs and lows and thrills all along the way.

My first sale was a record review of Pink Floyd's *The Final Cut* in 1983. My first national sale was with science fiction writer Frederik Pohl for the magazine *Starlog* in 1993.

And after that was:

Getting published in such magazines as *Cemetery Dance, Fangoria, Filmfax, Goldmine, The Brutarian* and many more. Receiving paychecks as low as ten dollars and as high as four figures and working as a staff writer for *Science Fiction Weekly* (the official website of the Sci Fi Channel, now the SyFy Channel from 2001-2008).

My first book, *Giants of the Genre* (Wildside Press) was published in 2003. It is so great to start with a nonfiction book and come back home with *Modern Mythmakers*!

Michael McCarty
Winter 2014

WELCOME TO THE MODERN MYTHMAKERS CIRCUS

Foreword

ALAN DEAN FOSTER

WELCOME TO THE CIRCUS.

Here there are no ringmasters: only acts. Within these pages you'll find a glistening, glittering, bombastic three-ring extravaganza. All ages are represented and all genders; masters and mistresses of the high wire of film, the acrobatics of the written word, the mesmeric mysteries of television. Some acts are new, some venerable, some famous, some less so, but none are less than interesting to those with a mind that has not yet been dulled to the cognitive consistency of tepid tapioca by a numbing diet of pernicious politics, vapid "best-selling" fiction, screaming radio hosts (if they're the hosts, then who are the parasites?), howling televangelists convinced God must be deaf, sniggering Ponzi promoters with

millions safely sequestered in off-shore banks, wars whose underlying rationales a coterie of inebriated chimps would find embarrassing and a news media whose most famous and trusted name is a professional comedian.

And to think there are those with the gall to stand forth and decry as disengaged the aficionados of fantasy.

Beset by a lollygagging libido? Herein be regaled by the tales of those Tinseltown temptresses for whom tripping the light fantastic means avoiding gashing ones feet to bloody ribbons on rows of shattered light bulbs, to whom the theatrical admonition to break a leg is sometimes a command to the on-set makeup artist, and for whom the phrase "Director's cut" (which should please Dan Curtis, John Carpenter, Herschel Gordon Lewis, Mick Garris, John Russo or Fred Olen Ray) takes on entirely new meaning.

The travails of daily life getting you down? Society says gulp a handful of pills. Better to heed the work and recommendations of the writers interviewed in this worthy tome. Their words will make you feel better, put pep in your step, stimulate the one organ of your body that raises you above the rats in your walls, and prove addictive without being narcotic.

Yes, it's a grand old circus on offer here, whose antecedents stretch back to the time of Gilgamesh and back to the Neolithic cave painters, whose sequential portraits of running aurochs and wooly rhinos presage by thousands of years the work of the inimitable Ray Bradbury—see Ring Number Two where the acrobats are gathered.

But this circus is not free. There are requirements

beyond the modest shekels you must shell out. To get in you must perforce open your mind as much as your wallet. Entry requires a dollop of intelligence, a modicum of daydreaming, and a desire to explore that which lies beyond the humdrum (which itself lies in a nebulous zone somewhere between the timpani and the snares, and must forever be played pianissimo).

That's why this book is called *Modern Mythmakers*. Come one, come all. I can't be the ticket-taker but I'm proud to stand forth, however briefly, as barker.

Alan Dean Foster
Prescott, Arizona

"Science fiction of the early days was primarily written by scientists who were daydreaming about the outcome of various experiments. Then came a second generation of fans inspired by these writers, but the fans didn't have the scientific education of most of the authors. Like Ray Bradbury, they became more tellers of tales of imagination than in the scientific content, which wasn't all that correct."
—Forry J Ackerman

FAMOUS MONSTERS SPEAKS

FORREST J. ACKERMAN

THE PRAISE FOR Forrest J. Ackerman comes from some of the biggest giants of the genre:

"If Forrest J. Ackerman doesn't have the greatest collection on earth of science fiction and fantasy books, magazines, manuscripts, artwork and movie memorabilia, including stills, posters, artifacts and materials pertaining to Lon Chaney, I don't know who has," said Ray Bradbury.

"A generation of fantasy lovers thank you for raising us so well," said Steven Spielberg.

1

Michael McCarty

"*Forry's love of the genre is a child's wonder, untouched by the sophistication which eventually corrupts. But this childish love has been coupled with the enthusiasm of a man who has found the thing which God made him to do and is doing it with a unique style and an energy which never seems to flag. Forry was the first; he was the best. He is the best. He stood up for a generation of kids who realized that if it was junk, it was magic junk,*" said Stephen King.

"*Forry—just the name, just hearing the sound Forry sends a montage through my mind. It begins with issue number four through the nearly two hundred issues of Famous Monsters (I started at issue four, but instantly sent for the first three issues). It set me on my current path through life,*" said Tom Savini.

"*Forrest Ackerman has been an inspiration to me since I was a little ghoul,*" said Elvira, Mistress of the Dark.

Forrest J. Ackerman is a walking encyclopedia of science fiction and horror. He is the World's #1 sci-fi fan and collector. As the well-known editor of *Famous Monsters of Filmland* for twenty years (and 200 issues), he has personally known such legends as Boris Karloff, Bela Lugosi, Lon Chaney Jr, Peter Lorre, Christopher Lee, and Vincent Price.

Famous Monsters was the first monster magazine to hit the newsstands, debuting in February 1958, with a press run of 125,000 copies. Those quickly sold out, necessitating a second run of 75,000.

He won the first Hugo; the Dracula Society's First Radcliffe; Trixie and Saturn Awards from the Academy of Science-Fiction, Fantasy and Horror Films; the Science Fiction, Fantasy and Horror Films Hall of Fame Award; and Hugos from Germany, Italy and Japan.

Forrest J. Ackerman passed away on December 4, 2008 at the age of 92.

MICHAEL McCARTY: Success spawned over fifty imitation magazines worldwide, including *World Famous Creatures*, which came out a few short months after the debut of *Famous Monsters*. Other copycat publications included *Monsterland, Fantastic Monsters,* and *Castle of Frankenstein. Famous Monsters* founder and publisher James Warren instigated a lawsuit against one of the copycat zines. What was the verdict of that lawsuit?

FORRY ACKERMAN: The judge said, "If you look at one monster, two different people are sure to come up with the same joke about it."

MM: Next to *Famous Monsters*, you are best known for your work on *Vampirella*. The first issue appeared in September, 1969. You were the first writer, and the soon-to-be-famous Frank Franzetta was the original artist. The Warren publication became the longest vampire comic of all time. It lasted over 112 issues and spawned several remakes. How did you come up with the idea of the seductive vampire?

FORRY: I was flying down to Rio around 36 years ago. It was midnight. Thunder and lightning were playing around the plane. I realized I wasn't going to get to sleep that night and I thought about how the publisher (James Warren) wanted to do a comic about a mod witch. Vampirella—from the planet of Draculon—jumped into my mind. I got back to New York and sat down at the typewriter and, two hours later, I had typed out the original story.

3

MM: You are famous for your many puns, jokes and catchphrases. You even coined the legendary word, "sci-fi." How did you come up with "sci-fi?"

FORRY: In 1954 I was riding around in an automobile. I had the radio on and someone mentioned "hi-fi." Since science-fiction has been on the tip of my tongue ever since 1929, I looked in the rearview mirror, stuck out my tongue and there, tattooed at the end of my tongue, was "sci-fi." (Laughs)

MM: You are leaving for New Zealand to see the filming of Peter Jackson's remake of *King Kong*. Please fill us in on the details.

FORRY: I was in New Zealand many years ago. I did a cameo in Peter Jackson's first film *Dead Alive*. I'm expected to do another cameo in his *King Kong* remake. He inquired about all my "Kong-ania." It will be an extreme pleasure to see this in its final resting-place, protected and displayed.

MM: You made numerous cameos in such movies as *Amazon Women on the Moon, The Time Travelers, Monster Invasion, Attack of the 60 Foot Centerfold* (written and directed by Fred Olen Ray, who is also interviewed in this book) and *Innocent Blood*. How many movies have you had a cameo role in?

FORRY: 106.

MM: You are known as an anthologist and editor. How many books have you edited over the years?

FORRY: Over fifty books. I started out with what was

called the *Ackermanthology*, and then I did *Sci Fi Womanthology* and *Martianthology*.

MM: You've been a fan of science fiction since the late 1920s. If at all, how do you think fantastical literature has changed since then?

FORRY: October, 1926, a little nine-year-old me was standing in front of a newsstand. A magazine called *Amazing Stories* jumped off the newsstand and grabbed hold of me. You are too young to know. In those days, magazines spoke, and that one said, "Take me home, little boy. You will love me." (Laughs)

Science fiction of the early days was primarily written by scientists who were daydreaming about the outcome of various experiments. Then came a second generation of fans inspired by these writers, but the fans didn't have the scientific education of most of the authors. Like Ray Bradbury, they became more tellers of tales of imagination than in the scientific content, which wasn't all that correct.

MM: Did you edit two hundred issues of *Famous Monsters of Filmland*? Of those, which were some of your favorites?

FORRY: That is exactly right. It seems to me my favorite was issue 26, when I did an extensive coverage of my life to date and my collection, and the very sad issue when Boris Karloff died.

MM: Why did you decide to leave *Famous Monsters* and was that a hard decision to make?

FORRY: There was rampant inflation (late 1970s, early 1980s) and I continued to get the same pay for *Famous*

Monsters. I realized year-by-year the pay was buying me less meat and potatoes. I pointed that out to the publisher (James Warren). He agreed that he'd bring me up to the current state, but he never did.

At the end of three years, I thought, "I'm older, working for far less money." So I called it quits, reluctantly.

MM: When you moved from your 18-room mansion on Glendower Avenue in Hollywood to your much smaller current bungalow, how much of your 300,000 pieces of monster memorabilia were you able to keep?

FORRY: Just about one hundred items. I kept the Martian machine from *War of the Worlds*, and Bela Lugosi's Dracula cape I saw him wear on the stage for the first time in 1932 and the last time in *Plan 9 from Outer Space*. I have the reconstructed robot from *Metropolis*. It took a year and a half—six hundred hours to reconstruct her. I have Bela Lugosi's personal Dracula ring and Boris Karloff's Mummy ring. Some original paintings by my favorite sci-fi artist, Frank R. Paul (famous for his illustration of Edgar Rice Burroughs' novels). I have the beaver hat worn by Lon Chaney in the lost film *London After Midnight*, together with the ghoulish teeth he wore for that.

MM: Talking about *London After Midnight*, it is the silent Lon Chaney film that has been lost over the course of time. Do you have any prints of the movie? Do you think the movie will ever re-surface?

FORRY: I understand that a print exists in a private collection in England. The owner isn't about to let go of it or make any duplicates. I don't know his name or address.

MM: You have known Ray Bradbury since the '30s?

FORRY: Since 1935.

MM: You must have some incredible anecdotes about Ray Bradbury. Would you care to share any with us?

FORRY: I financed his personal fanzine *Ventura Fantasia*. Then he wanted to go to the first World Science Fiction Convention in New York in 1939, but he couldn't afford it, so I loaned him the $50 to spend three and a half days and nights on a Greyhound bus getting there.

When Ray was a teenager and he wanted to take a girl on a date, it could be done for a dollar. Twenty-one cents for a first run film, a nickel for a streetcar ride downtown to the picture palaces and five cents for bottomless popcorn. He might even have a dime left over at the end of the date. I always gave him a buck for a book. He'd bring me a book, and I would buy it and finance his date.

One day—in 1939, I think—he had an extra heavy date because he wanted two dollars. For the extra dollar, he had the novelization form of *King Kong*, theoretically written by Edgar Wallace, who was the leading mystery writer of the day. He lived in England. He wrote about three words, then dropped dead, but they kept his name on the jacket.

Ray said, "Look, look, it was signed by Edgar Wallace. That oughta be worth an extra dollar."

I was young and naïve. I didn't stop to question how this high school kid got the autograph of this famous author six thousand miles away in London. So I gave him the extra dollar.

Many years later, I was living in a home that could accommodate sixty-five or so people. In order to celebrate my birthday, I had to have five birthday parties: Friday night, Saturday matinee, Saturday night, Sunday matinee and Sunday night.

On Sunday night, Ray Bradbury was one of the ninety-five fans and friends at my birthday party and his eyes fell upon that copy of *King Kong*, which he had sold me. He hesitantly took it off the shelf and opened it up and pointed and said, "Oh, Forry! I have a terrible confession to make. I wrote that Edgar Wallace (autograph)."

And I said, "You dirty dog! Give me back my dollar." (Laughs)

I realized he regretted selling me that, because it was one of his favorite books. It was a rather costly collectors' item.

I inscribed it:

"To Ray Bradbury, from the real Edgar Wallace."

MM: Last words?

FORRY: Here are some final thoughts: I'm being interviewed at age eighty-seven. I nearly died twice a couple of years ago, but I have made a remarkable recovery. It was problematic if I'd ever be able to walk again, but I started out in a wheelchair, graduated to a walker, graduated to a cane and, as a matter of fact, shortly before you phoned me, I walked seven blocks to have lunch.

I have a pacemaker. I am very encouraged to hear the local pacemaker person is 106. I'm aiming at breaking his record and living to be 107. (Laughs)

I'm looking forward to my 90th birthday in two

years. Then my 95th and finally my 100th birthday, which will be held at the popular Friars Club. I imagine there will be several hundred friends from all around the world.

"My favorite ending is from Hugo's The Hunchback of Notre Dame. *If you've only seen the Hollywood film versions where they let Esmeralda live, you don't know the power of the original. Esmeralda dies. Then Quasimodo finds her in the tomb, curls up with her corpse in his arms, and stays there until he also dies. We know this because years later two skeletons, one hunchbacked and misshapen, are found entwined, and when they try to separate his from hers, it crumbles to dust."*

—C. Dean Andersson

I AM DRACULA

C. DEAN ANDERSSON

C. DEAN ANDERSSON is the internationally published author of the 2007 Bram Stoker Finalist short story "The Death Wagon Rolls on By." His horror novels include groundbreaking vampire classics *I Am Dracula* and *Raw Pain Max,* and the controversial *Torture Tomb,* pitting feminist witches against snuff filmmakers. In Heroic Fantasy, he created the Bloodsong Saga (*Warrior Witch, Warrior Rebel,* and

Warrior Beast), a Sword and Sorcery epic published in American editions and Russian-language hardbacks. Trained from childhood in music, and with diverse degrees in physics, astronomy and art, he is also a professional artist, musician, robotics programmer and mainframe computer technical writer. His website is http://www.cdeanandersson.com/.

MICHAEL McCARTY: Why do you write horror?

C. DEAN ANDERSSON: I find it fun, for starters, and these days I don't want to waste time on fiction writing that is not fun. Thinking back, while in elementary school, I once gave a speech, complete with crayon drawings as illustrations, to my grandmother's church group. I'd read a book on UFOs and seen *The Thing* on TV, so I was trying to scare them into realizing the danger of space aliens. I warned them, "Keep watching the skies!" Their reaction was to think me awfully cute. But the trait that motivated me then is still with me: to show people things they've never seen, give them thoughts they've never had and feelings they've never experienced, all while having some fun telling a good story. If I need an artsy excuse for my motivation, I can quote Tristan Tzara's 1918 *Dada Manifesto*: "Art should be a monster that casts servile minds into terror."

Of course, I should also warn you that waking people up can make them grumpy, especially if new ideas do not validate their previously cherished beliefs, so if you're not merely thought to be cute, you might become unpopular. On the other hand, those people

are probably not reading stories like mine anyway. That's show biz!

MM: Do you have a sense if a book is going to be successful or not? What books surprised you by their success?

ANDERSSON: If you're happy with what you create, that's success. But as for what becomes of a story when it's released into the world and the publishing industry takes over, does any writer have a clue? My version of the Countess Bathory story *Raw Pain Max* had good sales potential in the days when horror novels were booming and boundaries in horror fiction were being demolished. Splatterpunk was on the horizon. Then, surprise! A major book chain passed on carrying *Raw Pain Max,* not because of the content, but because the excellent J.K. Potter cover art did not appeal to the chain's book buyer, which cut the publisher's bottom-line enthusiasm, advertising budget, and the print run. Afterward, I wondered if anyone had found and read *Raw Pain Max* at all.

Those were pre–Internet days. Couldn't Google it. Then a woman at a convention thanked me for writing *Raw Pain Max* and said that reading it had helped her, because reading it had been like reading her own autobiography. At another convention, a woman who'd worked as a stripper wanted me to help with her memoir, because *Raw* made her think I could understand the hell she'd been through. And at a World Fantasy Con, I met an excellent artist who told me he'd had his girlfriend read to him from *Raw Pain Max* to inspire him while he painted. Another *Raw Pain Max* surprise came when I attended my first

World Horror Convention. Without my being aware of it, *Raw* had become what one dealer called a "cult classic." He had a big price on the used paperback copy he was selling. And other writers I respected told me they were fans of the book. Now it's been requested that I have the book reprinted. Good idea. So, I checked with *Raw*, and when I find the right publisher, she'll be happy to dust off her whips and chains, kick-start her Harley, and ride again.

MM: *The Lair of Ancient Dreams* is a historical Lovecraftian horror fantasy novel. Do you still enjoy and find inspiration in H.P. Lovecraft's work? And if Lovecraft were alive today, what would he be doing for a living?

ANDERSSON: Yes, his work still inspires. As for what Lovecraft would be doing for a living today, after he'd written a daily blog on astronomy and another on literature, he might go to a day job as a tech writer. Technical documentation has a lot in common with imaginative fiction. You have to make difficult concepts and improbable things believable and understandable. Speaking of H.P. Lovecraft, if you ever hoped or feared that Cthulhu and company were more than just fiction, give Kenneth Grant's books a try, such as *Outside the Circles of Time, Hecate's Fountain, Cults of the Shadow, Nightside of Eden* and *Outer Gateways*. He treats the Old Ones as an occult reality. They're difficult books to read if you're like me and not a specialist trained in the terminology, methodology, and poetry of Crowley-esque, *Left-Hand Path Qabalistical Magick*. But Grant is worth the effort. Good food for deep thoughts, deep and dark.

MM: You've written about vampires in your books *I Am Dracula, Crimson Kisses*, and *Raw Pain Max*. Are vampire books easier or harder to write than other genre books?

ANDERSSON: We're not talking about selling a vampire novel to a publisher here. You'd have to ask an agent or editor about that. But writing a novel is never easy, no matter the genre. It can be fun, and it had better be, or chances are it will never get finished, in my case at least, but it's always hard work. Seems to me, if you're doing it right, going back and doing adequate self-editing, all of that. But with the hordes of vampire books in print now, if you develop a unique outlook, anything you write should also be unique. And if vampire stories are something you're into, something that's fun for you to write about and explore, then go forth and stick to it and do it. No publisher's stake has yet been able to make the vampire genre die. It's an ancient human fear and fascination that keeps coming back in new ways. Find one of those new ways, and it should not be any harder to write a vampire novel than any other kind. Your own book, *Liquid Diet*, is a good example of finding a different and entertaining approach.

MM: Thank you for the kind words about *Liquid Diet & Midnight Snack: 2 Vampire Satires* and thanks for writing the afterword to that book as well. What are some of your favorite vampire books?

ANDERSSON: My favorite will always be Bram Stoker's original *Dracula*. I've read it several times. Always brings back the creepy feeling I got the first

time I read it as a kid. After *Dracula,* my next two favorites are Richard Matheson's *I Am Legend* and Theodore Sturgeon's *Some of Your Blood.* Add Stephen King's loving homage to the genre, *Salem's Lot,* of course. I also enjoyed the novelization of *Dracula's Daughter,* written by Ramsey Campbell, I believe, under the pen name of Carl Dreadstone. [The movie] *Dracula's Daughter* was my first childhood encounter with vampires. I saw it one night late on TV. Still love watching it. Gloria Holden was perfect. And that great last line intoned by Edward Van Sloan's Van Helsing, "She was beautiful when she died . . . a hundred years ago."

MM: Why did you choose to write about Dracula and Erzebet Bathory?

ANDERSSON: I've already mentioned that Stoker's *Dracula* remains my favorite vampire novel, but nothing ever satisfied me in fiction or nonfiction studies of vampire beliefs, regarding exactly how Dracula became a vampire. So, I ended up writing my own explanation. And I became fascinated by Countess Bathory in childhood after reading about her in William Seabrook's *Witchcraft.* As a writer, I wondered how a modern woman might deal with discovering she was the reincarnation of Erzebet, a Hungarian noblewoman who killed and tortured hundreds of young women, and how that former life might be influencing her current life as a whip-wielding, live-sex S&M stage performer called Raw Pain Max who is driven by the same urges that drove Erzebet. Does she fight those dark and violent needs? Give in to them like Erzebet did? Or find a

way to transform them into fantasies? That's the struggle.

MM: *I Am Dracula* is an epic vampire novel about Vlad the Impaler and his struggle with Satan, stretching over five centuries. Did this novel involve a lot of research into Vlad?

ANDERSSON: Yes. I studied *In Search of Dracula* and the other books about Prince Vlad written by the historians McNally and Florescu, and also Leonard Wolf's notes in his *Annotated Dracula*. I also re-read Stoker's *Dracula* and many non-fiction books about vampires, too—the Montague Summers' classics, for example. *Crimson Kisses*, published in 1981, became one of the earliest "How-Vlad-became-a-vampire" novels, a hidden history of Vlad, showing how he became Stoker's vampire king. This did not violate the known history of Stoker. Trouble was, *Crimson Kisses* had a cliffhanger ending that was meant to lead into a series of novels. But *Crimson Kisses'* editor left the publisher, and the series did not happen. So, twelve years later I wrote *I Am Dracula*. The *Crimson Kisses* editor had preferred a third-person approach, so my original proposal, called *I Am Dracula* and written in first-person, had to be rewritten into third-person and retitled *Crimson Kisses*, with the invaluable help of an excellent, already published writer, Nina Romberg, under an androgynous pen name, "Asa Drake." With *I Am Dracula*, I gave the story back its original title and rewrote it again, returned it to first-person, expanded *Crimson Kisses'* ideas, revised it with updated knowledge, and resolved *Crimson Kisses'* cliffhanger ending.

MM: One of my favorite characters in your books is Tzigane, who appears in both *I Am Dracula* and *Crimson Kisses*. What was the inspiration for this character? And will she ever appear in any short stories or novels in the future?

ANDERSSON: Victor Hugo's *The Hunchback of Notre Dame* is, after *Dracula*, the book I've re-read the most. The first film version I saw as a kid was the one starring Gina Lollobrigida as the Gypsy, Esmeralda. Looking back, that's probably Tzigane's origin. So, when I discovered that a tribe of Gypsies were Dracula's allies in Stoker's novel, I wondered why and speculated that maybe one of their own had initiated Vlad into vampirism, a proud and powerful Gypsy woman devoted to a cause she saw as vital and just. Tzigane also has a small but important role near the end of *I Am Frankenstein* and is mentioned in *Fiend* by the immortal Greek witch Medea, who knows her. Then, too, she's in the new *Dracula* novel I'm working on now. And remember, in *I Am Dracula* Vlad reveals that Stoker's *Dracula* was Tzigane's idea, and that she secretly and mischievously used hypnosis and telepathy to inspire and control Stoker's writing. So, it all comes full circle, and anything in Stoker that does not agree with the "truth" in *I Am Dracula* is therefore Tzigane's fault. That probably goes for accepted "history" too, and maybe movie versions. That hairdo Gary Oldman wore at the first of Coppola's *Bram Stoker's Dracula* looks to me like something Tzigane would have dreamed up, and then laughed her head off at the premiere. Vampire humor is tricky.

MM: You have written *I Am Dracula* and *I Am*

Frankenstein. Do you have any other classic monsters you would like to write in the *I Am . . .* format?

ANDERSSON: I was set to write *I Am the Mummy* and *I Am the Wolfman* next, but the publisher changed my editor, and the new one wanted everything I wrote to be traditional. Nothing wrong with that approach, but the term "creative differences" applied. So, things just didn't work out between us, and those books were not written. But I still might write them, and others, eventually, Tzigane willing. Yes, that's it. It was all Tzigane's fault! I would have played ball with that editor, but Tzigane refused, and I did not want a centuries-old vampire mad at me. Would you?

MM: The Bloodsong Saga (*Warrior Witch, Warrior Rebel* and *Warrior Beast*) is an epic series. Tell us more about this series.

ANDERSSON: In the first one, Bloodsong comes back from the dead to work for the Death Goddess, Hel, because Hel is holding her daughter, Guthrun, hostage. In the second one, Bloodsong fights to rescue her daughter from Hel's forces, who want to awaken the dark magic Hel buried in Guthrun's soul. In the third one, Hel uses the powers Bloodsong helped her regain in the first book to invade the Lands of Life.

MM: With all of the warriors, shapeshifters, witches, gods and goddesses, how did you keep track of all the characters and places? Was it fun to write about Norse barbarian women warriors?

ANDERSSON: The characters and places mostly took care of themselves. Sometimes I looked back at a

previous book to check on something, of course, but all three were written within a year and a half, so it all stayed fresh in my mind. Writing the books was fun because of my long-time interest in Norse mythology. My father was born in Sweden, and so early on I became interested in Scandinavian themes. I began wearing a replica of a Viking Age Thor's Hammer medallion while I was in the Air Force. Years later, I discovered that others had begun doing that, too, first in conjunction with the rebirth of the Old Norse religion called Asatrú, and later by Scandinavian rock musicians like the Swedish group Bathory, whose leader, the late Quorthon, invented the Viking Metal genre and dedicated a song to me because of my Bloodsong Saga, "One Rode to Asa Bay," on Bathory's Hammerheart. I'm proud of that. It's a fine song. But back to Bloodsong.

Norse myths had not been used as much in fantasy as the Celtic myths at the time Bloodsong was created, nor were women warriors often featured as lead characters in those days before *Xena* conquered TV and warrior women in heroic fantasies became the norm. You could still hear serious discussions by respected elder writers at conventions about whether a female character could ever be truly believable as a warrior. Bloodsong fought to save her daughter for the first time less than a year before Sigourney Weaver blew 'em away to save Newt in *Aliens* and then later a tough Linda Hamilton battled a Terminator to save her son in *Terminator 2*. The times they were a-changin' for the acceptance of strong women fighting back, and I'm proud Bloodsong was part of it.

MM: What are your thoughts on the covers by artist Boris Vallejo?

ANDERSSON: They are all gorgeous and I thank him for doing such outstanding work for Bloodsong. Some people thought he exposed too much flesh on the women, but remember, he was boldly using female bodybuilders as models for my warrior women at a time when it was controversial to show women with muscles. Yes, there was such a time! And using bodybuilders for models wouldn't have made much sense if they'd been dressed in overcoats. Plus, Conan was always running around next to naked, muscles gleaming. On the other hand, I show on my website what the Russian artist, Ilia Voronin, did with Bloodsong on the covers of the Russian-language editions fifteen years later. His Bloodsong is a pumped-up, scarred, tattooed, and armor-clad warrior, just as magnificent as Boris' visions, but in a different way.

MM: As you've mentioned, your Bloodsong books have been translated into different languages. Do you need to keep that international audience in mind as you write? Do you work closely with any of the translators?

ANDERSSON: No. The Russian publisher, Alpha-Kniga, translated the Bloodsong books without any involvement from me. Someone who knows Russian read some passages to me, though, and it was close to the English. Maybe the Russian audiences liked them because of the old Scandinavian connection. Some Vikings, in particular Swedes, went east into Russia.

There are historians who think the name Russia came from a name given to those Swedish Vikings, "rus," meaning "red," referring to their reddish-blond hair. They were traders, mainly, and established trading towns such as Kiev and Novgorad.

MM: Happy endings in novels: good, bad, and indifferent?

ANDERSSON: Anything goes, as long as it works. I usually prefer there to be at least some hope of a happy ending. But one of my favorite endings is from Hugo's *The Hunchback of Notre Dame*. If you've only seen the Hollywood film versions where they let Esmeralda live, you don't know the power of the original. Esmeralda dies. Then Quasimodo finds her in the tomb, curls up with her corpse in his arms, and stays there until he also dies. We know this because years later two skeletons, one hunchbacked and misshapen, are found entwined, and when they try to separate his from hers, it crumbles to dust. That ending still gets me. But there are also those wonderful endings like in Arthur C. Clarke's *Rendezvous with Rama* and his *Childhood's End* and his "Nine Billion Names of God" and his "The Star." And at the end of Richard Matheson's *The Shrinking Man*, endings that leave you clutched by a deep sense of wonder and/or gasping with surprise. I love those, too. And the last page of Graham Masterton's *Tengu* is an ending I admire simply because it's totally merciless, in a mega-doom kind of way. There are also endings that are only happy ones from a certain viewpoint. Was the ending to Stoker's *Dracula* a happy one if you were hoping Count Dracula would escape Van Helsing's gang? Considering

Tzigane was behind it, though, we could look upon it as just another of her happy little vampire jokes.

MM: Last words?

ANDERSSON: Thanks for giving me the chance to urge everyone one more time to please, please, "Keep watching the skies!" Because those long-dead, ex-churchgoing ex-grandmothers from my small hometown still think I'm awfully cute, according to Tzigane. What more could a horror writer ask?

"I love Billie in Creepshow. *She's one of my all-time favorite characters. And I really didn't know what I was doing when I showed up for work. I just told George [Romero] I was going to do what I thought would work for her and if he didn't like it, he'd better send me home immediately. It was a new experience for me because she was so over-the-top."*

—Adrienne Barbeau

"A REAL GUN-TOTIN', GHOST-FIGHTIN' HEROINE"

ADRIENNE BARBEAU

By Mark McLaughlin and Michael McCarty

ACTRESS ADRIENNE BARBEAU first came to the attention of national audiences in the role of the outspoken daughter Carol in the hit TV series *Maude*. More recently, TV audiences have seen her portray Oswald's mom on *The Drew Carey Show*. She also

starred as Ruthie the snake dancer on the HBO series *Carnivàle*. Horror-suspense fans know her best from her performances in such films as *The Fog, Escape from New York, Swamp Thing, Creepshow, Burial of the Rats* (with Linnea Quigley), *Two Evil Eyes*, and *The Convent*. She has also been in a large number of made-for-television movies and made guests appearances on numerous shows including *Love Boat, Fantasy Island, Terror at London Bridge* (written by William F. Nolan) and *Star Trek: Deep Space Nine*. In the 1990s she provided the voice of Catwoman on *Batman: The Animated Series*. Her recent work includes roles in the TV series *Dexter* and *Sons of Anarchy*.

She recorded a country album called *Adrienne Barbeau* in 1997 and is the author of two vampire books: *Vampyres of Hollywood* (co-written with Michael Scott) and *Love Bites*. Director George Romero called *Vampyres of Hollywood* "smart, witty, fast-paced, thoroughly entertaining."

MICHAEL McCARTY: Where are you from? Are you considered a celebrity in your hometown?

ADRIENNE BARBEAU: I'm from all over California, primarily the Central Valley (the Armenian contingent in Fresno) and the Bay area (San Jose). I started working professionally with the San Jose Light Opera when I was 16 and so I am sort of known there as "hometown girl makes good." You can check my website, www.abarbeau.com, for more bio info.

MM: You didn't start your career in suspense-horror. You were one of the stars of the popular sitcom

Maude, which is pretty far from the horror field. *The Fog* was your first feature film and scary movie. What aspect of making horror films appeals to you?

ADRIENNE: Actually I didn't start my career with *Maude*. I started on Broadway in *Fiddler on the Roof* as Tevye's daughter, Hodel. And then went on to create the role of Rizzo in the original Broadway production of *Grease*.

What doesn't appeal to me about horror films is watching them. I'd much rather do them than see them. They're great fun to do because they provide an opportunity to express emotions we're not always dealing with in romances or comedies. I think what appeals to me most about the ones I've done has been the opportunity to work with the directors I've worked with. And to play a heroine, a real gun-totin,' ghost-fightin' heroine.

MM: Your role as the gleefully shrewish wife in *Creepshow* was one of the movie's highlights. Do you have any anecdotes about that segment?

ADRIENNE: I love Billie in *Creepshow*. She's one of my all-time favorite characters. And I really didn't know what I was doing when I showed up for work. I just told George [Romero] I was going to do what I thought would work for her and if he didn't like it, he'd better send me home immediately. It was a new experience for me because she was so over-the-top. I just trusted George to know what would work and tried to give it to him. Actually, when I first read the script, I didn't get it at all. I thought it was horrendously gory and didn't think I wanted to be involved. Tommy

Atkins had to explain to me that it was going to be shot like a comic book and I shouldn't take the script descriptions quite so literally.

MM: You bring a lot of intensity to your roles, whether you're the DJ/concerned mother in *The Fog* or the gutsy town recluse in *The Convent*. Is this the product of your training as an actress, or do you feel a rapport with these characters?

ADRIENNE: I think I find a rapport with the characters I'm playing; I search for an understanding of them that resonates with me. Why they do the things they do—whether it's bitch at a miserable husband or help a teenager blow away nuns.

MM: *The Convent* is a highly unconventional horror movie, with lots of dark humor and an almost rock-video feel. What was your initial reaction when you were first presented with this script?

ADRIENNE: As soon as I got to the part of *The Convent* script where adult Christine makes her entrance, I knew I had to do it. I think it's a great hoot of a movie and was really sorry it didn't get a theatrical release in The States. Mike Mendez did a great job with a funny script and no money.

MM: Which of your movies are you most proud of?

ADRIENNE: I guess I'm proudest of *Creepshow*, just because she's such an outlandish character and so far away from me, and I managed to pull it off. I don't even drink. Never have. Don't like the taste of alcohol.

MM: How much of your own stunt work do you do?

Did you do any stunt work in *The Convent* or any of your other movies?

ADRIENNE: I do my own stunts whenever I can. I did the motorcycle driving in *The Convent,* swimming in the swamp in *Swamp Thing*, etc.

MM: Were you creeped-out by the rats in *Burial of the Rats*? What frightens Adrienne Barbeau in real life?

ADRIENNE: The rats didn't bother me, although they weren't trained and they did bite. And I love working with the snakes in *Carnivàle*. The only thing that creeps me out is roaches. I wouldn't have done E.G. Marshall's scene in *Creepshow,* not for any amount of money. Or let's put it this way, I wouldn't have been acting.

MM: Last words?

ADRIENNE: What I'm most excited about these days is the second season of *Carnivàle*. That may not be my most unusual role but [it is certainly] unique. A snake dancer who has a romance with a young boy half her age, a boy who has the ability to heal and who brings her back from the dead. Can't beat that. I'm also excited about the two books I'm writing—a novel for all my horror fans and another, entitled *There Are Worse Things I Could Do*, that's a collection of stories from my life. The rats are prominently mentioned.

"Science fiction and horror have to do with our dreams and our fears and our hopes, which you don't find in one hell of a lot of other literature. I love writers like Edith Wharton, Ernest Hemingway, John Steinbeck. They are not in the same business as I am, of dreaming and fearing and reacting to life and doing something about it. Science fiction and horror and fantasy provide what we all need: something to speak for our hopes, our dreams and our terrors."
—Ray Bradbury

FAREWELL SUMMER

RAY BRADBURY

WHEN YOU HEAR the name Ray Bradbury, several images come to mind: a barren Martian landscape, a magical carnival in the Midwest, and firemen burning stacks of books in the near-future.

Bradbury is a legend in speculative fiction, with good reason—his books have withstood the test of time, and are just as popular now as when first written.

The science fiction, fantasy and horror genres have all embraced his works, claiming him as one of their

own. He has written over sixty books, including novels, novellas, short story collections and poetry collections. Bradbury's works include such classics as *The Martian Chronicles, The Illustrated Man, Something Wicked This Way Comes, The October Country* and *Fahrenheit 451.*

Besides writing plays, he also adapted sixty-five of his stories for television's *The Ray Bradbury Theater*, and won an Emmy for his teleplay of *The Halloween Tree*. In 2000, Bradbury was honored by the National Book Foundation with a medal for Distinguished Contribution to American Letters.

Among his recent books are the novels *Dawn to Dusk: Cautionary Tales* (edited by Donn Albright); *Farewell Summer; Summer Morning, Summer Night; The Fall of the House of Usher / Usher II by Edgar Allan Poe; Match to Flame: The Fictional Paths to Fahrenheit 451; Somewhere a Band Is Playing;* and *Bradbury Speaks,* a collection of essays on the past, the future, and everything in between. His website is at http://www.raybradbury.com/. Ray Bradbury passed away on June 5, 2012 at the age of 91.

MICHAEL McCARTY: What is the inspiration for the short story "The Crowd"?

RAY BRADBURY: "The Crowd" is a true story in many ways, because when I was fifteen years old, I used to hang out down around Vermont and Washington Boulevard here in Los Angeles, near a graveyard. One night when I was visiting a friend, I heard a car crash outside. We ran out and discovered there was this

accident on the street in which five people dropped dead right in front of us. They were staggering around from the wreck and they fell down and died. Within moments, a crowd gathered from nowhere, which was especially strange, because most of the surroundings were the graveyard. There was nowhere for the crowd to come from. The shock of that terrible event stayed with me for years. When I was in my twenties, I wrote it down and turned it into "The Crowd" which I sold to *Weird Tales* (magazine) for fifteen dollars. And that is how "The Crowd" occurred.

MM: Let's talk about your books *Match to Flame: The Fictional Paths to Fahrenheit 451* and *Somewhere a Band Is Playing*.

BRADBURY: My friends at Gauntlet had come to me and told me I had written a lot of short stories before *Fahrenheit 451* that pointed in that direction. I didn't think of it, but that is part of my subconscious; all these things are lodged between my ears and in my ganglion.

I wrote a story about a vampire coming out of the grave called "Pillar of Fire," which was in the magazine *Planet Stories* when I was in my early twenties. It had to do a lot with book burning. The character in the short story takes an attitude toward the people who had burned his and his friend's books.

And then I wrote a short story called "Usher Two," about a man who hates intellectuals, doesn't like fantasy books and hates the history of Edgar Allan Poe and similar authors. So he gets them together and burns them in "Usher Two." It has been a very popular story of mine. I did it as a play and as a film for my Ray

Bradbury television series (*The Ray Bradbury Theater*). People love that, because the lead character attacks the intellectuals who hate books, who hate Edgar Allan Poe and all the great writers in fantasy. I took arms against them, so you see I was preparing for *Fahrenheit 451* without knowing it. The new book that will come out this year, *Match to Flame*, will be all about my unconsciously leading the way to *Fahrenheit 451*, which I wrote in the autumn of 1950. I wrote it in nine days at the library of UCLA, down in the basement. I found a typing room where I could rent a typewriter for ten cents a half hour. I moved in with a bag of dimes and I spent nine dollars and eighty cents, and nine days later I finished *Fahrenheit 451* in its first version, which is 25,000 words.

Two years later, Ballantine Books came to me and said, "We love your story *The Firemen* (the original title). If you find a new title for it and add words to it, we'll publish it." So I sat down, wrote an additional 25,000 words, and changed the title from *The Firemen* to *Fahrenheit 451*.

After *Match to Flame* comes out this year, I have another book called *Somewhere a Band is Playing*, which I began to write when I met Katharine Hepburn back around 1957. George Cukor (who directed her in such films as *A Bill of Divorce, Little Women, The Philadelphia Story,* and *Adam's Rib*) wanted me to write the screenplay of *The Bluebird*. Katharine Hepburn suggested it too. So I had a meeting with the two of them and fell in love with Katharine Hepburn. I liked her so much that I wrote this novel about a country, a land and a city where people are sort of immortal. At the center of it is this beautiful woman

that I have a young writer fall in love with. That is what *Somewhere a Band Is Playing* is all about. I'm sorry I didn't finish it sooner, so that Katharine Hepburn could have played the lead (she passed away in 2003).

MM: *Farewell Summer* is your first sequel to a novel. You have written sequels to your short stories in the past, but never a novel. Why did you decide to write a sequel to *Dandelion Wine*?

BRADBURY: *Farewell Summer* is *Dandelion Wine, Part Two*. They were both written at the same time, fifty-five years ago. Therefore, I didn't have to think about it. I saved the second half and published it fifty-five years later. It's a sequel, but I didn't have to think about it because it was part of the original story and the publishers decided that *Dandelion Wine* was too long, so they wanted me to cut it in half, which I did. I published the first half as *Dandelion Wine* and *Dandelion Wine, Part Two* was called *Farewell Summer*.

MM: In *Farewell Summer* there is an age-old conflict: the young against the elderly in Green Town. Whose side do you sympathize with the most and why?

BRADBURY: Both sides, because I am both of them. All the characters in the book are me. Douglas (Spaulding) is me as a youth, the Colonel (Calvin C. Quartermain) and all of his friends are me when I am old. So I am not on either side; I am on both sides and that is what the whole book is about.

MM: Are the seasons in *Farewell Summer* metaphors for age? Spring brings the birth, summer the youth, the fall middle age and old age with winter?

BRADBURY: I never thought of that. If you take them as metaphors for age, that is up to you. I never considered that, intellectually.

MM: Themes that used to be the driving force of much of Science Fiction in the Golden Age, like interstellar travel, seem to have lost some of their appeal. Agree or disagree?

BRADBURY: I agree, because they haven't had any appeal to me. If you look at all my science fiction stories, you won't find anything there about interstellar travel. I wrote about other things, human things. People, real people moving on to create civilization on Mars (*The Martian Chronicles*). Mars isn't about interstellar travel and all my other fantasy and science fiction in *The Illustrated Man* or *Golden Apples of the Sun* are about dinosaurs; things like that instead of interstellar travel.

MM: What do you think are the main preoccupations with Science Fiction today?

BRADBURY: In my case, I hope readers are interested in my stories and hopes for the future and going back to the moon and gathering our energies together and moving on out to Mars. We should have never left there, and if I can encourage people to back the government to build the rockets to go back to the moon, I hope to do that. And then, sometime in about thirty years, we'll move on to Mars. After Mars, we'll move out to the other planets, moving around other suns, like Alpha Centauri (a multiple star in the Centaurus whose three components represent the brightest object in the constellation.) That gives us a

chance to be immortal. We can't stay on Earth because Earth isn't going to last forever, but we (mankind) want to last forever. Therefore, space travel is very important and there isn't enough of that being written about in science fiction today. I hope my fellow writers will write about that more often.

I will be doing a story, sometime in the future, about an entire church of priests who go out into the universe in their search for God, not realizing that God is buried in their hearts. You don't search for it (God) in other places. It is in your breast, in your psyche and in your soul—I hope to work on that more and publish it in about two years.

MM: What is your favorite Universal Picture monster movie? And why?

BRADBURY: I have several. I was three years old when I saw *The Hunchback of Notre Dame* and I figured on growing up and becoming a hunchback. (laughs) I saw Lon Chaney's *He Who Gets Slapped* a year later and I decided I'd like to be a clown. A year after that I saw *The Phantom of the Opera*. I fell in love with the Phantom, Lon Chaney, even further. All of Lon Chaney's early films became my favorite monster movies, because he was brilliant. There was no one in the history of films like him, before or since.

MM: Several of your books have been turned into movies. Which are some of your favorites?

BRADBURY: The best one so far is *Something Wicked This Way Comes*. It has flaws, but it's darn good. Of course, I'm very proud of *Moby Dick,* which I wrote for (Director) John Huston forty years ago. I'd spent

almost a year adapting (Herman) Melville's novel. Beyond that, *The Ray Bradbury Theater* has been on the air for the last eight or nine years. I wrote 65 scripts for that and they've come out very well. Out of the 65, they had only three clinkers; that's a good track record.

MM: Talking about *Something Wicked This Way Comes*, Jason Robards bears an uncanny resemblance to you. Do you see a lot of yourself in the character Charles Halloway?

BRADBURY: Oh, I think so, sure. If you read the book, all the characters are me. The two boys (Will Halloway and Jim Nightshade) are the two halves of myself—the light half and the dark half. The father is me in the library. The entire book is me.

MM: Do you think *The Martian Chronicles* has been accepted more by fantasy fans than science fiction fans?

BRADBURY: It doesn't matter, they all read it. Cal Tech, M.I.T—all the scientific colleges teach it and talk about it. It's pure fantasy except one science fiction story in it called "There Will Come Soft Rain." *The Martian Chronicles* is labeled science fiction but it's fantasy. People don't mind. The book is about the future—it's mythical. I took Greek mythology and Roman mythology and Egyptian mythology, brought them forward into our time and projected them into the future.

MM: You're very vocal about the subject of censorship and book burnings. This is evident in your book *Fahrenheit 451*. Is there any event in your life that brought this about?

BRADBURY: Well, sure. First of all I'm a library person. I never made it to college—so I went to the library two or three days a week during my late teens and twenties. I knew libraries well. I heard they were in danger, when Hitler burned the books in Germany in the mid-1930s, when I heard rumors of what Russia was doing with the books and authors—they were burning books, too. They kept it quiet—but the word got out.

And the history of the Alexandria Library, which burned at least three times 2,000 years ago, twice by accident and once on purpose. When you hear things like this—this is terrible.

Libraries are my home, my nest. Quite naturally I began writing about it.

MM: What was the inspiration for *Dandelion Wine?*

BRADBURY: I grew up in Northern Illinois—Waukegan, which is 35 miles north of Chicago. I lived there until I was 14. I remember all the wonder years quite well. My grandparents lived next door and one of my favorite uncles lived in yet a third house nearby.

Between the two houses was my grandparents' house, which was filled with books. The Oz books, Alice in Wonderland and fairytale books. And my uncle's house had all the Tarzan books and all the John Carter, Warlord of Mars books. Between the two, I had a wonderful library in one city block.

MM: To what do you attribute the fact that your work has been successful in so many different genres?

BRADBURY: It's pure genetics—it's the way I was born. I was curious about the theatre, curious about

writing poetry, curious about essays. I have always loved the mystery field. A lot of writers in my field don't care about theatre and I grew up in the theatre. They don't care much about radio. I started my career acting on it when I was 12 years old (he sold his first script on the radio, for the *George Burns and Gracie Allen Show,* at the age of 14).

I wrote for a lot of the radio shows in my twenties. It's natural for me, to do all these things. I have loved poetry all my life, so I've written 12 books of poetry. Other people in my field simply don't do those things.

MM: If you could be any monster, which monster would you be?

BRADBURY: The Frankenstein monster, in love with Elsa Lanchester who played the bride of the monster in *Bride of Frankenstein.* It is one of the best monster films made at Universal (Studios) in the 1930s.

I think *The Phantom of the Opera* is a super monster for me.

MM: You've written in an astounding variety of genres, yet you are renowned for your science fiction, fantasy and horror.

BRADBURY: I've only written one science fiction book; that is *Fahrenheit 451.* All the others are fantasies and horror.

MM: Are the advances in modern science difficult to compete with when writing science fiction?

BRADBURY: No, of course not. Any modern science, you grab on to it, hold to it, and use it as best as you

can. Charles Darwin did write about such a mysterious thing as the soul of a dog.

I'm going to write more about love which was created in dogs. Maybe they're the next step up from human beings. Human beings don't love completely yet. Dogs understand it completely, and I wrote about it in a book called *Dogs Think that Every Day Is Christmas*. I recommend you read that book. Most people don't know about it.

MM: What is it that science fiction and horror do that mainstream literature can't do?

BRADBURY: Science fiction and horror have to do with our dreams and our fears and our hopes, which you don't find in one hell of a lot of other literature. I love writers like Edith Wharton, Ernest Hemingway, John Steinbeck. They are not in the same business as I am, of dreaming and fearing and reacting to life and doing something about it. Science fiction and horror and fantasy provide what we all need: something to speak for our hopes, our dreams and our terrors.

MM: What is the most perfect Ray Bradbury book?

BRADBURY: All my books are perfect. Why? Because I wrote them with fun and love. Each one is a perfection or I wouldn't have sent them out. I am very proud of knowing I live in the body with Ray Bradbury. There are two of me, the one that writes and the one who watches him write. I take credit for what Ray Bradbury does. I am not him, and he is not me. There are two of me here; the one that writes and the one that watches.

MM: What is the inspiration for the short story "The Next in Line?"

BRADBURY: It's my adventure in Mexico. When I was twenty-five years old I traveled there with a friend. I made the mistake of going to the city of Guanajuato and going up to the graveyard, going down to the catacombs, witnessing the mummies wound up and wired to the walls, a long line of them, about a hundred mummies. I walked to the end and had to turn around and come back, which terrified me. I wanted to get the hell out of Guanajuato as soon as possible. When I did leave, it was a great relief, but when I got home, I had to write the nightmare down, so it became the story "The Next in Line."

MM: You were reluctant to publish *Dark Carnival*, which was republished by Gauntlet Press. Why?

BRADBURY: There is a lot of stuff in *Dark Carnival* that is in the book that isn't efficient or as beautiful as my other stories. I wanted to pick and choose among things I did when I was twenty-two, twenty-three and twenty-four years old. Naturally, I had learned a lot about writing. I hope when people read *Dark Carnival*, if they read the complete edition (from Gauntlet Press), they understand that it was written by a young man and they can't expect high quality from every story. Later in my life I began to write short stories that were excellent each time I wrote them. I wanted to pick and choose in *Dark Carnival*, but I didn't have a chance to do that. When people buy that Gauntlet Press edition they got to sit down and read my complete life's work from when I was in my early twenties.

Michael McCarty

MM: You wrote *Zen in the Art of Writing*, which is a terrific how-to book for writers. What advice would you give to new writers today?

BRADBURY: Read my book *Zen in the Art of Writing*. It's all there. It has to do with love. I was paid to write those essays, twenty-five dollars an essay by *The Writer* Magazine. Over a period of over two years, I wrote a series of small articles. I think I was paid all together around one hundred and fifty dollars for those articles, which I put in a single book. It all has to do with love.

The best advice I would give new writers is write what you love. It doesn't matter what other people love, it doesn't matter what your editors love or your friends love. It's what you love.

My total work, they're all love stories about dinosaurs. They changed my life. I fell in love with dinosaurs when I was six. I wrote about them when I was in my twenties. I wrote a short story about a dinosaur and a lighthouse and a foghorn (called "Foghorn" which the film *The Beast from 20,000 Fathoms* was loosely based on). When I was thirty-one years old, (director) John Huston read that love story about a dinosaur and a lighthouse and he gave me the job writing *Moby Dick* (the screenplay). I got the job because I was in love. That is the advice I'd give to any writer, not only today, or yesterday or tomorrow. Love is the answer to everything.

MM: You lived and wrote for the most part of the 20th century. Now we are in the 21st century. What do you think of humanity's prospects in the 21st century? Where do you think the world is heading from here?

40

BRADBURY: It's heading for the future.

Look at what we have done. In the last one hundred years we invented ways to heal death. All the great doctors, all the great physicians have invented medicines like sulfanilamide and penicillin. Now billions of people are not dying from those diseases that have been cured. All over the world, we're doing things to save people. We're heading for survival. We're heading for less sickness. If there is any new sickness developed, we'll cure those, too.

The main thing is we're heading back to the moon. That is where we have to go. If we have one or two people who shout and yell about it, that's where we'll head. Look where we have come. We've been out of the cave for a few thousand years. Yes, we had wars, it's true, but we also survived them. It's an ironic balance, isn't it? We rise above our wars and make it, somehow, so that the world is full of billions of people. We have a good chance of going to the moon and colonizing Mars: that is my dream. Listen to me. If you don't want to listen to anyone else, don't listen to them. Listen to me.

MM: Do you think we'll get a manned mission to Mars?

BRADBURY: We'll do it, unfortunately after my death. I'm going to provide for my ashes to be put in a Campbell Soup can, and I will be the first dead person to be buried on Mars. I hope they will obey me and do that.

MM: Last words?

BRADBURY: I feel very fortunate for the life that I

had. I never had one day of melancholy. I never had writer's block. Why? Because I write what I love. People who have blocks, that means they are writing the wrong thing. They are trying to please other people. You can't do that. You've got to please yourself. You've got to act out of love.

I never had one writer's block in my life! And the only melancholy days I had when my best friends or my relatives died. Outside of that, I never had any gloom or sadness or self-destruction.

"At the end of the last century I may have given some people the idea that I'd abandoned my field. I don't think I ever have, and I've certainly no plans to do so."
—Ramsey Campbell

EXPLORING HORROR FROM LIVERPOOL TO THE STARS

RAMSEY CAMPBELL

By Michael McCarty and Mark McLaughlin

RAMSEY CAMPBELL SHOULD never put all of his literary awards on one shelf—the weight of the trophies would probably send it crashing to the floor. Over the years, he has won the British Fantasy Award numerous times, in addition to the World Fantasy Award, Bram Stoker Award, and International Horror Guild Award. He has won all those honors simply by doing what he does best: writing terrifying stories and novels.

He was born John Ramsey Campbell on Jan 4, 1946, in Liverpool, England, where he still lives with his wife Jenny. He sold his first story "The Church in High Street" in 1962 to August Derleth of Arkham House, for an anthology entitled *Dark Mind, Dark Heart*. In 1964, Derleth published Ramsey's first story collection, *The Inhabitant Of The Lake And Less Welcome Tenants*. Pretty impressive for a writer who was still in his teens!

Some of Ramsey Campbell's recent work includes *Dark Companions, The Hungry Moon, The Darkest Part Of The Woods* and *The Nameless*. He became a full-time writer in 1973, and has developed a body of work that includes many different types of fear fiction—Lovecraftian lore, psychological menace, erotic horror, ghost stories and more. He has written stories set on the worlds of the Cthulhu Mythos and in his own community of Liverpool—he is as versatile as he is prolific. And he is still going strong.

MICHAEL McCARTY: Your first story collection, *The Inhabitant Of The Lake And Less Welcome Tenants*, was released by Arkham House while you were still a teenager. Tell us about your early association with August Derleth.

RAMSEY CAMPBELL: I'd written a handful of stories imitating Lovecraft as closely as I could. My friend Pat Kearney, the British fanzine editor and later historian of the Olympia Press, and the American fan Betty Kujawa suggested I should send them to Derleth for his opinion. I don't think I expected more than that—certainly not that he would offer to publish them if I

applied the detailed editorial suggestions he provided. I was even luckier to get such editing at the start of my career than I was to be published. I'd imitated Lovecraft's occasional stylistic excesses without taking anything like his care with structure; I'd even set the tales in Massachusetts when I'd never been out of England. I rid myself of all that to my and the world's considerable benefit.

MM: Your early work focused on Lovecraftian themes. Do you still enjoy and find inspiration in Lovecraft's works?

CAMPBELL: Very much so. He remains one of the crucial writers in the field. He united the American tradition of weird fiction—Poe, Bierce, Chambers—with the British—Machen, Blackwood, M. R. James. He devoted his career to attempting to find the perfect form for the weird tale, and the sheer range of his work (from the documentary to the delirious) is often overlooked.

Few writers in the field are more worth rereading; certainly I find different qualities on different occasions. I recently read "The Outsider" to my wife to both our pleasures. I still try to capture the Lovecraftian sense of cosmic awe in some of my tales, and *The Darkest Part of the Woods* has a little of it, I think.

MM: Your second and third Arkham House collections, *Demons by Daylight* and *The Height of the Scream,* employed psychological themes, with considerable attention to characterization. Were you consciously trying to move away from Lovecraftian themes?

CAMPBELL: As fast as I could. I had to deny him in order to discover my own themes and eventually to rediscover him. August Derleth had advised me to study M. R. James to tone down my excesses, but the great example from within the field was Fritz Leiber. I read *Night's Black Agents* when I was sixteen and saw the contemporary direction I wanted to take. What Fritz did with Chicago, and later with San Francisco, I tried to achieve with Liverpool—the same sense that the everyday can be the source of terror rather than being invaded by it. Still, I'm glad I learned my craft by imitating others while I was homing in on what I had to say for myself.

MM: Your novels *The Doll Who Ate His Mother* and *The Face That Must Die* address the theme of a dormant evil that lurks just beneath the veneer of everyday life. Is that how you see the world—like an apple with a worm lurking inside?

CAMPBELL: I certainly think the everyday can cloak a great deal that people would rather not acknowledge. I suppose I first dealt with the theme back in 1967, in my tale "The Scar," in the person of the neighbour who won't believe a father could maltreat his children and who drags them back for more. There's some of it in the novel I'm presently writing, *Secret Stories*.

MM: Your story collection *Scared Stiff* practically invented the erotic horror genre. What thought processes went into the creation of a book of sexual horror stories?

CAMPBELL: Thought process may be dignifying it a little. My old friend Michel Parry was editing the

Mayflower Books of Black Magic Stories and commented to me in a letter that nobody was submitting tales of sex magic. I thought I would, and wrote "Dolls," which so disconcerted his publishers that they showed it to their lawyers for an opinion about possible obscenity. The lawyers cleared it, and I wrote several other such tales for Michel. It was dishonest of me to include so little of my favourite perversion, though. To some extent I rectified this in time for the expanded Tor edition of *Scared Stiff*. I still have a novel in mind, to be called *Spanked by Nuns*—a pity George Churchward isn't around to illustrate it.

MM: Your book *Midnight Sun* features a unique monster—an ice demon. In fact, monsters play a major role in many of your stories and novels. Would it be fair to say you have a fascination with monsters? And if so, why?

CAMPBELL: I imagine I've always been fond of them. M. R. James's spectres appealed to me in their inhumanity, and I fell in love with the paintings of Bosch at an early age—hardly surprising that I relished Lovecraft so much. In my own stuff they tend to be distorted versions or reflections of the characters who suppose themselves normal. In the Dreadstone/Leyton books I wrote—*The Bride of Frankenstein, Dracula's Daughter* and *The Wolfman* were all of them—I was intrigued to tell much of each story from the viewpoint of the monster.

MM: You've written numerous ghost stories, ranging from the traditional to the erotic. What is it about ghosts that attract your attention? Do you believe ghosts really exist?

CAMPBELL: Like the monsters, my ghosts tend to be inextricably entwined with the psychology of the characters. If you'd asked me the second question last year I would have given you a pretty negative answer. This year, however, I've had several experiences in our guest-room, which my wife and others already thought was haunted. A coin fell from nowhere before my eyes onto the middle of the floor; something I would have taken for a kitten, if we had pets, sat next to me on the bed twice; and an object the size of a hand, but lighter touched me on the shoulder. In the most alarming incident, I awoke to find my wife (whom I was giving time off from my snoring) had joined me in bed, and then I realized that the silhouette next to me under the cover was not my wife. If that was a nightmare, it was certainly by far the worst and most prolonged I've ever had.

MM: What differences do you see between British and American horror stories?

CAMPBELL: I don't see any significant differences these days. Any characteristics one might think national are usually true on the opposite side of the ocean as well. Perhaps the traditions have always developed in parallel. After all, Poe was refining the Gothic and concentrating on the psychological aspects around the same time Le Fanu was. Equally, there were ghastly hacks writing British library fiction while American pulp writers did their worst.

MM: You've worked on completing Robert E. Howard's Solomon Kane stories. What was it like, channeling Robert E. Howard? What did it take to get into that mindset?

CAMPBELL: Not much at all. Kirby McCauley (my agent) and Glenn Lord (for the Howard estate) suggested the task when I was in New York for the 1976 World Fantasy Convention. I read one fragment ("The Castle of the Devil") while waiting to meet Jack Sullivan at the Staten Island Ferry, and by the time he arrived I'd come up with the rest of the plot. I didn't try to imitate Howard's style, but did my best to keep mine out of the way. I'm not sure that I entirely caught Kane's character, though.

MM: You've written under pseudonyms in the past— E.K. Leyton, Montgomery Comfort and Jay Ramsey. You've written novelizations of *The Bride of Frankenstein* and *The Wolfman* under pseudonyms. Why didn't you use your real name?

CAMPBELL: The Universal monster movie novels were commissioned by Piers Dudgeon of Star Books in London. The original idea was that I should write all six, but two werewolf novels would have been one too many, and since I can't swim, I wouldn't have been much use to *The Creature from the Black Lagoon* (at the time I didn't know to suggest David Schow). We therefore needed a house name, and I originally suggested Carl Thunstone, but Manly Wade Wellman felt people might think it was hiding him. Dreadstone was the compromise. For the record (and no matter how many times I say this, I seem to need to repeat myself) I did not write *The Mummy, The Werewolf of London* or *The Creature from the Black Lagoon*, and even Piers can't recall who did. As for Jay Ramsay, it was to disguise my authorship of a single book for a different publisher, though it wasn't meant to fool

anyone who might be interested. Eventually the novel involved (*The Claw* or *Night of the Claw*, depending on which side of the Atlantic) was reissued under my name.

MM: What's in your pockets right now? Any items you carry for good luck?

CAMPBELL: As I sit at my desk, very little. My wife and daughter and son are my luck, and I can't carry them about with me. Whenever I'm out I will be carrying at least two notebooks, one for the novel in progress or about to be, the other for random notions as well as any imminent or current short story. That's one of the few essentials I've learned in more than forty years in this business—another is always to know what the first line to be written is going to be before I sit down to write it.

MM: If H.P. Lovecraft were alive today, what would he be doing for a living? Do you think he'd enjoy the internet? Do you enjoy it?

CAMPBELL: I should think he would be doing what any real writer does—writing (I know Dashiell Hammett was a sad exception). I've no idea what Lovecraft would have made of the internet—he might have been fascinated or seduced by it. I'm both. Borges' notion of the Library of Babel has become reality, pretty well. Of course one needs to be critically wary of it, too, but I find it a great boon for research.

MM: Your work has been featured on British radio. Which of your works have made it onto TV or movie screens?

CAMPBELL: My tale "The Seductress" was an episode of Ridley and Tony Scott's television series *The Hunger*, and quite faithful, I thought. Two novels have been filmed in Spain. *The Nameless* was adapted by Jaume Balaguero as *Los Sin Nombre*, and very unnerving it is. *El Segundo Nombre* (Second Name) sounds like a sequel but is, in fact, a version of *Pact of the Fathers* by Paco Plaza. This too is actually bleaker than the original novel, which suggests that the filmmakers' creative hearts are decidedly in the right place. Both films are available on Region 2 DVDs. *The Influence* is in development at Universal. Joe Dante's office once contacted my agent about *Ancient Images*, but nothing came of that—a pity. Many years ago Fred Olen Ray expressed interest in "The Moon-Lens."

MM: Any last words?

CAMPBELL: At the end of the last century I may have given some people the idea that I'd abandoned my field. I don't think I ever have, and I've certainly no plans to do so.

"The ultimate bogeyman? The ultimate unkillable thing? If one goes back and looks at Westworld, that picture involved a robot gunfighter that keeps coming back again and again. I copied a bit of that idea and added it to a horror film on Halloween night with teenagers. To make Michael Myers frightening, I had him walk like a man, not a monster"
—John Carpenter

HALLOWEEN AND BEYOND

JOHN CARPENTER

By Michael McCarty and Mark McLaughlin

JOHN CARPENTER HAS been thrilling and enthralling moviegoers for years with hits like *Starman, John Carpenter's Vampires, John Carpenter's Ghosts of Mars* and many more. But certainly his greatest fame came from his 1978 film *Halloween,* which has spawned numerous sequels and countless imitators.

Though most of Carpenter's heroes are men of

action, he doesn't ignore the strength and valor of women. Laurie Strode, as portrayed by Jamie Lee Curtis in *Halloween*, proved to be the only one brave and resourceful enough to subdue the relentless silent killer, Michael Myers.

Carpenter was born in Carthage, New York, and raised in Bowling Green, Kentucky. He enjoyed westerns as a child, which may explain the stalwart outlook of most of his heroes, as well as the high-action energy he brings to his work. He attended Western Kentucky University and later enrolled in the University of Southern California's School of Cinema. As a student, he completed the 1970 short subject *The Resurrection of Bronco Billy*, which won an Academy Award. He went on to direct *Dark Star, Assault on Precinct 13* and then *Halloween*, which earned over $75 million worldwide on a budget of $300,000.

Following *Halloween*, he scored big with the suspense and horror hits *The* Fog, *Prince of Darkness, Christine, The Thing, In the Mouth of Madness* and *Village of the Damned*. He ventured into other genres, including the science fiction flicks with *Memoirs of an Invisible Man, Ghosts of Mars, They Live, Escape from New York* and *Starman*.

For TV, Carpenter directed the thriller *Someone's Watching Me*, the mini-series *Elvis* and the Showtime horror trilogy *John Carpenter Presents Body Bags*. As a screenwriter, Carpenter's credits include *Eyes of Laura Mars, Halloween II, The Philadelphia Experiment, Black Moon Rising, Meltdown* and the TV western, *El Diablo*.

John Carpenter's recent work includes the movie *The Ward*, a thriller centered on an institutionalized

young woman who becomes terrorized by a ghost. He also directed two episodes of *Masters of Horror* with "Pro-Life" and "Cigarette Burns." His movies *Halloween, The Fog* and *Assault on Precinct 13* were remade by others.

MICHAEL McCARTY: What did executive producer Irwin Yablans give you to start *The Babysitter Murders* [later known as *Halloween*] creatively and how did you and Debra Hill develop that into the script?

JOHN CARPENTER: Irwin Yablans said, "I want a movie about babysitter murders, about a stalker, a killer going after babysitters." He thought that all teenagers could relate to that, because they all babysat at some point. So I said, "Okay fine."

Debra and I outlined an idea and I went off and directed the TV movie *Somebody's Watching Me*. She wrote the first part of the script, and after I finished the TV movie, I came back and finished it. One day Yablans called me on the telephone and said, "Why not set the film on Halloween night and we'll call it *Halloween*." It had never been used as a title before.

MM: Michael Myers—*The Shape*—is the ultimate bogeyman: unstoppable, without reason or humanity. How did you and Debra go about creating Michael?

CARPENTER: The ultimate bogeyman? The ultimate unkillable thing? If one goes back and looks at *Westworld,* that picture involved a robot gunfighter that keeps coming back again and again. I copied a bit of that idea and added it to a horror film on Halloween

night with teenagers. To make Michael Myers frightening, I had him walk like a man, not a monster.

MM: Was Michael Myers' character history, as conveyed in the later films, part of your original Myers mythos?

CARPENTER: Michael Myers' connection to [Laurie] was all made up in the later films because my business partners wanted to make sequels. I can't stop them from making sequels. For *Halloween II* I contributed a screenplay, but I didn't want to direct it.

MM: Most of Michael Myers' victims were sexually active, while the one who eludes him, Laurie [Jamie Lee Curtis], is virginal. Were you trying to make some kind of statement about sex being deadly?

CARPENTER: For over 30 years, people have brought up this so-called "sexual statement" issue. It has been suggested that I was making some kind of moral statement. Believe me, I'm not. In *Halloween*, I viewed the characters as simply normal teenagers. Laurie was shy and somewhat repressed. And Michael Myers, the killer, is definitely repressed. They have certain similarities.

MM: *Halloween* sparked a glut of horror movies based on serial killers attacking on holidays, for example *Friday the 13th, My Bloody Valentine, Valentine's Day, Mother's Day*, etc. They say imitation is the sincerest form of flattery . . . were you flattered?

CARPENTER: I was flattered, but I took it not as much about me as money. One could make money and get a career going with a low-budget horror film about

killers attacking on holidays. It is always flattering to have somebody copy you.

MM: You shot some scenes for the TV broadcast of *Halloween* to help pad the running time, using the cast and crew from *Halloween II*. Why?

CARPENTER: NBC purchased the right to show *Halloween* on network television. The minimum length requirement was 93 minutes, if I remember correctly. *Halloween* only lasted 88 or 89 minutes. So we had to pad it to get to the length NBC required. I just added a lot of foolish crap—nothing particularly good.

MM: You produced and scored *Halloween 3: Season of the Witch*. That movie broke away from Michael's story. Was the intent at that point to release a stand-alone movie in October?

CARPENTER: I wanted to get away from what I thought was the dead end of the original *Halloween* story. It's basically the same idea over and over again. Nothing really changes. *Halloween 3* was an attempt for something new. I was wrong. The audience didn't want to see a change. They wanted the Shape. So the Shape is what they got.

MM: What was your level of creative input with the other *Halloween* sequels?

CARPENTER: After 3, I didn't have any creative input. I just collected checks.

MM: Aliens and monsters hidden among us—that's the theme behind your movies *Village of the Damned,*

The Thing and *Ghosts of Mars*. The main sense of horror in these films seems to come from paranoia: no one can be trusted. Do you see that as a dominant source of fear in today's world?

CARPENTER: Evil hiding among us is an ancient theme. Demonic possession has been with us for centuries. With the emergence of science fiction, this evil sometimes takes the form of malevolent aliens.

MM: You've written, directed, scored the music, edited and produced several of your movies. How do you juggle so many responsibilities?

CARPENTER: With great difficulty.

MM: What are your thoughts on the horror and science fiction genres?

CARPENTER: I've always had a fondness for horror and science fiction.

MM: You worked extensively with the late Donald Pleasence. Do you have any stories about your years of working with him?

CARPENTER: Donald Pleasence was a dear friend for many years. I admired him as an actor and loved working with him. He was one of the funniest men I've known.

MM: Satan and the Anti-God, as depicted in *Prince of Darkness*, appear to be science fictional as well as supernatural. For example, the Anti-God is trapped in a mirror dimension, and the liquid life-form in the ancient canister acts like a contagious virus. Do you feel the supernatural might be, in fact, another form of science?

CARPENTER: This is a difficult question. I personally don't believe in the supernatural. On the movie screen, the supernatural certainly can exist, but in real life, no. But most people on the planet have a deep hunger for supernatural meaning. One can't just ignore it. I combine science and the supernatural to tell a story, nothing more.

MM: *Ghosts of Mars* also combines the supernatural and science fiction: ghosts of long-dead aliens possess modern Earthlings. Do you believe in life after death, as either a supernatural or scientific phenomenon?

CARPENTER: I don't believe in life after death.

MM: *Escape from New York* and *Escape from L.A.* are set in a distant police-state society. Do you feel the United States is headed in that direction?

CARPENTER: I don't feel the U.S. will resemble the world that I portrayed in the *Escape* movies. Certain aspects of it, yes—but I doubt to the extent of the fictional country that Snake Plissken found himself in.

MM: You played a coroner in *Body Bags*. Do you have any acting roles lined up in the future?

CARPENTER: If anyone asks me, I'll do it.

MM: What scares John Carpenter?

CARPENTER: That is another question that I've been asked for the last 30 years. I have the same answer every time. What scares me is what scares you. We're all afraid of the same things. That's why horror is such a powerful genre. All you have to do is ask yourself what frightens you and you'll know what frightens me.

"Dark Shadows will live forever."

—Dan Curtis

THRIVING IN THE DARK SHADOWS

DAN CURTIS

*D*ARK SHADOWS, CREATED by producer/director Dan Curtis, is a pop culture phenomenon. The series ran for a half-hour each weekday from June 27, 1966 to April 2, 1971. The success led to two feature films, *House of Dark Shadows* and *Night of Dark Shadows*. The gothic soap opera has a cult following reaching Beatlemania proportions and a fan-base stretching over four decades.

Other movies directed by Curtis include *Burnt Offerings* (which was co-written with William F. Nolan, also in this book). He made several TV movies: *The Night Stalker* and *The Night Strangler* (both written by Richard Matheson, who is also in the book) led to *Kolchak: The Night Stalker* series. Curtis and

his company Dan Curtis Productions designed such classics for the tube such as *The Strange Case of Dr. Jekyll and Mr. Hyde, Dracula* and *Frankenstein.*

Curtis directed such TV movies as *The Norliss Tapes* (also written by Nolan), *Scream of the Wolf, Trilogy of Terror,* and *Dead of Night.* At that time, he was dubbed "Television's King of Horror." In the 1980s, he made the mainstream made-for-television movies *The Winds of War* and *War and Remembrance,* based on the books by Herman Wouk.

Dark Shadows has been resurrected on DVD, and Tim Burton directed a *Dark Shadows* movie starring Johnny Depp, as Barnabas Collins, and Michelle Pfeiffer in 2012.

Dan Curtis passed away on March 27, 2006, at the age of 78.

MICHAEL McCARTY: Why do you think *Dark Shadows* has had such a devoted following for over 40 years?

DAN CURTIS: If I knew the answer to that I'd be a genius. Obviously it has some kind of deep seated appeal that reaches down into the bowels and the hearts of the viewers. It's not just a horror story—it's a romance story that crosses centuries as well. It's a reincarnation story of lost love. It can be very scary at times, with a lot of imaginative twists and interesting characters.

It has a universal appeal, because it appealed to people of all ages and continues to appeal. It wasn't just a question of whether it would appeal to kids in the late '60s. It seems to appeal to all who watch it.

MM: Of the 1,225 episodes of *Dark Shadows*, what were your favorite story lines?

CURTIS: My favorite story is when Victoria Winters (Alexandra Moltke) goes into the past and we find out how Barnabas Collins (Jonathan Frid) became a vampire, the whole Angelique (Lara Parker) story and the cursing him and all that whole business.

MM: You introduced Barnabas Collins in episode 210. Was the vampire going to be just a short-term character?

CURTIS: I had turned the show supernatural and I was going to see how far I could go with it in terms of how much the audience was going to buy it. I put on a vampire, which I consider the scariest of all supernatural creatures; that's how it happened.

When Barnabas Collins turned into such a huge hit, I couldn't kill him off, which I had originally intended to do. I had to find a way to keep him alive.

MM: Why did you kill Barnabas Collins off in the end of the *House of Dark Shadows* movie?

CURTIS: That is what I always wanted to do with that story, but I couldn't on the television series. So I did it in the movie.

If one looks very closely, right around the time of the credits, you see a bat fly up toward the camera, which would have given us the opportunity to come back and do a sequel. It's a little hidden fact that probably nobody knows. (Laughs)

MM: What are your thoughts on *Kolchak: The Night Stalker* series?

CURTIS: I had nothing to do with the series. I made the first two pictures. I made the original which was the big hit, *The Night Stalker*. Then I made *The Night Strangler*. I didn't want to do the series. I had nothing to do with the series, the Monster-of-the-Week formula of what happened to Kolchak after the first two movies.

MM: Over the years there have been a lot of comparisons made between *The X-Files* and *Kolchak: The Night Stalker*. What are your views on this?

CURTIS: I could never understand that. I don't know what the similarity is.

MM: We never do discover what happens to Norliss by the end of *The Norliss Tapes*. What do you think happened to Norliss?

CURTIS: (Laughs) That was supposed to be a pilot for a series. I just left everyone up in the air. When they didn't pick it up as a series, I laughed my ass off.

What do I think happened to him? I have no idea. (Laughs)

MM: *Trilogy of Terror* is famous for the last story, about the Zuni Fetish doll that chases Karen Black with a knife. Was the Zuni doll done with puppets or stop-motion photography?

CURTIS: We had ourselves a hand puppet and another puppet that had a rod stuck up its ass and was held up above the floor. The floor of the set was held up by risers. We cut lines into the floor that were covered by the carpet and we had some idiot underneath running with this thing that moved its (the puppet's) arms up

and down, and its legs. It was pathetic. (Laughs) It was the worst looking thing I had ever seen.

This was done in desperation. It was the last day of shooting and everyone went home. I kept the puppeteer there. I said to him, "I'm going to get a bunch of close-ups of this thing against a black (backdrop) and you stick your hand in that puppet and just have it open its mouth—keep it moving within and without of the frame."

So I basically made it all work in the cutting room. I sped those shots up, by skip framing them; I flopped them over to make them go from left to right and right to left. The knife would jump from one hand to another—but nobody had ever noticed that. It was against black—I would cut to it anytime I wanted.

I shot the whole thing in four days.

MM: Why did you get out of the horror field in the late 1970s?

CURTIS: I was just getting so tired of doing it. It is a very difficult thing to do, to do a horror film properly and make it good. Far more difficult than a normal drama.

I love scary stuff, so it was fun. I was just hungering for the time to do real stories, dealing with real people, where every line isn't suspect, where you didn't have to constantly squeak the door.

That is why horror films stink. Because people don't know what the hell they are doing, they think it's a horror film and they can do anything. They can't. They do a horror film, they have to be really careful. You have to use logic. Just because there is a ghost or a monster involved, it can't become totally illogical and

if you do that, and they always do—you lose the audience completely, all realism and believability are gone. They never know how to end these things.

I used to say, "Anybody can write a horror story if you didn't have to end it."

I just ran out, I couldn't come up with another great scary idea. I couldn't find any existing material. I just wanted to forget it and put horror behind me.

MM: Last words?

CURTIS: *Dark Shadows* will live forever.

"Elvira has become the queen of Halloween, an icon for the holiday. She basically became what Santa Claus is for Christmas"

—Cassandra Peterson

ELVIRA, THE QUEEN OF HALLOWEEN

CASSANDRA PETERSON

"I'M THE GAL who put boo back into boob tube"—Elvira from *Elvira, Mistress of the Dark*.

Movie critic Roger Ebert once described Elvira as a "cross between Mae West and Vampirella." That might explain why, for over three decades, she has been horror comedy's funniest and sexiest actress.

Elvira is the voluptuous vampire-like persona of actress Cassandra Peterson. Elvira was created in 1981 after Peterson landed a job with KHJ-TV in Los Angeles as hostess for the station's horror movie program, *Movie Macabre*. On May 23, 1982, she hosted a screening of *The Mad Magician*, a 3-D film.

Michael McCarty

More than 2.7 million pairs of 3-D glasses were distributed, and Elvira became the first person to appear on television in 3-D.

Peterson grew up in Colorado Springs, Colorado, but she "busted out" (a bad pun, I know) and began her career in show business as a showgirl in Las Vegas.

In 1985 she received the Count Dracula Society Award from the Academy of Science Fiction, Fantasy and Horror Films. In 1986, Marvel Comics began to publish *Elvira's House of Mystery*, which ran for eleven issues. In 1986, the Elvira costume became the best-selling costume of the year. In 1987, she made her first appearance in commercials for Coors Beer, becoming the first female celebrity hired to endorse a beer product.

She also starred in the TV movie *Elvira's Halloween Special* and two feature films: *Elvira, Mistress of the Dark* and *Elvira's Haunted Hills*.

Elvira's Movie Macabre original TV shows are now available on DVD and the show was back on the air again from 2010-2012.

Elvira is everywhere: on T-shirts, posters, pinball machines, slot machines, computer games, and much more. Elvira, Mistress of the Dark is the best-selling female Halloween costume of all time. To find out more about Elvira and Cassandra Peterson, go to www.elvira.com.

MICHAEL McCARTY: Is it comfortable or uncomfortable to wear such a low-cut bustier? How long does it take for you to change into the Elvira costume?

ELVIRA: I have it timed to exactly an hour and a half, and that is rushing like crazy. It is uncomfortable to wear for a long time. All the things that men like about women dressing up sexy are uncomfortable: tight clothing, push-ups (bras) don't really feel that great, six-inch heels and the hair and all of that. It gets really old after a couple of hours.

MM: You dated both Elvis & Jimi Hendrix. Who was the better kisser?

ELVIRA: I was so busy thinking I was with Elvis when I was with him that I couldn't even think. I don't even remember kissing. It was like, "Oh my God! I'm kissing Elvis."

Jimi Hendrix was pretty damn good, too.

I was so overcome with something. (Laughs) I don't know what. (Laughs) Maybe the fact that I was kissing them, I don't remember how great it was.

MM: As Elvira, why did you never do any truly revealing photo shoots for publications like *Playboy*? You did work as a showgirl before, so why not pose for *Playboy*?

ELVIRA: I did photos for *Playboy* as myself, when I was a showgirl in Vegas, and I did revealing photos, but I've never done them as Elvira. That was mostly because, back then I was young, making money, modeling topless. No big deal. It was me, and every single other actress in the entire world . . . ever (Laughs) has done that to pay the bills. Being a showgirl was not a big deal, for me. I did several Playboy magazine issues. I did *Oui* magazine. A few others.

Michael McCarty

I was asked to do *Playboy* as Elvira, and I turned them down. I know Hef (Hugh Hefner) very well.

MM: Was there a particular reason you turned them down? Did you think *Playboy* would be too risqué for the Elvira character? Or wasn't she suited for *Playboy*?

ELVIRA: I think she was suited for *Playboy*. (Laughs) First, not only adults like Elvira. Although Elvira is not aimed at children, kids really love the character. I do a lot of merchandising, which crosses over to kids, like Elvira candy, Elvira video games, Elvira pinball games. Lots of things that kids really enjoy. So I had the feeling if Elvira did photos, it would take away the kid appeal. Second, I polled fans of mine at a convention and asked them if Elvira should pose for *Playboy*, and they said they thought it would take away too much mystique from the character. What is sexy and mysterious about the character is that you never get to see too much. If you see everything, then what else is new? Now she is like everybody else.

MM: Why do you think humor and horror go so well together?

ELVIRA: When something funny happens in a horror film, you let your guard down. Then you can zap them with something scary. It is something so out of left field that you really get a good scare. You make a film like a roller coaster ride, getting them to laugh, getting them to relax, laughing a little bit. It's that funny, then laugh, then BOO! You scare the crap out of them because if they are tense the whole time, they are waiting for the scare.

Humor and horror play off each other well. In my

case, being silly and funny all the time—I find that people who enjoy horror have a great sense of humor, too.

MM: How did the character of Elvira get started? And why do you think she is so popular after three decades?

ELVIRA: The character got started as a horror host in L.A, hosting late night bad horror movies here in Hollywood. After a few years, we were able to syndicate the show, so it went national. I was the first horror host to go completely national.

The reason she is so popular is because she became very synonymous with Halloween. I do so many things during the Halloween season. Elvira has become the Queen of Halloween, an icon for the holiday. She basically became what Santa Claus is for Christmas.

MM: But without the red suit?

ELVIRA: Yes (Laughs)—without the red suit.

MM: You've met Vincent Price before. What was he like?

ELVIRA: He was fantastic. I loved him. I adored him long before I was Elvira. He was my favorite star when I was a child. Meeting him was really a thrill. He was just one of the nicest, kindest, funniest men I've ever met in my life. Every time I saw him, I told him that he missed his calling. He should have been a stand-up comedian. He was just one of the funniest guys alive, and I don't think many people knew that about him.

He was also a really well-rounded individual. Not just an actor. He was a chef, he collected art, and he was a brilliant guy!

MM: Because you are such a big fan of Vincent Price, is that the reason you did *Elvira's Haunted Hills* movie?

ELVIRA: Absolutely! I'm a fan of not only Vincent Price, but also the whole American Pictures genre of film. When I was a kid, my favorite films were those series of films that Roger Corman did that were loosely based on Edgar Allan Poe stories, like "The Pit and the Pendulum," and "The Fall of the House of Usher." Those were my absolute favorite childhood movies. I tried to make a movie that was a parody of and also an homage to those movies. Those movies aren't around anymore. I have a very special place in my heart for those films.

MM: New World Pictures, the distributor for *Elvira, Mistress of the Dark* went out of business soon after its release of the film. Did going broke hurt the movie? Could have it been a bigger film if this hadn't happened?

ELVIRA: It hurt it horribly; it was one of the worst things that happened in my entire career. (Sighs) My movie had so much pull behind it, so much leading up to it. Then the distributors, New World, went bankrupt the day my movie was released.

MM: That's horrible.

ELVIRA: I can't remember the exact number. It was going to be released in 30,000 theaters in America. And boom! That day, it was released in 300. It was cut from 30,000 theaters down to 300. I don't care if you're *Star Wars*, you cannot be a hit movie in 300

theaters. There is no way. You can't get that many people in 300 theaters.

It was released in the major markets only: New York, Chicago, San Francisco, Los Angeles. In the cities it was released in, it did really well. In New York it was number two, in LA it was number one and in San Francisco it was number one. It was competing with major profile films like *Gorillas in the Mist*. It was weird, weird. A really bad thing that happened. The movie would have been so much bigger and more famous and more popular had it been released in 30,000 theaters. Any movie would be.

When I tell people about this, it always sounds like sour grapes, but it's true. That's what happened. I'm not sure my career really ever recovered from it.

The video *Elvira, Mistress of the Dark* went on to become one of the Top 60 selling videos of all time. That was when videos were selling for $24.99. It is still in the Top 60 video sales for any video ever. That says something about it.

MM: You were in *Peewee's Big Adventure*. What was it like working with director Tim Burton?

ELVIRA: At the time, when I was trying to do my movie, *Elvira, Mistress of the Dark,* and Peewee (Paul Reubens) was trying to do his, we were fighting over Tim Burton.

I saw Tim Burton's movies, and all he had done at the time was a short film called *Frankenweenie* and a little animated film called *Vincent* about Vincent Price.

I saw those movies and said, "Oh my God, he'd be perfect." At the same time, Peewee was looking for a director for *Peewee's Big Adventure*. He ended up

71

getting him, somehow. I'm not sure of what it was, the money offer, the deal, whatever it was. He snatched Tim Burton up first. We were too late moving on it. Peewee got him, and I didn't. Another little thorn in my side.

MM: How did you end up on the cover of Tom Wait's *Small Changes* CD?

ELVIRA: You are not going to believe this, but that is not me. I even say, "Oh my God, that looks so much like me." I wish it was me—but it's not. I never did that. It is so strange.

MM: Not many people know you are an author, too. You co-wrote *Transylvania 90210* and *Camp Vamp* and *The Boy Who Cried Werewolf* with John Paragon (who also co-wrote Elvira's movies *Elvira, Mistress of the Dark* and *Haunted Hills*). Tell us about those books. Any other books in the works?

ELVIRA: No, it was just those three. It was a young adult series of books that came out when R.L. Stein's *Goosebumps* were really popular. John and I thought we'd do our own version a little sexier, a little more adult like. They are pretty tame. They are for young adults. We did only three, unfortunately. We'd like to continue, but the market was pretty saturated with horror novelettes at the time.

I later wrote another book called *Bad Dog Andy*. It was as myself and with my writing partner John Paragon. It was a parody of the Good Dog Carl books— they are children books about a Rottweiler. We did a parody about John's dog that was a Dalmatian.

I have written a few books. I certainly intended to

someday write my own autobiography, if I ever get time to do it. That is something I really want to work on.

MM: A few years ago, you released Elvira's *Box of Horror*. Is there another DVD set in the works?

ELVIRA: No, but I just made another deal which will be out next year, with a company called The Shell Factory. It is for my original *Movie Macabre*, the original ones in a box set. That is going to be really cool. That stuff hasn't been around for twenty-five years.

I've been watching it recently. I pulled it out of storage and there is some damn funny stuff in there. It's all the old movies I hosted back in the '80s, and they are going to be re-released in a box set.

MM: Which of your career achievements do you consider your greatest?

ELVIRA: Certainly making the movies *Elvira, Mistress of the Dark*, and *Elvira's Haunted Hills* were my greatest career achievements. The first movie I made was through the studio. It had a bigger budget. The second movie, my ex-husband and I basically made, produced, and wrote. Did the entire thing. It is quite an achievement to make your own movie. It takes years of your life. We financed it with our own money, a big mistake.

To be in the Rose Parade in my own float, the largest parade in the world. And there was the time I rang the bell at the Stock Market for the closing of the New York Stock Exchange.

I have my own pinball machine and, of course, the

beer commercials. Pinball machines and beer, to me, beat winning an Academy Award. (Laughs)

MM: Do you think there will be a third Elvira film?

ELVIRA: I'm actually having meetings right now about another Elvira film. It may be animated. I think an animated Elvira would be so cool.

MM: How did you get involved with animal rights?

ELVIRA: Dan Mathews with PETA got me involved. I found out about all the suffering involved in factory farming, fur coats, raising animals for fur.

I must have been wandering around in some kind of naive dream before I met him. He told me about the realities of all that. I couldn't help becoming involved. Once you hear, have it explained to you, shown to you the pictures, you become so floored. If you've ever had a pet before in your life, you know you have to do something to help the plight of animals. Animals are the voiceless. Someone has to speak up for them. PETA are the ones who got me involved initially. I have a special place in my heart for the animals—I love them.

MM: Is there a project you passed on that you now regret you didn't do?

ELVIRA: Brandon Tartikoff, the late President of NBC, begged me to do an Elvira sitcom. I kept saying "No." I kept turning it down and turning it down, because I wanted to do a film first. I was adamant about it. Finally, Brandon Tartikoff and the people of NBC were the people who funded my first film *Elvira, Mistress of the Dark*.

I've regretted not going with Brandon's first suggestion: doing a sitcom on TV.

MM: It probably would have been huge.

ELVIRA: I know it would have been. Since then, I did a foray into Elvira Sitcom. That was for CBS. It was an incredibly funny pilot that never made it.

MM: Last words?

ELVIRA: Be sure to go to www.elvira.com and check out everything I am up to. Unpleasant dreams.

"As popular as everyone 'thinks' zombies are, the numbers—at least in YA lit, for me anyway, don't generally support that. Every time one of these great, supportive YA bloggers posts an interview or guest post or review, nine out of every ten comments is, 'I've never read a zombie book before, but I think I'll give this one a chance . . . '"

—Rusty Fisher

ZOMBIES DON'T CRY

RUSTY FISCHER

Rusty Fischer IS a professional freelance writer who lives in sunny Florida with his beautiful wife, Martha. They enjoy riding bikes, long, leisurely walks on the beach, romantic dinners and zombie movies; lots and lots of zombie movies (well, Rusty does, anyway)!

Rusty is the author of several YA supernatural novels, including *Zombies Don't Cry; Zombies Don't Forgive; Zombies Don't Surrender; The Girl Who Could Talk To Zombies; Ushers, Inc.; Detention of the Living Dead; Becca Bloom and The Drumsticks of*

Doom; The Littlest Werewolf's Story; and *Monster Party.*

Visit his blog, www.zombiesdontblog.blogspot.com, for news, reviews, cover leaks, writing and publishing advice, book excerpts and more! And if you can't wait for his next release, download his complete YA novel *Vampires Drool! Zombies Rule*! absolutely FREE at www.scribd.com/doc/38953974/Vampires-Drool-Zombies-Rule-by-Rusty-Fischer.

MICHAEL McCARTY: Why do you write horror?

RUSTY FISCHER: I love horror! The only movies I ever really get excited about are horror movies; you should see my Netflix queue—it's nothing but bad '80s horror movies, slasher films and, lately, I'm trying to catch up on the first four After Dark Horror Fest films.

I think most kids are VERY reluctant readers. I know when I taught, the only things the boys ever wanted to read were the darker things: Poe and "The Raven" and Goosebumps and all that. So when it came time to write for teens, I felt like YA horror was a great melding of what would excite me, and hopefully, them!

MM: When writing YA horror, how far can you go in terms of violence and sex?

RUSTY: Not very, but that's okay; I've tried "adult" horror where there are no limits and . . . I'm just no good at it. Even when I try to write R-rated violence for grown-ups, it still comes off sounding PG-13, so I've kind of found my groove just keeping the blood, gore and sex to a minimum. Instead I try to concentrate on creating a kind of tense, dramatic

atmosphere. Then, too, I usually screw that up by having my main character toss off an aside or a joke to ruin the mood.

MM: Are you planning a sequel to *Zombies Don't Cry*?

RUSTY: I'm planning on one, but I'm not sure if the publisher is! By that I mean, if sales are good enough on the first one, I'd LOVE to do a sequel. I've actually outlined it in a spiral-bound notebook and keep fiddling with it, taking the characters in new directions, tweaking the love triangle, complicating things; it's turning out to be more of a mystery than the first one, and a little darker as well. (Author's note, he has since written and has published *Zombies Don't Forget* and *Zombies Don't Surrender*.)

MM: What can you tell us about your new book *Vamplayers*?

RUSTY: It's my first vampire book, so like *Zombies Don't Cry,* I wanted to give the old genre a new twist. A Vamplayer is basically a pretty boy vampire—part player, part vampire, you know the type—who slithers into a school and takes out the "cool kids" one by one until he's the cool kid; then he seduces all the cool chicks and, one by one, infests the school with his minions.

But there are other vampires who follow these Vamplayers around from school to school, trying to stop them. They're called the Sisters and they're always these three hot, cool vampire chicks who try to beat the Vamplayer at his own game. In this case, the Vamplayer gets the best of two of the sisters, leaving one to save her friends, and the school, from the bad guy.

MM: Authors are often told to "take chances" with their writing. What does "taking chances" mean to you?

RUSTY: For me, taking chances means shutting my door, drowning out the naysayers and editors and trends and agents and all the writing "advice," ignoring my own doubts and fears and insecurities, putting my fingers over the keyboard and just telling the best story I can, regardless of whether or not there is an audience for it or everybody will "get it."

As popular as everyone "thinks" zombies are, the numbers—at least in YA lit, for me anyway, don't generally support that. Every time one of these great, supportive YA bloggers posts an interview or guest post or review, nine out of every ten comments is, "I've never read a zombie book before, but I think I'll give this one a chance . . . " I was kind of surprised by that, but it didn't stop me from going on and writing six more zombie stories!

MM: With *Zombies Don't Cry* you really created some cool zombie mythos about eating brains, copper stakes, graveyard dirt, The Sentinels, The Elders and The Zerkers. Did you have the mythos in mind before or during the writing of the book?

RUSTY: I had some of it in mind, like the Sentinels; but every time I turned a corner in the story I needed a new explanation for this or that. Why were the good zombies good? Well, they needed laws, so here come the Elders. Where was the tension if all the zombies were good? Well, they needed "bad" guys, so here come the Zerkers.

The copper stakes and grave dirt were kind of a "wink, wink, nudge, nudge" thing to the vampire crowd, so I can't take *too* much credit for that!

MM: What sort of reaction do you get from people when you tell them what you do for a living?

RUSTY: I get two reactions: first, everyone says, "I had no idea you could ghostwrite for a living!" Then, the next words are usually, "You know, I have this idea for a book. Do you have a few hours, right now, I mean here at this cocktail party or Christmas party or movie lobby for me to tell you my life story?"

Okay, I'm exaggerating a bit, but I really do believe that many, many people are frustrated writers!

MM: You live in Cape Canaveral, Florida. You've probably seen your share of Space Shuttle launches. Which one impressed you the most? Did you see The Challenger explosion during the '80s?

RUSTY: I'm spoiled, I know it. I'm actually writing in front of the window where I've literally watched most of the shuttles in the last five years launch. For me, these last ones are the most poignant. I mean, they're retiring shuttles, people!

People I know personally, kids I went to high school with who got jobs gluing on shuttle tiles right after graduation, guys who've eaten lunch in my dad's restaurant every day for the last twenty-five years, they're all being phased out as the shuttle program winds down. The crowds have been bigger and bigger, too, so each of these last launches feels like a real event.

As for the Challenger, yes, I was there, front and center. Back then, and maybe they still do, the teachers let you out of class for each shuttle launch. I was a senior, and I just walked out to the front of the school with a couple of friends. When it happened, when we all realized what happened, everyone was silent except for this one classmate who was screaming, "It's their fault! It's all their fault!" She was hysterical; I doubt she even realized what she was saying and I didn't know her enough to ask, nor was it the time to ask, who "they" were. I'll never forget that moment, or what it meant to the community after that disaster.

People forget it now, but everything shut down or was put on hold. Tourism dried up for years; my dad nearly lost his business, which had been open since the earliest days of the space program, the days *The Right Stuff* talked about. It was a dark, dark time and put a face to those brave men and women who risk their lives to explore space.

MM: If you could be a monster, which monster would you be?

RUSTY: I would definitely be a zombie; it fits my personality. No flash, no dash, no sizzle, all steak. My zombies are the underdogs of the monster world; I've said that more than once. In high school I played the center, not the quarterback; the nose guard, not the linebacker. In Drama I was always the supporting actor, not the star. In Yearbook I took the pictures, but wasn't in any. I was the original wallflower and that's where my mind goes whenever I write YA; my main characters are NEVER the popular kids, the starting quarterbacks, the pretty boys or girls—they are always

just off center, lurking around on the fringes, watching it all. That fits a zombie to a "T," don't you think?

MM: How did you get into ghost writing?

RUSTY: I literally answered an ad in the paper for my first ghostwriting gig (the one and only time I've ever found ghostwriting work in the paper!). It was for a gentleman who was a big fan of Robert E. Lee and wanted to write a fictional business book based on Lee's equally fictional "diary." It just so happened I had done freelance work in both history and business and he liked that; he hired me and paid me what I was then making at a local book packager. I realized, "Hey, I could do this for a living!" And that's exactly what I've been trying to do for the last eleven years!

MM: What have the fans been like so far?

RUSTY: Amazing! There is this whole world of YA bloggers, reviewers and "cheerleaders" who are eager and open and ready for new things, new voices. I was never a big fan of social media until I started promoting *Zombies Don't Cry,* but I've met a few dozen loyal, encouraging and supportive YA bloggers through Twitter and Facebook, mostly, and they have really helped spread the word!

MM: Last words?

RUSTY: Just a few! I've been thinking a lot lately about this whole eBook versus paper book discussion I see playing out all over Facebook and Twitter and now even in the mainstream media. While *Zombies Don't Cry* and *Vamplayers* will both be paperbacks, I have several other YA supernatural stories coming out as

eBook only versions and I'm equally excited about all of them.

I know that *Zombies Don't Cry* being out in paperback has helped get reviews; say what you want, but most YA reviewers prefer paperback. But I also know that, as far as sales, even at $9.99 the paperback version seems to have been prohibitive for some folks; the Kindle at $7.99 still seems to outsell it two or three to one.

I know that, in my own buying habits, I'm more likely to buy big name authors or impulse buys at the local bookstore(s) in paperback, but the folks I meet on Facebook and Twitter and such, like you Michael, I'm more apt to go from a conversation or "meet and greet" we've just had and pick a Kindle version and download it for a few bucks. That's how I bought *Partners in Slime* by Michael McCarty and Mark McLaughlin—bip, bam, boom and I had it there on my computer and read it whenever I can. It's very easy for me to meet a new author on Facebook or Twitter and, for five or six bucks download their book, read it, review it on Amazon or Goodreads or whatnot, and make a new author "friend" that way, so I like that aspect of it.

Meanwhile, at night after a long day of staring at a computer screen, I'm much more likely to lie in bed with a good paperback and relax the old-fashioned way. So, short answer, I'm hopeful for both forms of readership and just glad to be active in such dynamic times in the publishing world.

MM: Mark McLaughlin and I thank you for purchasing *Partners in Slime* and I thank you for doing the interview.

"American SF fans receive the mail from the Postal Service, while British SF fans get the post from the Royal Mail. American fans are more likely to say 'y'all' (southern) or 'you betcha' (Minneapolitan) than British fans, who are more likely to know who the Clangers were, and why they had to visit the Soupdragon."

—Neil Gaiman

M IS FOR MAGIC

NEIL GAIMAN

NEIL GAIMAN IS the New York Times best-selling author of many wonderful works, including *American Gods, Coraline, Neverwhere, Anansi Boys, Fragile Things, M is For Magic, The Ocean at the End of The Lane, Odd & The Frost Giants, The Graveyard Book, Unnatural Creatures* and *Chu's First Day of School.*

Among his various awards include the World Fantasy Award, The Bram Stoker Award, the British Fantasy Award, the Hugo, The Nebula, the Eisner, the Newberry Medal and the Carnegie Medal in Literature.

Originally from England, he now lives in the

United States. Gaiman is certainly one of the undisputed frontrunners of modern day dark/urban fantasy. He is a multi-talented, multi-media author. Novels, graphic novels, short stories, comic books, audio books and screenplays—all of them are top-notch, top-shelf works. Well-written, clearly imaginative, with inventive imagery, genuinely likeable characters and snappy dialogue. In short, he is sheer joy to read and you won't be disappointed. His website is www.neilgaiman.com

Taking a break from writing, this is what he had to say.

MICHAEL McCARTY: What were your favorite gods in *American Gods*?

NEIL GAIMAN: It depended who I was writing, but certainly Czernobog was a lot of fun, and so were the Egyptian Gods. And Wednesday himself was fascinating.

MM: *American Gods* is one of your biggest books to date, over 450 pages long—a blockbuster in size and sales. How do you feel when the critics compare *American Gods* to your *Sandman* series?

NEIL: It depends if they say it's as good as *Sandman*, worse than *Sandman*, as bad as *Sandman* or even worse than *Sandman*.

MM: Your books *Stardust, Coraline, The Day I Swapped My Dad For Two Goldfish* and *The Wolves in the Walls* deal with the magic of youth. The time in one's life when you're not afraid to believe in the fantastic. Agree or disagree? Tell us a little about *The Wolves in the Walls*—great title, by the way!

NEIL: I suppose I would agree.

The Wolves in the Walls is about a little girl who is convinced there are wolves living in the walls of the house. Her parents laugh at her and tell her there aren't any wolves and it's all her imagination. Of course there are wolves and one night they do come out of the walls. That's basically it—it's a story of what happens next.

MM: When you started the *Sandman* series, did you ever imagine that it would still be popular after a decade? That you would win a World Fantasy Award and sell millions? Do you know if Metallica's "Enter Sandman" was inspired by your work?

NEIL: No. When we started, I thought *Sandman* would be a minor critical success, a major commercial failure, and be cancelled at issue 12 (it went for 75 issues).

I don't know if "Enter Sandman" was based on *Sandman*. I do know that copies of *Sandman* circa *Season of Mists* were on the Metallica Tour Bus, because that was where Bob Pfiefer (who got to do the Alice Cooper comic) read them . . .

MM: Talking about Alice Cooper, what is Alice the writer like?

NEIL: My most vivid memories are of a storm coming in and knocking the hotel power out, so sitting out on the balcony, watching the lightning, while Alice told us about "The Night He Met Elvis."

MM: Douglas Adams passed in 2001. What is your fondest memory of Mr. Adams?

NEIL: My favorite memory of Douglas, was when I was doing a Hitchhiker's Guide Companion (called *Don't Panic*). When I was in his office going through his filing cabinets and looking at BBC scripts and so on and so forth—all the Hitchhiker material.

His mother had come to stay. She'd gone off and had a bath. And all of a sudden there was a banging on the door. And she was shouting, "Douglas, Douglas, I can't find a towel."

Douglas was walking around the house, looking for a towel.

I said to him, "There's *A Hitchhiker's Guide to the Galaxy* moment for you."

And he said, "Don't you dare put that into the book."

I loved the idea, that Douglas Adams was walking around unable to find his towel (Laughs).

MM: How are American and British science-fiction fans different?

NEIL: It's hard to explain. American SF fans receive the mail from the Postal Service, while British SF fans get the post from the Royal Mail. American fans are more likely to say "y'all" (southern) or "you betcha"' (Minneapolitan) than British fans, who are more likely to know who the Clangers were, and why they had to visit the Soupdragon.

MM: What was it like working with Terry Pratchett on *Good Omens*? Do you think you two will ever write another novel together again?

NEIL: It was enormously fun for both of us, and no, I don't think so; we did it once, and we did it well.

MM: *Neverwhere* was originally a TV series on the BBC in England. Then you turned the script into a novel. Was that a difficult task?

NEIL: Not really. It was like collaborating with another author, only the other author in question was me.

MM: You wrote *Stardust* long-hand—did you get writer's cramp?

NEIL: Nope. I wrote *American Gods* in long-hand, too, and didn't get writer's cramp.

MM: Although *Stardust* was written in the 1990s it has an old-fashioned storytelling quality about it. Was this something you were aiming for?

NEIL: Very much so, yes. I was trying to write it as if I was writing in the 1920s. In my head, with the possible exception of one rude word, the book was kind of written in about 1920. I tried to pick that kind of vocabulary, that kind of attitude.

MM: You wrote a biography of Duran Duran simply called *Duran Duran*. The Fab Five (that was the nickname of the group at the time) was one of the most popular bands in the world. How did you get that gig?

NEIL: I got a phone call one day from a publisher saying, "Hey, we've got some books that need writing. We're out of authors. Would you like to write a rock 'n' roll book?" And I said, "Yes, yes, yes—I would."

Then he said, "Your choice is Def Leppard, Barry Manilow, or Duran Duran."

I said, "I'll take Duran Duran, please. On the

grounds that they have done a lot lately and at least I can listen to them."

And that is what I chose.

MM: What advice would you give to writers?

NEIL: Write. Finish things.

MM: Last words?

NEIL: "I'm sorry you didn't like my book. Now, if you'll put down that gun, I'm sure we can discuss it like civi—"

"Stephen King (is) a very kind and generous and fun-loving man. I think a lot of it has to do with similar upbringing: we both came from broken homes, brought ourselves up on (Richard) Matheson and (Ray) Bradbury and Twilight Zone and Universal monsters and all those cultural touchstones."

—Mick Garris

BAG OF BONES

MICK GARRIS

MICK GARRIS BEGAN his career with a bang. Steven Spielberg was the first person to hire him as a professional writer for TV's *Amazing Stories* (he also worked as a director and story editor for the series). When Stephen King wrote his first screenplay, *Sleepwalkers*, he hired Garris to direct the motion picture.

Garris started writing short fiction at the age of twelve. In the '70s he was a singer-songwriter in a theatrical progressive rock band. He has worked on the TV series *Freddy's Nightmares*, *Tales from the Crypt*, *She Wolf of London* and *The Others*. In the year 2000,

his short story collection *A Life in the Cinema* was published by Gauntlet Press and in 2006 his debut novel *Development Hell* was published by Cemetery Dance Books.

His movie credentials include **batteries not included* (writer), *Critters 2: The Main Course* (writer and director), *The Fly* II (writer), *Psycho IV: The Beginnings* (director), *Hocus Pocus* (co-executive producer and writer), *Ghosts* (writer), *Host* (writer, producer and director) and *Coming Soon* (writer and producer).

Garris was also the director for the acclaimed mini-series *The Stand,* as well as *The Shining* (both adapted for television from screenplays written by Stephen King), *Quicksilver Highway* (based on the stories "Chattery Teeth" by Stephen King, and "The Body Politics" by Clive Barker) and *Bag of Bones* (director, based on a King novel). He wrote and directed the feature film *Riding the Bullet,* based on a King story.

He was the creator and executive producer of the *Masters of Horror* TV series. Recent work includes directing episodes for such TV series as *Witches of the East End, Pretty Little Liars* and *Ravenswood.*

MICHAEL McCARTY: You directed *Psycho IV: The Beginning*, which is such a great film. The scene when radio talk-show host CCH Pounder asks Anthony Perkins to identify himself and he says, "You can call me Ed." Was this playing into the whole Ed Gein murders, the inspiration behind the original *Psycho* and *Texas Chainsaw Massacre* and *Ed Gein* films?

MICK GARRIS: Very perceptive, and thanks for the

compliment. I'm very fond of *Psycho IV*, and wonder why it never got released on DVD except as part of a four-disk set in England. Joe Stefano, who wrote the original *Psycho*, based on Robert Bloch's novel, also wrote the *Psycho IV* script, and that was his little tribute.

MM: What was it like having Clive Barker, Tobe Hooper and Stephen King on the set all at the same time in *Sleepwalkers*?

GARRIS: Well, what would you imagine? It was candy store time for me. That was the first time I officially met King in person, but I had known and worked with Clive before, and Tobe and I had been friends for quite a while. It was great fun, especially since they were not only all in the same scene—they were in the same long Steadicam shot.

It was almost disastrous though. That morning, a couple hours before they were to arrive to do their scene, I was having my morning granola on the set, bit down on something, and a molar broke in half! I had to rush off for an emergency temporary crown, but was back in time to shoot the scene. I didn't even notice the pain, though, once we got things underway. They all had a great time, and though King and Barker had communicated before, they had never meet until that day. It was a lot of fun, but King was only there for two hours before he had to split. I've had all of them on camera numerous times since.

MM: King considers you his "best friend in the business." You've done a number of his films. Why do you think you two work so well together?

GARRIS: Again, it is very, very flattering, but we really do get along and trust one another. He's a very kind and generous and fun-loving man. I think a lot of it has to do with similar upbringings: we both came from broken homes, brought ourselves up on (Richard) Matheson and (Ray) Bradbury and *Twilight Zone* and Universal monsters and all those cultural touchstones.

But we were brought up in very meager financial circumstances and seem to have similar senses of humor. We both have a heavy rock 'n' roll background as well. And then, there's that intangible essence of friendship that you just can't quantify.

MM: Why did you decide to set *Riding the Bullet* in 1969?

GARRIS: A lot of reasons. Mostly, though, because it's the story of a life-and-death choice, and I felt that 1969 represented a social life-and-death choice. It's also because it was a time that represented more concern with humanity than with possessions, a time when there was a true attempt to make the world a more human and humane place to live. It was a sort of love letter to things in our souls that seem to be slipping away, if they've not crashed to the floor already.

MM: *The Stand* mini-series is often considered one of the best adaptations of a King book. Why do you think the mini-series was so well received by the critics and public?

GARRIS: Who knows? Perhaps because all of us involved were so committed to making it as good as it could be. Again, I'm a huge fan. It is my favorite King book, and as a fan, it was as important to me as it was

to the King community that we did it justice. Fortunately, King wrote the screenplay as well, which was a good place to start, and it attracted a cast of formidable actors. It happened to hit its audience in a very personal place, it seems. And its success—the most successful mini-series ever, I'm told—is amazing as it is gratifying.

MM: You are friends with Linnea Quigley. What is she like?

GARRIS: Very sweet. I met her when I was casting for what would have been my first film (a romantic comedy, by the way . . . where would that career have gone!). She and my wife, Cynthia, became good friends. You'd like her.

MM: I've heard you're a big fan of monster movies. What are some of your favorite creature features over the years?

GARRIS: In general, (David) Cronenberg's *The Fly* and the first *Alien*, but some of my favorites are, of course, the Universal guys. You know: the usual suspects.

MM: Was *Hocus Pocus* originally written as a Disney movie?

GARRIS: *Hocus Pocus* was an idea by the producer, David Kirshner, who also created the "Chucky" movies. We first pitched it to Steven Spielberg and Amblin (Author's note: Amblin Entertainment is Spielberg's production company, named after his student film *Amblin*. The company produced early Spielberg classics such as *E.T.* and *Amazing Stories*).

I was working for him on *Amazing Stories* at the time. It was a very elaborate pitch, with witch-brooms and trick-or-treat props, but they passed.

I wrote the first draft for Disney seven years before they made it into a motion picture, and there were over a half-dozen other writers on it after me. But they ended up going back to something close to what I had done in the early drafts, hence the credits awarded by the Writers Guild.

MM: You wrote the short story collection *A Life in the Cinema*. What was the reaction when you came out with the book?

GARRIS: Rather remarkable, really. Though it was not much reviewed in the mainstream press, it got a great review in *Publisher's Weekly*, as well in other publications and websites. All of the reviews were remarkably strong, which surprised the hell out of me. It kind of goes for the throat in a way that makes me laugh. I guess it made others laugh, too.

MM: What was the inspiration for the story "A Life in the Cinema?"

GARRIS: You can't work in the film industry without meeting unsavory, ego-driven, money-over-art maniacs who will do anything to advance a career for all the wrong reasons. I've been lucky that they have proven to be the minority in my life, but I've stumbled over them more than once.

In a way, I guess it's all about karma, a concept I don't really believe in, but one I wish were fully in play. In a way, it's similar to the theme of *Magic Christian*, though we have a fluid-sucking mutant baby rather

Michael McCarty

than a pool of urine and shit as the wall between rich and poor.

Now that, and its sequel story "Starfucker," have been revised somewhat in the first two chapters of my first novel *Development Hell*, published by Cemetery Dance.

MM: Last question, what can you tell us about your project, *Masters of Horror*?

GARRIS: It's an anthology of thirteen one-hour horror films directed by the greats in the genre (and me). They will be as dissimilar as possible, and we begin shooting at the end of April. I was able to get filmmakers, both friends and strangers, who have made some of the best horror films of the last several decades to do episodes.

They are completely director-driven. Many of the directors are writing their own scripts, some are written by others. Most are original, though we are adapting stories by Richard Matheson, Clive Barker, Joe Landsdale, Bentley Little, H.P. Lovecraft and others. Our directors include George Romero, Tobe Hooper, Dario Argento, John Carpenter, Don Coscarelli, Joe Dante, John Landis, Stuart Gordon, and others.

There will probably be a deal with a pay-cable channel in the U.S. for broadcasting, but it is fully financed by a DVD company and will ultimately end up on disc.

96

"I don't think of myself as a vampire writer, because there are lots of other kinds of monsters in my books. Funny, how no one ever says someone is a werewolf writer. My main character isn't even a vampire. But there is something about putting a vamp in your stories that does indeed make people label you as a vampire writer."

—Laurell K. Hamilton

SEDUCED BY MOONLIGHT

LAURELL K. HAMILTON

By Michael McCarty & Cristopher DeRose

ONE OF THE top vampire writers in America, Laurell K. Hamilton burst onto the scene with a paperback titled *Guilty Pleasure*, which introduced the world to Anita Blake, a vampire hunter and animator of the recent dead.

Momentum quickly followed with *Laughing Corpse* in 1994. For the rest of the decade and into the new millennium, her popularity rose with each new Anita Blake book.

Michael McCarty

Born in Arkansas and raised in Indiana, Laurell was first inspired to write horror by the stories her grandmother used to tell. Laurell felt she was destined to become a writer, one who would become known for not shying away from potentially controversial aspects of storytelling, like sexual situations and violence.

Her latest in the Anita Blake books includes *Affliction, Kiss The Dead, Skin, Flirt, Bullet* and *Hit List*. She has over twenty books in the series that has sold over six million copies and has been translated into sixteen languages.

Hamilton lives in St. Louis with her family and is active in animal charities. Her websites can be found at www.laurellkhamilton.org and www.laurellkhamilton.com

MICHAEL McCARTY: Why did *Micah* come out only in paperback?

LAURELL K. HAMILTON: The publisher wanted to try something new—novellas (we are calling them novel-lites) in paperback between hardback books. So this was the first experiment to see how it would go over. It did go well, and more are planned. It does give me the opportunity to do things I have been planning for a while but just somehow never seem to make it into the books.

MM: *The Killing Dance* was originally called *Dance Macabre*. Your new Anita Blake hardcover is called *Danse Macabre*. Why did you decide to use this title?

LAURELL: I had been wanting to use that title for years. The first time, I was told I couldn't because

Stephen King had a book out by that title. This time, I got the go ahead. It is also the name of the dance club Jean-Claude owns.

MM: What are some of your favorite vampire books?

LAURELL: *Carmilla* by Sheridan Le Fanu, is still a sensuous and frightening tale, even after a century. The writing is smoother and more "modern" than a lot of stories from the same time period. The nonfiction book that stands out for me is *The Natural History of the Vampire* by Anthony Masters. I first discovered it in high school, and it is still one of my favorite reference books for vamps. It was one of the earliest books I came across that had a large bibliography in the back. One of the things I've learned in reference books is that if the book does not contain an extensive list of books, has a reference section, then you are often merely getting the opinion of one person, the author of that one book. I also have a copy of *The Vampire Book* by J. Gordon Melton on my shelves. It contains more popular culture and covers more modern cases, and also has a nice bibliography. And no list is complete without Anne Rice's *Interview with the Vampire*. That was, and still is, a most lovely book.

MM: Did getting pigeonholed as a "vampire writer" ever a concern to you early on in your career?

LAURELL: No. First, I don't think of myself as a vampire writer, because there are lots of other kinds of monsters in my books. Funny how no one ever says someone is a werewolf writer. My main character isn't even a vampire. But there is something about putting a vamp in your stories that does indeed make people

label you as a vampire writer. My books are mysteries, romance, fantasy (some people have even called them science fiction), but because there are some horror elements in every book, and vampires in most, I did get pigeonholed. But I'm okay with that. A pigeonhole is only a burden if you don't like where you've been shelved. I am writing exactly what I want to write in exactly the way I want to write it. There is nothing better as a writer, than that.

MM: Do you allow your characters the luxury of taking the story in an unexpected direction, or do you stick to the original outline? Any examples?

LAURELL: Outlines were meant to bend or break, at least for me. I will never sacrifice characterization for plot. The plot can be reworked. Character growth, once screwed up, is almost irretrievable. I don't always like the choices my characters make, but I am amazed that they are "alive" enough to make the choice, to argue with me. I've finally made peace with the fact I'm wrong, a lot.

Example: early in the series I would have bet good money that Jean-Claude would never be a romantic lead. I was so tired of the vampire as a romantic figure. I mean, they are walking corpses. What's so hot about that? That was honestly how Anita and I both felt in the first book *Guilty Pleasures*. I swore that I'd kill him before he ever became a true romantic lead. It would take me two more books before I began to understand that I couldn't kill Jean-Claude off, that losing him would hurt Anita and me. Anita is like most of my friends—I can give them dating advice, but they rarely take it. Career advice? I don't even try. I would like to

see Anita truly happy for more than moments at a time, but I no longer know the route we will be taking to get there.

MM: Is the Anita series proof that a genre novel can be a bestseller, too?

LAURELL: I think the question answers itself. *Cerulean Sins* debuted at number two on the New York Times Bestsellers List, and stayed on for four weeks. I think *Narcissus in Chains* debuted at number five and stayed on for several weeks. If you include my Merry Gentry series, where I have done for the fey of Celtic myth and folklore what I did for vampire, brought them out of the closet and mainstreamed them, then my last four books have made the list.

MM: What are the origins of the Church of Eternal Life? How important is it to the Anita Blake series?

LAURELL: When I sit down to write I always think, if this was true, then what? It's part of how you're told to write science fiction. But I think it is equally valid with horror or fantasy. If vampires are real in Anita's world, and they have rights and freedoms, the whole nine yards, then what next? What would that mean for a modern day America? The Church of Eternal Life was one of the things that came from that early brainstorming session. The idea that if vamps were real, that people would want to be one. Here was a church that didn't require a leap of faith. As a church member you want to know what's it like to be dead. Most people don't believe in the immortal soul anymore, not really. I think if you don't sweat that little detail then people would be signing up in droves for a

little guaranteed immortality. It's still one of the most disturbing ideas that I've come up with, at least to me. I'm hoping we'll be seeing more of the Church in book twelve (as yet untitled) of Anita, but I can't promise.

MM: Is networking conventions and other places writers gather essential to long-term success these days?

LAURELL: Yes, and no. At the beginning of your career, very yes. First, dress for success. You can be dramatic, by all means be yourself, but don't show up in jeans and a T-shirt, unless you look really good in jeans and a T-shirt. Be clean, neat, presentable. This is a business, treat it that way. I highly recommend dressing nice, so you don't look hungry.

By that, I mean, if you look and act like you need this job, need this contract, need to sell a book, people will run from you, or treat you badly. If you act businesslike, and not like the fate of the world, or least your sanity, rides on this editor's opinion, you'll do better. Trust me. I speak from experience. Act confident, no matter how you feel inside. Have business cards made, but be sure they look good, not cheap. You can do some pretty nice ones on most computer printers these days. But they must not look cheap.

You can be the best writer in the world, but at a convention no one is reading your writing, they're just seeing you. Remember that. If you present yourself badly, you hurt yourself. You don't have to be brilliant, just professional. I've had breakfast meetings, lunch meetings, dinner meetings, snack meetings, every kind of meetings, over the years. I think, of all those

meetings, I sold one short story and no books. Was it wasted time? No. Some of my fellow writers (members of my writing group), Deborah Millitello and Mark Sumner, to name two, sold more short stories than I did at the same meetings. It led to a book contract for Mark. So it wasn't wasted. You never know what contact will pay off. I met my first agent at a convention, though that is highly unusual. But be wary. Some people who go to conventions are not always as good as they seem. Anyone can claim to be editing an anthology or be an agent. Get the agent's client list. Find out who they represent.

If they are legitimate, then they will have people you can call. That will tell you what kind of job they're doing as agent. Though bear in mind that the agent isn't going to give you names of people they think suck.

MM: Anita Blake has come to understand the world is not simply black and white, but has shades of gray in it as well, and it's happened in a very natural progression. Was this something planned from book one or did it happen as the characters matured?

LAURELL: When I first researched Anita's world I talked to policemen for the first time in depth about their job. I learned something of the cost of the job. I watched my brother-in-law go from bright and shiny to tired. As I continued to research for Anita, I talked to combat veterans, and was privileged to have them share some of their experiences with me. Because Anita really has a violent level that is far above most police work, I used to joke she lived in a combat zone until I did one book where she visited what amounted to a real combat zone, and she was out of her depth.

Book nine, *Obsidian Butterfly*, we visit Edward's world, and see something closer to real soldiering.

It was frightening. But as I talked to men, and some women, about their lives, I realized that to keep Anita at the level of violence that she was at, she would have to pay a price. Part of that price is innocence, and the knowledge that the world is not black and white, and answers are not as simple as they seem.

Anita has to go through this process, or it would have felt like a betrayal of those people who spoke with me and shared their experiences.

MM: Your grandmother told you horror tales taken from the hills of Arkansas, leaving you with the thought, "Rawhide and bloody bones will get you if you aren't good." Do you ever think back to those stories for influence or inspiration?

LAURELL: I don't really think back to my grandmother's stories for inspiration, but I think that I have absorbed those stories into the pores of my being.

It was simply an accepted fact that ghosts were real, that the dead didn't always rest easy, that things could move by themselves, and that simple things could be frightening. I used to blame my family's penchant for macabre true stories and other real life tragedies for my dark turn of mind. Recently, I've had to rethink that. My daughter is eight, and she loves mummies. Her favorite book for ages was *Cinderella Skeleton* (by Robert D. San Souci), where all the characters are ghouls and such, and the main character loses a lot more than just her slipper running down the stairs. It's made me remember that long

before my mother's death, when I played cowboys and cowgirls, it wasn't enough for the chairs to be tall cliffs. No, we had to have a pit of rattlesnakes at the bottom of the cliff, so we'd be bitten to death. A fall just wasn't horrible enough. My daughter's childhood is making me rethink my own. Apparently, it wasn't early tragedies that made me this way. Maybe, just maybe, it was the way I came.

"(Rod Serling of The Twilight Zone) has become an icon of television history. I stand by, amazed that I had any hand in it, watching it as it became a greater and greater representative of the early days of television, as it was developing from the live form to film form."

—George Clayton Johnson

NOTHING IN THE DARK

GEORGE CLAYTON JOHNSON

By Cristopher DeRose & Michael McCarty

EVEN IF YOU'VE never read a story by George Clayton Johnson, lovers of genre stories have been exposed to his work, which encompasses not only tour de force science fiction works like *Logan's Run* (co-written by William F. Nolan) but also numerous stories for *The Twilight Zone* and scripts such as "The Four of Us Are Dying" (from his story "All of Us Are Dying"), "Execution," "A Penny for Your Thoughts," "The Prime Mover," "A Game of Pool," "Nothing in the

Dark" (starring Robert Redford), and "Kick The Can" (which was later remade in the feature-length *Twilight Zone: The Movie*). He is also responsible for the *Star Trek* classic "The Man Trap" where the crew of the Enterprise battle the salt vampire.

A contemporary of writing legends like Rod Serling, Richard Matheson, Charles Beaumont and Ray Bradbury, George showed his versatility not only for genre fiction, but also with TV shows like *Route 66*, *The Law and Mr. Jones*, *Kung Fu* and co-authored the book *Ocean's 11* (with Jack Golden Russell) that was turned into a movie starring Frank Sinatra, Dean Martin and Sammy Davis Jr, and was remade as *Ocean's Eleven, Ocean's Twelve* and *Ocean's Thirteen* with George Clooney, Brad Pitt and Julia Roberts.

He's appeared in a number of documentaries, including *American Masters: Rod Serling: Submitted for Approval* and *My Life with Count Dracula,* and an appearance in the upcoming documentary about the California writing group during the Golden Age called The Green Hand, founded by the late Charles Beaumont with Johnson, Nolan, Dennis Etchison and Richard Matheson.

He was also the subject of the biography *George Clayton Johnson: Fictioneer* by Vivian Kooper. One of the nicest guys you'll ever want to meet. Johnson was born in Cheyenne, Wyoming and currently lives in southern California.

MICHAEL McCARTY: As a writer for the classic series *The Twilight Zone*, what was working with Rod Serling like?

Michael McCarty

GEORGE CLAYTON JOHNSON: The truth of it is, I didn't work with Rod. What I did was work with Buck Houghton, the producer of the series. I would go in and pitch him stories and Buck would say, "Okay, if you take the kinks out of that, I'll buy it." I'd take the kinks out of it, and he would hire me to write a script.

He would do this three or four times a year at best. In that process, I was in a room with Buck, serving like collaborators. Half of the ideas in this growing idea that we were shaping were coming from him. But he wasn't getting any credit for it. But he's having a hell of an influence on the story. As I discuss it with him, as I tell him what it's going to be, he'd suggest other things I might want to think about.

I would go home and work on these things; I'd end up writing outlines. I'd end up selling him the outlines, and I'd be hired by him to adapt the outline into a script.

Rod Serling didn't see it until after Buck had approved it. If Buck said it was okay, he'd pass it on to Rod. If Rod agreed, they would film it. That was the relationship.

MM: Which did you like better: the television or *Twilight Zone: The Movie* version of your "Kick The Can?"

JOHNSON: I like the TV show the best. Someone else changed what was in the TV story into the movie story.

My general feeling of everything that appeared on *The Twilight Zone* is—I was ecstatic. For heaven's sake! Look at the care they took: the casting was great, the settings were perfect, and look how much detailing went into the series.

When I would sell a story to Rod, like "The Four of Us Are Dying" or "Execution," I would be astonished at what he did with it; Rod took my story and used it as an armature. He'd add all the clay to it. And when it came on television I'd be glued to the screen, amazed at how much richness and detail Rod put in the show.

I was invited to come watch the film "A Penny for Your Thoughts." I was there with my wife Lola and we were snooping around in the dark, eavesdropping on everything, watching the actors do the scenes. Then the door opened and here comes Rod Serling with a bunch of guests. He sees Lola and me and comes over with this crowd of people and says, "This young man here is the guy who wrote this dandy piece that we're filming right now," and everybody clapped. I felt really lifted by that. Rod's style was that, he was remarkably generous with people. He didn't mind confessing himself to be a fan.

I'm a fan, too. I'm a Richard Matheson fan, I'm a Charles Beaumont fan, I'm a Philip K. Dick fan, and I'm a Ray Bradbury fan. I read their stuff, I know all about it, and just love it.

MM: You were also on the set during the filming of "*Nothing in the Dark*" for the Twilight Zone series. You had the chance to meet a young Robert Redford. What was he like? Did you have any idea he'd become such a major star years later?

JOHNSON: As a result of watching Robert Redford act and being around him—because I went there every day, I found every opportunity to talk to him. Gladys Cooper, Robert, the wonderful R.G. Armstrong, would be bored sitting around waiting for the shots to be set up.

I went to New York for some business and that was the time Robert Redford was on stage with Jane Fonda in *Barefoot in the Park*. I stopped by the theater after one of the productions and got the chance to meet Redford again. I spent half the night talking with Redford. He had to go home and get ready to do a matinee performance that day.

I met him when he came to California with his wife at the time, Lola. They lived at the beach and I got a chance to see his paintings. He's a remarkable artist, a remarkable painter. I think he has given as much effort to painting as he has with his acting or directing. I am surprised that he hasn't tried to exhibit his work.

MM: *The Twilight Zone* has one of the fan bases that continues to expand as time goes on. What leads to this kind of timelessness?

JOHNSON: Reruns, for one thing: shown in every timeslot and on every channel in every country of the world for the last thirty-five years. Everybody's had a chance to see his or her favorite episode two or three times—I know I have.

In the course of that, it has become television literature. The reason is because the stories are surreal. They go beyond realism, which Rod Serling was an expert at in those days of "Requiem for a Heavy Weight." That was utter realism.

Now Rod took his next step up, when he added the undeniable, but the unbelievable in the same package. His ability to do that created a literature that stands out above heads of even the oldest shows like *I Love Lucy* and *The Honeymooners*.

He has become an icon of television history. I stand

by amazed that I had any hand in it, watching it as it became a greater and greater representative of the early days of television as it was developing from the live form to the film form.

This is a spiritual literature: it's not supernatural, that is not what its attraction is. It's more spiritual than it is religious. It's got the mind and matter on the one hand; it has the unseen spirit, the mystery and the magic on the other. And that little touch of the strange in the midst of all of that realism makes those shows have substance, not only in the context of the show, but also in the presentation, the format and the concept. When Rod Serling says, "There is a fifth dimension beyond that which is known to man . . ." We all know that is true.

MM: What was the inspiration for "All of Us Are Dying?"

JOHNSON: Ray Bradbury wrote a story called "Death and the Maiden." In the story, the maiden is told by her father to never leave the castle, because if she leaves the castle it will be disaster, because Mr. Death is out there and if she leaves the castle Death will get her. If she stays in the castle she will live forever. A young man comes riding up to the castle on his beautiful horse. He takes out his mandolin and plays a beautiful tune. The girl comes to the window. And he says, "Come out here where the sun is. I want to talk to you. You are so beautiful." She says, "No, my dad told me I shouldn't do that." He says, "Nonsense, take a look around, it is just wonderful." He starts to pitch woo to this young woman. After a while, she comes down. She gets on the back of the horse with him and

they ride off. When she does, she is aware of what is going on. The point of the story is not the story, but the fact that Death is not an evil, malicious, frightening, ghastly thing, but a young, handsome, highly plausible, sincere man.

When I read that idea, I thought it was a fresh look at the whole "mystery of death" story. I guess it entered into my subconscious. I was hardly aware I was stealing from Ray Bradbury.

MM: What was your opinion of the film version of *Logan's Run* when it first came out, and has it changed over time?

JOHNSON: I was invited to see the premiere at MGM. William F. Nolan was sitting six rows ahead of me and my daughter Judy. The film started, and the music started, and it was so big and so beautiful. And there was this cotton candy look to this universe that was cleaner than *Star Trek*. It all was very sweet. When things start moving in the super city of the future and they (Logan and Jessica) leave the super city and go out to a Paramount back lot it loses interest, and it drags and it drags. Then Logan comes upon the old man, who is pictured as a revolutionary in the novel. He appears and most of my concentration just went out. My ass turned to stone. I was waiting for it to be over.

When it finishes, everyone goes out into the aisle, and they start clasping hands and telling each other how wonderful the picture is and here is William F. Nolan and he says, "Judy, what did you think of it?" And Judy says, "I did like it but—" She explained to him what I was trying to explain to him. It must have

been a real shock to Bill to be told the truth. The truth is, when I first saw it, beautiful music, beautiful coloration, lovely actors, great casting, the sets—some of them were quite exquisite. They had the look of *Doc Savage*. Everything was okay until they left the super city.

Now I come to understand that Joel Silver, who did *The Matrix*, is going to do a remake of *Logan's Run*. It is going to be one of those big budget movies. The truth is, I know nothing about it. Everything I know, I know from William F. Nolan who has been tracking on this.

MM: Which actor (any era, living or dead) would be your ideal Logan?

JOHNSON: When I first saw a young (Leonardo) DiCaprio, I thought that was interesting. We wrote it to be less than twenty-one. This is a society where you die at twenty-one. You've got to have characters with strong personalities, because usually, at that age, people don't. They haven't developed their inner shape yet. When I saw a young DiCaprio, I thought "My God, he would have made a good Logan, if you did it like the book."

I think the book is far superior, and I hope the new production follows the book. What really went wrong is that they took three chapters out of a ten-chapter book and a couple of props and things from outer settings and tried to jam them together in order to create a city of domes.

Bill and I weren't talking about living in domes. We were talking about an interconnected world where you could jump in the maze and you could be in Tokyo in a couple of hours.

MM: Were there any hard feelings when William F. Nolan decided to continue the Logan universe on his own?

JOHNSON: Oh no, Bill and I had a nice little tearing. We said, "Let us by magic, turn our one baseball into two baseballs. I take one and you take one."

I am the author of *Logan's Run*. When I talk to people, I tell them I wrote *Logan's Run*. When he sees people, he says he wrote *Logan's Run*. If you have to mention me, mention me: that's it. I tell Bill, "Go get some assignments to write books with *Logan's Run*. Kill Logan off, marry him up, do anything you want to him. I exercise no control over what you do with Logan. And I will do the same." He said "fine" and wrote a couple of novels.

I'm in the process of writing the sequel to the *Logan's Run* book. I have about forty or fifty pages of it completed. Lots of outlines and notes to complete the book. I'm waiting for the opportune moment, hoping that when the new *Logan's Run* movie comes out, that will give me a real reason to negotiate some good bucks for another Logan novel. And when it happens, I will probably get William F. Nolan to write an introduction for it. So everyone will know that there is nothing but harmony between Bill and me. We never had any problems at all.

MM: Is it true that you and William F. Nolan met at a coffee shop for a year discussing the ideas for *Logan's Run*, before writing anything down?

JOHNSON: Bill and I spent a lot of time in coffee shops, plotting and planning and working things out.

We were both very good at it. Bill, in fact, used coffee shops like an extra office. When he didn't want to stay home, he'd find himself a coffee shop, take along a couple of notebooks, order a coffee and some food, sit back and take the place over for an hour and a half.

Bill and I determined that we were going to do something together, but he had a book to finish and I was on a screenplay assignment. I knew that it would take about six months to get out of my project, and I wouldn't have any time until then, and he was of the same mind. But we had several meetings to discuss *Logan's Run*. In the course of it Bill brought a pack of index cards and he gave me half of them and said, "Any name, game, piece of slang, a piece of apparatus, anything that occurs to you, put it down on these cards, so when we get together again, I can tell you what I thought of and you can tell me what you thought of."

In a meeting, he'd pull out a card and it would say "fuser" on it. What is a fuser? Is a fuser some kind of exotic drink? Is it a weapon? Is it a process? Is it a gadget? Then out of that, we could come up with some fairly imaginative hardware and apparatus for the story. We kept this up, making little diagrams for ourselves.

Then Bill rented a motel room on Malibu Beach. I went to that motel room, every day for two weeks. In the course of two weeks, with two typewriters and a coffee table, we manufactured most of *Logan's Run*.

Bill took the manuscript over to his house and for the next week, we met in his garage, which he fixed up as an office.

At the end of that time, Bill took the manuscript,

rushed off to San Francisco, ran it through his typewriter again to take out all the handwritten notes and memos and sort it all back together again. He brought me back copies and we went to find an agent. We told the agent that we didn't want any kind of a deal less than one hundred thousand, which was our bottom line on it. If they didn't have one hundred thousand we didn't want to talk to them. The agent thought we were crazy.

Eventually we got the book published by a prestigious house; we got really good reviews on it. It was taken quite seriously as a science fiction story.

It deals with an important subject, which is how far do you let the government go? Do they finally get around to telling you how long you have to live?

MM: What is your favorite, most perfect George Clayton Johnson story and why?

JOHNSON: There are two of them. The first one is "Nothing in the Dark," the old lady and Mr. Death. It is a simple little fable. It really works well for me. I've seen it produced a couple of times on the stage. It really is a reverie piece of theater.

On the other hand, every time I look at "A Penny for Your Thoughts," it's whimsical and a little odd, oddly stilted and British in its approach to humor. The actors don't think they are being one bit funny. It has a sort of slightly fey humorous quality.

It's a choice between those two, although I'm really enamored of "Kick the Can," "All of Us Are Dying," "Execution," and "Perchance to Dream" (which Charles Beaumont adapted for *The Twilight Zone*).

"There's a whole spectrum of pain awaiting us out here in the world all the time—physical and emotional. If you decide you're going to essay the subject of pain—and you do it well—you make the reader feel it, identify with it, just like any other experience or emotion."

—Jack Ketchum

OLD FLAMES

JACK KETCHUM

By Amy Grech and Michael McCarty

"**W**HO'S THE SCARIEST *guy in America? Probably Jack Ketchum*"—Stephen King.

He is named after a train robber (Black Jack Ketchum), praised by such giants of the genre as Stephen King, Robert Bloch, Bentley Little, Edward Lee, Richard Laymon and Ed Gorman. Jack Ketchum writes high-voltage horror. You don't get novels this electrifying unless you bite into a toaster with your braces. Shocking? Yes. Scary? You betcha. Sick? And yes, he is one sick puppy.

Michael McCarty

Jack Ketchum is the pseudonym for a former actor, singer, teacher, literary agent, lumber salesman, and soda jerk—a former flower child and baby boomer who figures that in 1956, Elvis, dinosaurs and horror probably saved his life. His first novel, *Off Season*, prompted *The Village Voice* to publicly scold its publisher in print for publishing violent pornography. He personally disagrees, but is perfectly happy to let you decide for yourself. His short story "The Box" won a 1994 Bram Stoker Award from the Horror Writers Association and his story "Gone" won in 2000. Again in 2003 he won Stokers for both best collection for *Peaceable Kingdom* and best long fiction for *Closing Time*. He has written eleven novels, the latest of which are *Red, Ladies' Night*, and *The Lost*. His stories are also collected in *The Exit at Toledo Blade Boulevard* and *Broken on the Wheel of Sex*.

His novella *Old Flames* is available as a limited edition hardcover from Cemetery Dance and as a mass-market paperback from Leisure Horror. Other recent works include *Hide and Seek, Closing Time* (co-written with Clarissa Yeo), *The Woman* (co-written with Lucky McKee) and the reprinting of *She Wakes*. Stephen King cited Jack's novella *The Crossings* in his speech at the 2003 National Book Awards

MICHAEL McCARTY: When is extreme horror too extreme for Jack Ketchum?

JACK KETCHUM: When there's no point to it. Graphic for graphic's sake. When it's predictable.

MM: Your books *Red, The Girl Next Door* and *The Lost* all have been turned into movies. Of the three,

which one do you feel is truest to the book and why?

KETCHUM: I think I've been amazingly lucky in that all three have been quite true to the source material. Each of them have diverted here and there, of course—the brief love affair was cut from *Red*, the coda eliminated from *The Lost*, Ruth's death scene changed in *The Girl Next Door*—but they're movies, so you expect changes. But the feel of each of the books is there, the emotional weight is true. And damned if I'm picking one.

MM: You and Clive Barker are famous for writing about the different levels of pain. Pain is an individual experience; how do you give it mass-market appeal?

KETCHUM: There's a whole spectrum of pain awaiting us out here in the world all the time—physical and emotional. If you decide you're going to essay the subject of pain—and you do it well—you make the reader feel it, identify with it, just like any other experience or emotion. And identifying with a character or characters is probably the main reason fiction is appealing in the first place. You don't usually read a novel through to the end because you find the setting appealing. It's the characters and the situations they find themselves in that capture you.

MM: Your relentless novel *The Girl Next Door* challenges the reader to consider what they know about pain as they witness an unthinkable act. What inspired you to write this book?

KETCHUM: The true story behind it—the murder of

Sylvia Likens. There are exceptions, like *The Executioner's Song* and *In Cold Blood*, but often fiction can do what just telling the facts of a story can't do. So I'd considered a true-crime approach and discarded the idea because I thought that I could—through characters, through what they see and feel and do—bring the story home to readers on a far more personal level. Really hurt you with it. The strength of fiction is that it frees the imagination by its very nature. People with little imagination usually don't read novels. Those that do, can be reached almost as though they were experiencing these things themselves.

MM: When Stephen King wrote *The Dead Zone*, his antagonist killed a dog and he received several angry letters from pet lovers. In the beginning of *Red*, the protagonist's dog is killed. Did you receive several angry letters, too? Are you a pet owner?

KETCHUM: I grew up with dogs but since college, when I took up apartment living, it's been cats. Now I can't imagine life without them. I have four of them—Zoey, Cujo, George and Gracie. I never got angry letters from anybody, really—reviewers excepted—until the movie *The Girl Next Door* got widely distributed and a movie tie-in edition of the book was published. Since then I've even had a couple of death threats. I wrote to Steve King and said, "Look! I've joined your club!"

MM: You write both extreme horror and kids' books and do it well. Is it harder or easier to write for kids?

KETCHUM: I've only written one book for kids, called

The Sandcastle, and it's never been published. Anyone out there interested? You must be referring to *The Transformed Mouse,* which started out its life as a kids' book and which I turned into a fable for adults. I don't find it any easier or harder. It's fiction. You find the characters, tone, and story and you run with it.

MM: Which do you find more difficult to write: novels or short stories?

KETCHUM: Novels. Largely because they're more difficult to start. With a novel, you're talking about a marriage. With a story, it's a brief affair. Contemplating marriage, at least for me, is a lot more daunting.

MM: When you start a new project, be it a collaboration, a novel or short story, do you work from an outline or notes, or do you run with the story wherever your characters take you?

KETCHUM: I hate outlines. They kill the fun, the spontaneity. I have a three-quarter wrap-around bulletin board and I work from that. As far as I'm concerned, whoever invented post-a-note stick-um pads deserves the Nobel Prize for Literature.

MM: Why do you write most of your work set in New England? Do you think New England is scarier than elsewhere in America?

KETCHUM: Most of my stuff, though by no means all, seems to call for characters in relative isolation. There's still plenty of that in New England. I've found it in New Jersey, though, in Greece, along the Mexican border—even in Florida.

Michael McCarty

MM: What's next for you?

KETCHUM: I've written two movies this year, an adaptation of my novel *Offspring,* which ModernCine have already shot and which is now in post-production—they did *The Girl Next Door.* That should be out early next year. Also an adaptation of my novella *Old Flames,* which has been optioned by Chris Sivertson, the director of *The Lost.* Next summer Leisure will publish *Cover,* which last saw paperback in a barely distributed Warner edition way back in 1987. There are a couple of new short stories in the offing, and *Broken of the Wheel of Sex.* Next for me at the writing desk is probably a short half-hour film, about which I can't say much at the moment.

MM: Writers are advised to "take chances" in their writing. What does taking chances mean to Jack Ketchum?

KETCHUM: Write what you like to write, when you want to write it, not what you think might sell big time. If it does, fine. If not, no problem. Have fun.

MM: What advice would you give to a writer after they published their first novel?

KETCHUM: Don't be afraid of writing the second one. Don't get worried that you're a one-hit wonder. That can really mess with your brain—I know it did for me. Chances are that if you gave birth to one decent novel, your hips are wide enough to give birth to another.

MM: Last words?

KETCHUM: You mean like an epitaph? I like the real

Jack Ketchum's last words on the gallows. "I'll be in hell before you finish breakfast, boys! Let 'er rip!"

"(Writer's Block.) Never had it. All writer's block arises from self-doubt, and I have as much self-doubt as any writer I know. But the trick is turn the doubt into a tool, use it to force yourself to revise and revise and polish and revise some more, improving the work—rather than letting it weigh you down like a dinner of gnocchi in cream sauce."

—Dean Koontz

FEAR NOTHING

DEAN KOONTZ

DEAN KOONTZ MUST have been a gourmet chef in a past life because he can take science-fiction and suspense, mystery and monsters, love and lust, humor and horror and blend them all together into a delicious nonfat novel.

Koontz is the word factory, the author of over 130 books, including novels, graphic novels, kids' books and different series (Frankenstein, Odd Thomas, Christopher Snow and Trixie). He is also the wordsmith to such classics as *Whispers, Watchers, Lightning, Chase, Shattered, Night Chills, The Taking,*

Twilight Eyes, Darkness Under The Sun, Phantoms, The Demon Seed, Strangers, What The Night Knows, Velocity, Mr. Murder, The Vision, Strange Highways, Dark Rivers of the Heart and many more.

The Master of Suspense doesn't rest on his laurels. He has been penning novels almost nonstop for over four decades. When he was a senior in college, Dean Koontz won an *Atlantic Monthly* fiction competition and has been writing ever since. His books are published in 38 languages. He has sold 400,000,000 copies, a figure that currently increases by more than 17 million copies per year. Fourteen of his hard cover books have risen to the number one position and sixteen in paperback have hit number one. Recent books by Koontz include *The City, Innocence* and *Deeply Odd* (an Odd Thomas novel).

There is no doubt that Koontz is one of the hardest working writers in speculative fiction. Like all of his works, his answers to my interview questions were masterpieces.

MICHAEL McCARTY: It is reported that you spend twelve hours a day, seven days a week when you're working on a book. What kinds of things are you doing during that time: Writing? Plotting? Re-writing? Outlining? Character development? Or is this just an elaborate excuse to your wife so you don't have to take out the garbage?

DEAN KOONTZ: I sit down at my desk about 7:30 (a.m.), or 8:30 or if it's my turn to walk the dog—9:00 if I also have to polish the alligator—and I'm there until dinner, because I rarely eat lunch. When I need an

excuse to avoid taking out the garbage, I usually claim to have been abducted by extraterrestrials, because deadlines aren't a sufficient excuse to deflect Gerda. Why she buys the evil-aliens story, I don't know, but she's never called me on it.

Outline? I never outline. For me, fiction is character driven, not plot driven, so I start with one or two interesting characters and a brief premise—and then leap off the narrative cliff. On the way down, like a circus clown, I'm desperately opening a series of ever larger umbrellas, hoping to slow my speed of descent and land on both feet.

Character development? That isn't something I do as a separate task. I don't cobble up lists of a character's favorite foods, habits, preferences in clothing, political attitudes, favorite game shows, or his excuses for not taking out the garbage. That's all useless. If characters come alive, they do so by virtue of their actions, their decisions and choices, and it's in the writing that they assume dimension, not in some portrait or capsule biography written prior to launching the book. Though I was once a Freudian writer, showing how every character's traumatic past shaped the person he became, I have in the '90s become virulently anti-Freudian because I believe it's all bunk and dangerous bunk to boot. Freudian-colored writing—which is 99% of all fiction in this century—reduces every character to a victim on some level; the writer who either consciously or unconsciously uses Freudian dogma to explain his characters' motivations is reducing the mysterious complexity of the human mind to monkey-simple cause-and-effect mechanism. Dickens' characters were

not given depth by mechanistic psychological analyses of their childhoods; Freud hadn't yet started to infect the world, and Dickens defined his characters by their actions, by their decisions and choices and attitudes. Some critics won't get what I'm doing, because they're conditioned to looking for certain devices and techniques as signs that characterization is taking place—but, happily, most have not only caught on to it but have supported it as more natural and, ultimately, deeper reaching.

As for plotting . . . well, this is also something that resolves itself in the process of writing, not in an outline. If I keep the characters moving, keep them thinking and feeling, the plot will evolve as I go. An outline always felt unnatural to me, and I stopped using one when I began *Strangers*. Before that, I created outline, but the books never followed them anyway.

Rewriting is also not a separate task for me. I don't bang out a book, or even a chapter, and then go back to revise it. I rework every sentence before moving to the next, and then rework every paragraph before moving to the next, and then revise each page twenty, thirty, fifty times before moving on to the next. When I reach the end of a chapter—which has by that time been revised exhaustively—I then print it out and pencil it three or four times, because I see things on the printout that I don't see on the screen. By the time I reach the end of the book, every line in it has received so much attention that there's nothing to go back and revise—unless the editor spots a problem that, on reflection, I agree needs to be addressed. I've sometimes described this method of writing a novel as

being similar to the way coral reefs are formed from the accreted skeletons of marine polyps—though I must admit I've never polled any polyps to see if they agree. Some writers have wondered how I maintain spontaneity when working in this fashion, but it's no problem at all, because you get so intimately involved with the fine details of the story that it remains eternally fresh to you on a lot of levels rather than just on the level of plot. I'm sure all those polyps feel spontaneous and full of life as they form colonies, reproduce, and finally die in the service of creating underwater tourist attractions and providing the raw material for junk jewelry and dust-catching paperweights.

MM: How do you decide which political or social issues to incorporate into your books?

KOONTZ: I never think about it at the start, because the characters, as they form through the narrative, will show me what issues affect their lives. Of course, I always try to make a serious statement about the plight of the endangered lousewort, and I'd feel that I was worthless as a writer if I didn't always make it clear where I stand on the separation of church and MTV.

MM: Several of your books were also published in England with Headline Press. What do the Brits think of American authors?

KOONTZ: Headline has published all of my books— and very well. They're a great house. What do Brits think of U.S. authors? Well, they never mention the Revolutionary War, so I guess they've gotten over that, though a few are still pissed about the War of 1812. I

suspect they feel we ought to wear monocles and say "Jolly right" more often than we do. Otherwise, they seem to take to us warmly enough . . . though I noticed that it's possible to outsell many of the books on their bestseller lists while being kept to lower numbers, behind homegrown authors. But that's an understandable bit of pumping for the homeboys, and none of them has ever called me a "bloody sod."

MM: If you had to choose five favorite books that you've written, which five would you pick and why?

KOONTZ: *Watchers, Lightning, The Bad Place, Cold Fire, Intensity, Dark Rivers of the Heart,* and the Christopher Snow trilogy. That's seven or nine, depending on how you look at it, but I never promised you that I would be perfectly cooperative. I haven't cut your head off and stowed it in the refrigerator, so I don't think you've got much to complain about.

Watchers was a dream to write, and during the whole last half of it, I was in something of a flow state. That does not mean I was having intestinal disturbances. A psychological flow state, what athletes call "being in the zone." I like the book because the characters seem real to me and because multiple layers of theme and metaphor thread through the narrative more unobtrusively than in anything I'd written to that time.

Lightning was a technical challenge greater than any other I've faced, and considering the tremendously convoluted nature of the time-travel element, I think I acquitted myself well enough to escape embarrassment. But I also have a particular fondness for the book because of the characters, because of the

tragic love story of Danny and Laura and the angst-ridden love story of Laura and Stefan, both of which were wildly uncommercial; the kind of thing publishers warn you against doing, yet they worked. And in this book, I began to use humor to a degree and in an uncloaked fashion that I'd never before dared in a suspense novel—which has by now become an element in most of my better books.

The Bad Place was just flat-out weird from beginning to the end, over the top, yet readers and critics seemed to think it worked–which showed me that virtually any outrageous development in a novel can work if you prepare the reader for it and if you ground it in sufficient real-world detail to make it feel right. And, of course, I loved the character of Thomas, the Down's-Syndrome boy. This was the first time I used a disabled person in a major role, and it was exciting to be working with such fresh material, struggling to create a viewpoint for him that felt true. The world is full of people who never get written about in popular fiction—or in literary fiction, for that matter. There's a socially useful purpose in writing about them, but there's also tremendous creative exhilaration to be had by tackling such tricky material.

Cold Fire: I enjoy twisting the reader through surprise after surprise, and this deceitful story line appealed to me. Again, it only works if the characters work, and the challenge was to keep Jim sympathetic even while leaving him shrouded in mystery and concealing central elements of his background and leaving the door open to the possibility that he was somehow a threat to Holly; that was possible only if Holly was so appealing, so amusing, so clear a

character that you fell in love with her, because then, as she fell in love with Jim, you had to want to like him simply because she did.

Dark Rivers of the Heart was a backbreaker, because of its complexity, but I enjoyed writing it because it was the first book of mine in which every metaphor, every simile, every image worked in the service not only of description but of the underlying themes of the novel—although this isn't something the reader should be able to see in the course of an ordinary reading. I was able to integrate text and subtext, story and technique, to a degree that I'd never been able to do before, so writing *Dark Rivers* kept me entertained. Since I'm not a masochist, I need to have fun while I'm working, to find the process exciting and entertaining, and I was entertained by the challenges of *Dark Rivers*.

I have a soft spot for *Intensity* 'cause it brings my anti-Freudian viewpoint to the surface, also because it was an exercise in exhilarating pace, and because the two-character structure was such a challenge. I knew Chyna Shepherd's "reckless caring" would be one of the primary qualities defining her, but I never anticipated some of the steps she took as the story evolved –and at times her boldness scared the hell out of me. I was dismayed but not surprised when a few reviewers said they found it difficult to believe in Chyna's actions because "no one would put his or her life on the line for a stranger." Well, first of all, the young girl for whom Chyna risks her life is, to Chyna, the image of herself as a helpless child. No one was ever there for Chyna when she was growing up under dreadful circumstance, and she has built a new and

decent life for herself by striving to be everything that her criminally-minded mother was not. That means living responsibly both on a public and private level. At first, Chyna wants only to get out of the killer's motor home—and she does. But in the service-station scene, she sees a photo of the young girl that Vess is holding captive somewhere, and in that photo she sees herself as a girl; it is not just a stranger that Chyna is trying to save . . . she's trying to save herself. Anyway, when a reviewer says no one would risk his life for a stranger, the reviewer is telling us that he would not do so and therefore cannot comprehend anyone doing so—and thus reveals an unpleasant truth about himself. The week I had to go out and do interviews in support of *Intensity;* the actor Mark Harmon risked his life to pull two total strangers from a burning car. The media made much of the incident—and so did I! But I pointed out we are a cynical culture, reflexively denying that heroism actually exists anymore, so the only time a heroic act makes national news is when it involves celebrities; yet every day, all over this country, people do what Mark Harmon did and are celebrated for it only on the local level if at all. There is such a thing as "reckless caring," and by God there has to be in order for any civilization to arise and to be sustained.

MM: A lot of your books were turned into movies. Which are some of your favorites and least favorites? And how many lame sequels can Roger Corman squeeze out of *Watchers*?

KOONTZ: *Watchers* sucked. *Watchers II* sucked worse. *Watchers III* sucked like a tornado. *Watchers*

Reborn proved to me that there must be a Hell, because Roger Corman has to suffer somewhere for all the bad taste and vile filmmaking that he has perpetrated.

Hideaway reeked. I spent more in legal fees, trying to have my name removed from the film prior to its release, than Tri-Star had paid me for the film rights. I managed to keep my name out of the trailers, out of most advertising, and out of everything but the billing block on the posters, but I couldn't get complete removal—and then they used my name in the video. Condos in Hell are waiting for the guilty parties.

MM: On the same subject, some film critics claim you write your novels with eventual movies too much in mind. Is this true?

KOONTZ: What critics said this? I've never seen these statements. I never think of film when I write books—which is one of the reasons they don't adapt easily to the medium. The story lines are too complex, the characters too complicated, and the themes too dense for movies. Movies are basically short stories, and the novels that adapt best to film are those that have plots that can be completely summed up in two sentences: "high concept," it's called. Anyway, for the last five or six years, I've gone out of my way to avoid having movies made of my books. A couple of studios wanted to buy *Intensity*, but both of them wanted to make one big change to the story: They wanted to introduce a male lead, an FBI agent, who is tracking Vess, the serial killer, and shows up in time, at the end of the film, to save Chyna and Ariel. Since the story is fundamentally about Chyna's self-transformation and

her rise to great courage, their version would have
been a travesty. Not a travesty on the order of
remaking *Citizen Kane* with Adam Sandler in the
Orson Wells role, but a travesty nonetheless.

I turned down their offers—and only made a deal
for a miniseries when I had control to be sure no such
horrendous changes would occur. I have refused to
offer the Chris Snow books *Fear Nothing, Seize the
Night* and *Ride the Storm* (the work in progress) for
film because they're too close to me, and I can't bear
to see them screwed up. Besides, I know it is a major
problem for anyone to turn these books into film
because the first-person viewpoint cannot be recreated
in a medium without interior dimension, and that
viewpoint is crucial to the success of the story;
secondly, everything takes place at night, and
filmmakers hate such limitations and prefer stories
that they can "open up" to lots of varying locations and
lighting conditions. Besides, night shooting costs
more. In short, throughout my entire career, I've been
told that I've got to simplify, simplify, and then further
simplify if I'm going to have major film sales, and I've
always interpreted this as advice to dumb-down the
books, which I've ignored.

MM: What's the hardest part of being a professional
novelist?

KOONTZ: The hardest part of being a professional
novelist is wearing those silly-looking paper hats and
the badge that says, "Hi, my name is Dean Koontz, and
I'm here to entertain you." After that, it's doing
publicity—which I try to keep to a minimum—and the
related agony of reading about myself. Even when a

magazine article is flattering and factual, I find reading about myself to be so embarrassing that it took me two weeks to get through the *Rolling Stone* piece, for instance. Yet I have to read them because people will ask things like, "Is it true what they said about you in that article—all that business about sleeping in bunny pajamas and sacrificing gerbils to Satan?"

MM: You have a great sense of comic timing in interviews and with your books. Have you ever thought of doing stand-up?

KOONTZ: My wife says I'm a frustrated stand-up comic. Actually, I'm a frustrated blacksmith, but I conceal my yearning for the forge and the anvil, so no one is aware of the aching void in my heart. Over the years, from public speaking, I've learned that I can keep an audience laughing loudly for an hour—which is an incredible power, a real rush. If Hitler could have done that, he would have wound up playing early Vegas instead of trying to rule the world; ruling the world isn't half as much fun as getting a laugh—and comedians don't have to sit in meetings with economist and farm-price specialists. Because the amusement factor was high on some of the appearances I've made on Tom Snyder's show and others, we get a lot of requests for me to do television and radio, most of which I avoid—because otherwise I would become a game-show fixture and started thinking about changing my name to Shecky Koontz. One producer recently called to invite me on a show, and he said, "We don't want the scary you, just the funny you." So either he thinks I'm twins pretending to be one person . . . or have multiple-personality

syndrome . . . or maybe have a little switch on the back of my neck with three positions: SCARY, FUNNY, UNKNOWN. Better never jog it to UNKNOWN. That might be my lounge-singer mode.

MM: You've written over seventy books. Have you ever suffered from writer's block? What are some of your cures for blocked writing abilities?

KOONTZ: Never had it. All writer's block arises from self-doubt, and I have as much self-doubt as any writer I know. But the trick is turn the doubt into a tool, use it to force yourself to revise and revise and polish and revise some more, improving the work—rather than letting it weigh you down like a dinner of gnocchi in cream sauce.

MM: Since you brought up the Chris Snow books: you have never written a sequel before. Why did you decide to tackle a trilogy starting with *Fear Nothing*?

KOONTZ: The characters came alive for me to such an extent that I did not want to let them go. Apparently readers felt the same way, because our mail jumped from thirty letters a day to about seventy, and all of the increase was about *Fear Nothing, Seize the Night* and *Ride the Storm*. Now that I've finished the trilogy, I might return to the characters from time to time.

MM: Who are easier to work with: agents, editors, directors or producers?

KOONTZ: Mafia hitmen. Mad dictators. No, really, I've had little trouble working with agents and editors. Disagreements. Some of them agonizing and prolonged. But in the end, it was all in the service of

seeking the best book possible. And recently, with Bantam, I have finally found a publisher—and an entire group of people therein—who understand what I do, relate to it, and are unhesitatingly supportive. For once, we're all pulling the train together—and in the same direction.

MM: What advice do you have for beginning writers?

KOONTZ: I tell every young writer to find the material about which he or she can become passionate, work hard at using the language as well as he/she can use it—and to persevere. Throughout my career, until recently I was continually told that my books would never hit big, that I couldn't mix genres the way I did, that my stories were too eccentric, that my vocabulary was too large and therefore limited the potential size of my audience, that even the very subtle spiritual elements in my work were too prominent and would bore or flat-out offend modern readers, that readers didn't want stories with as much thematic freight as mine carried . . . blah, blah, blah. I was even told these things, relentlessly, after I'd seen my books rise to the #1 slot on bestsellers lists. What every young writer has to realize is that if he or she is doing something truly fresh, it will not immediately be supported, will not win big ad budgets, will not be understood. You must keep an open mind to criticism if it's about technical matters—that is, about grammar and syntax, about logic holes and clear story problems—but must diplomatically reject all criticism that relates to style, intent, theme.

If you have clear and passionate purpose in your writing, something to say and a determination to say

it in a way unique to you, if you can explain to yourself exactly why you are doing what you're doing in the way you are doing it—then you have to stand fast and politely resist all attempts to change you. At the end of the day, if you write with conviction and passion, then the world will come around to your stories. If you bend too much to the will of others, you'll be reduced to blandness, to vanilla fiction, and no one will care. It also helps to sell your soul to Lucifer.

"Until Blood Feast began amassing incredible film rentals, resistance was fierce. We also were accused of killing business at the refreshment stand . . . an exact reverse of the effect horror movies have today. Some newspapers refused to carry our advertising. We started with a hard core of theatres, both hardtops and drive-ins, that valued box-office gross above on-film grossness."

—Herschell Gordon Lewis

THE WIZARD OF GORE

HERSCHELL GORDON LEWIS

By Michael McCarty and Mark McLaughlin

IN 1960, MOVIEGOERS were shocked by the infamous shower scene in Alfred Hitchcock's *Psycho*. They sat stunned as an ominous silhouette with a knife murdered a woman who, mere seconds earlier, had been enjoying a relaxing shower. They gasped as a stream of black blood (no red in this black-and-white thriller) swirled stylishly down the drain. Little did

those theatre patrons know, but in 1963, *Blood Feast,* directed by Herschell Gordon Lewis, would make *Psycho* look like a quaint body-wash commercial.

"NOTHING SO APPALLING IN THE ANNALS OF HORROR!" screamed the bold, sans-serif headline of the promotional poster for *Blood Feast,* which depicted a mad-eyed killer (in a suit and tie—he's got class) with a meat cleaver looming over his lovely, doomed victim. The poster went on to predict, "You'll Recoil and Shudder as You Witness the Slaughter and Mutilation of Nubile Young Girls in a Weird and Horrendous Ancient Rite!" Across the bottom, crimson-splashed letters enthused, "MORE GRISLY THAN EVER IN BLOOD COLOR!"

The movie lived up to the poster's claims; no false advertising there, with lurid, lingering scenes of dismemberment, scooped brains, and barbaric tongue removal. The plot concerns an insane caterer who decides to honor the goddess Ishtar by cooking up an "Egyptian feast"—a banquet with human-meat entrees. *Blood Feast* was the first gore-infused feature to hit, or rather, splash across the big screen, making it a milestone in the history of cinematic horror.

Director Herschell Gordon Lewis was also the movie's cinematographer, score composer, and special-effects wizard. *Blood Feast* was so successful, Lewis and the movie's producer, David F. Friedman, released two more flicks in the same gory vein: *2000 Maniacs!* in 1964, and *Color Me Blood Red* in 1965.

2000 Maniacs! tells the gruesome tale of Pleasant Valley, Georgia, a Southern town destroyed by Yankee soldiers during the Civil War. Every hundred years, the town springs back to life, just like the enchanted village

in the musical *Brigadoon*. On that magical day, the Pleasant Valley townspeople round up some Yanks, hold a festival and torture their victims in a variety of bizarre, lethal ways. They aren't into polka, but the term "roll out the barrel" takes on a horrible new significance on that day—especially since their barrel is lined with spikes. In *Color Me Blood Red*, an unsuccessful, frustrated artist finds that using blood for paint inspires him to create masterpieces. Critics and art patrons alike adore his new works. The only problem is, his pigment of choice isn't available in stores.

Friedman and Lewis eventually went their separate ways. Lewis kept on making gore films, all with key traits in common. All of them are filled with exuberantly wicked humor and revel in their over-the-top, Grand Guignol wickedness. These movies opened the door for countless other directors who wished to explore the darkest and strangest extremes of horror. Could *Night of the Living Dead* or *The Texas Chainsaw Massacre* ever have been made, without Lewis' work to first tickle America's fancy for freakiness?

Lewis also has made movies outside of the horror genre, including many sexy comedies, like *The Adventures of Lucky Pierre*. The titles of his releases reflect a general sense of thrills and excitement—just look at these examples: *Boin-n-g, Goldilocks and the Three Bares, Scum of the Earth, Sin, Suffer, Repent*, and *Alley Tramp*. Who wouldn't want to check out the goings-on in movies with titles like those?

In addition to his career in movies, Lewis is also enjoying a long, high profile career in advertising. He

has served as the chairman of a full-service direct marketing agency called Communicomp, and now heads his own writing and consulting service, Lewis Enterprises. For more than twenty years, he has been an adjunct lecturer to graduate classes in Mass Communications at Roosevelt University, Chicago.

His fame in the world of advertising isn't just national, it's global. He has addressed many meetings of the Direct Marketing Association (DMA) in America and has spoken at DMA meetings in other countries, including the U.K, France, Spain, New Zealand, Austria, Switzerland, Brazil, Singapore, and South Africa. He has even been named to the DMA Hall of Fame. He has presented copywriting seminars in Mexico, Holland, Belgium, Germany, Hong Kong, and more. His books on advertising include *Copywriting Secrets and Tactics*, *Direct Marketing Strategies and Tactics*, *Big Profits from Small Budget Advertising*, *Direct Mail Copy That Sells*, *More Than You Ever Wanted to Know About Mail Order Advertising*, and *How to Make Your Advertising Twice as Effective at Half the Cost*. In addition, he is producer of the video, *100 of the Greatest Direct Response Television Commercials*.

A man of many diverse interests, Lewis also enjoys tennis and scuba diving and has authored *Everybody's Guide to Plate Collecting* with his wife Margo.

MICHAEL McCARTY: Tell us about your childhood. Did you always want to be a combination ad-man/moviemaker?

HERSCHELL GORDON LEWIS: None of this entered

my mind during childhood. It wasn't as though I wanted to be a firefighter; my vistas, in a small Pennsylvania town, were foreshortened. My father died when I was six, and my mother struggled to keep the household together. We moved to Chicago, and for years I spent most of what would have been "leisure time" delivering groceries.

The "Eureka!" effect occurred when I was ushering at Orchestra Hall, with exposure not only to concerts but to other forms of entertainment, sometimes visual and sometimes, in my immature opinion, less than effective.

MM: Besides advertising and moviemaking, what else have you done in your career?

LEWIS: I've written some music, but most of it was as background for films. I taught school, at first full-time and later part-time. I was a "morning man" on a radio station and also sold time on that station. I was a producer/director at a television station. And I did and do write articles and columns for marketing publications.

MM: How did you get started in the world of advertising?

LEWIS: I was teaching at Mississippi State University, English and the Humanities. A local retailer needed some advertising. I found it ridiculously easy. From that point forward, I always had a fist dipped in the waters of what I call force-communication.

MM: Since you're so skilled at advertising, did you come up with some clever innovations or campaigns to promote your movies?

LEWIS: My partner in what now is called "The Blood Trilogy," David Friedman, was the master of publicity and promotion. Between us, we introduced barf bags, ambulances, nurses, vampire teeth, and paperback book versions of the movies. Looking at some of the campaigns for current major company product—using all media—I feel secure in the claim that we knew how to convince potential moviegoers to take a chance and buy a ticket.

MM: What innovations have you used in Internet advertising?

LEWIS: "Innovation" is a dangerous claim, because no one has access to every Web message or site. I think I was one of the first to test position of the recipient's name in the subject line. In many of my columns I preach the personal dogma of catering to a gnat-sized attention span. As is true in any civilized advance, today's innovation is tomorrow's ho-hum. Consider "morphing" and CGI in moviemaking.

MM: These days, practically every serious horror movie has gore in it—some more than others. Would it be correct to call you the inventor of movie gore?

LEWIS: I've been given that title so often I now believe it.

MM: What do you think of modern gore epics like the *Saw* movies and *Hostel* sequels?

LEWIS: I'm the wrong person to ask. I think they're both derivative and humorless.

MM: You directed, produced, acted, did cinematography,

composed music and even sang in your movies. How did you juggle so many responsibilities?

LEWIS: That is both the pleasure and the curse of low-budget independent moviemaking. I never regarded myself as a juggler. Getting the picture done was the single goal. I wrote the music because I was aghast at the price-quotes I was getting from arrangers. I saw no ego-food there. In fact, usually I used a different name. Check "Sheldon Seymour" on the credits . . . or, occasionally, "Seymour Sheldon."

MM: Which of your movies had the biggest budget? The smallest budget?

LEWIS: Biggest budget was *She-Devils on Wheels*, my female motorcycle gang movie. That one required patience, plus a lot of night-for-night photography. Smallest budget was *The Adventures of Lucky Pierre*. Dave Friedman and I were the entire crew. We bought just eight thousand feet of 35mm color film. The finished movie ran six thousand three hundred feet. Aside from throwing away nothing, we had to be careful that we never had a "Take two."

I'm eliminating *Blood Feast 2* from this estimate, because only marginally can I claim it was "my" film. Jacky L. Morgan was the producer and Boyd Ford was the screenwriter. The budget was nominal, but considerably higher in any production area than any of my films. I was a hired director, and I had a wonderful time on the set.

MM: Have your movies launched any acting careers?

LEWIS: Larry Drake, who had an ongoing role in *L.A.*

Michael McCarty

Law (and the *Dark Man* movies and *Dr. Giggles*) . . .
Harvey Korman, who was second banana on the Carol
Burnett show and a featured player in some of the Mel
Brooks films . . . Karen Black, who had a role in *The
Prime Time*. Others, maybe. I don't recognize an
alumni association.

MM: Was Connie Mason a Playmate before or after
appearing in *Blood Feast*?

LEWIS: Before. We exploited that.

MM: Because of the extreme violence of *Blood Feast*,
was it hard to book the film into theaters? Was there
resistance from theater owners? Did it receive a
warmer welcome from the drive-in circuit or was there
resistance there, too?

LEWIS: Until *Blood Feast* began amassing incredible
film rentals, resistance was fierce. We also were
accused of killing business at the refreshment stand . . .
an exact reverse of the effect horror movies have today.
Some newspapers refused to carry our advertising. We
started with a hard core of theatres, both hardtops and
drive-ins, that valued box-office gross above on-film
grossness. As word spread, resistance faded. Critics
were universally unkind, and then as now, I recognized
that their judgment came from a different planet.

MM: *2000 Maniacs!* was set during the Civil War,
when the United States was fighting the Vietnam war.
Was this a conscious decision? Were you making a
statement about the violence in Vietnam?

LEWIS: Regrettably, no. *2000 Maniacs!* was designed
as entertainment. It has been looked at as a parallel to

Brigadoon. We hadn't ever heard of *Brigadoon* when we made *2000 Maniacs!* The violence in Vietnam was far removed from the world of entertainment. Public involvement in no way came up to a quarter of the level of reaction to Iraq.

MM: You did a number of films about hillbillies such as *Moonshine Mountain, 2000 Maniacs!* and *This Stuff'll Kill Ya!*—what was your fascination with Southern culture and its people?

LEWIS: I love the whole notion. I love hillbilly, bluegrass, and redneck music. I also was aware that my films played well in the south. Some theatres played *Moonshine Mountain* six or seven times.

MM: You did a series of sexploitation movies such as *Alley Tramps, Suburban Roulette, The Girl, the Body and the Pill,* and *Blast-Off Girls*. Which is easier to film, sex or violence, and why? And which is more fun to film?

LEWIS: *Alley Tramps* wasn't my movie. I directed it for Tom Dowd. The other three were easy and represented a good time . . . so I'd have to conclude that they were more fun. But note that word "fun." ALL movies are fun to film if you can keep your ego off the set.

MM: How did you get Colonel Sanders, of Kentucky Fried Chicken fame, to appear in *Blast-Off Girls*?

LEWIS: We always made a deal with a chain to shoot a scene in exchange for lunches for crew and cast. I already had a track record with Arby's and Church's Fried Chicken. I asked a local KFC outlet if they'd be

interested in a swap in exchange for publicity. After we had agreed on a date, I had a call from an excited public relations representative, who said Colonel Sanders would be in town and might be available. Of course I said yes. Fortunately, this was *Blast-Off Girls*. Had it been a gore movie, the good Colonel's sensitivities might have prevented an appearance.

MM: Tell us about *Blood Feast 2*. Is that a sequel or remake of *Blood Feast*? What did you do different the second time around?

LEWIS: Over the years, I had at least fifty different conversations with would-be producers who said they were interested in making *Blood Feast 2*. All turned out to be conversationalists rather than producers. Suddenly Jacky Morgan appeared, script in hand. To my astonishment, he was ready to produce. And what a treat for me! I didn't have to operate the camera (although I wanted to, because the slow camera activity was frustrating). I could watch the action on a TV monitor. And I didn't have to stow the cables when we broke a location. On the negative side, I felt the editing wasn't the way I'd have handled it, and the screams weren't right.

MM: Gene Simmons of KISS is a fan of your films. The band's "Gore Gore Girls", "Blood Feast" and even "10,000 Maniacs" (their name is tied to your film *2000 Maniacs!*) have all honored your work with their names. Have you ever met any of these rockers?

LEWIS: No, I never have. Gene Simmons made some comments I treasure. I proudly wrote program notes for *The Gore-Gore Girls*. I revel in reflected glory.

MM: What advice would you have for today's aspiring filmmaker?

LEWIS: That's an easy one. Leave your ego at the door. Don't cast your cronies in key roles unless they actually have acting talent. Don't shoot rehearsals, but stay with a strict schedule. Constantly think the way a potential viewer thinks—what entertains, not what you personally like. And always remember, it's the campaign that sells the movie.

MM: Last words?

LEWIS: You never may realize how honored I am to still warrant an interview for *Modern Mythmakers*.

MM: Thank you, Herschell Gordon Lewis.

"After I abandoned doing My Work Is Not Yet Done as a screenplay, my plan was to write it as a novel of 300 pages or so. But that would entail far too much material that is extraneous to the core of the narrative. In its present form, My Work Is Not yet Done is a short novel, which is a separate genre from a novella."

—Thomas Ligotti

PUPPETS, NIGHTMARES AND GOTHIC SPLENDOR

THOMAS LIGOTTI

By Mark McLaughlin and Michael McCarty

IF YOU WERE to ask most aficionados of fright fiction to name the most sophisticated and literate of today's horror writers, chances are that one name would be on all of their lips: Thomas Ligotti. Many believe he is the heir to the thrones of both Edgar Allan Poe and H.P.

Lovecraft, and some will insist he's better than either one. People who enjoy the works of Ligotti have very strong opinions about his work.

Like Poe and Lovecraft, Ligotti is primarily known for his short fiction. His story collections—from *Songs of a Dead Dreamer* to *Grimscribe: His Lives and Works* to *The Nightmare Factory* and more—are noted for their nightmarish Gothic surrealism. Even though the majority of his stories take place in the present day, they have a timeless quality to them. They could be set in the 1800s or even 500 years from now. In Ligotti's twilight dreamworlds, the past, present and future all blur together, and nothing is as it seems.

MICHAEL McCARTY: You worked in Detroit for over two decades. Did seeing all those abandoned, decayed buildings influence your dark, brooding fiction?

THOMAS LIGOTTI: I would say they inspired me more than influenced me. I've never been one for realism, so what I rendered in a number of my stories was the impressionistic effect on me of Detroit's desolation rather than its details. In "The Chymist" I mention several locales that I fabricated but which have their counterparts in Detroit. Same thing with "The Red Tower" and "The Bungalow House." And I mentally set the whole of *My Work Is Not Yet Done* in Detroit, although I never name the city. There's a book called *American Ruins* by Camilo José Vergara that features a number of Detroit's most desolate spots. Vergara proposed to the Detroit City Council that a section of the city's downtown area be set aside as an "urban ruins theme park."

They thought he was crazy, of course, and dismissed the idea.

Whoever wants to get a sense of what a run-down marvel Detroit has become should rent the movie *Narc*, which is set entirely in Detroit. And at the end of *Transformers*, when all the robots have their battle royal, much of that is set in Detroit. I didn't know this before I saw the movie, but I immediately recognized the downtown district where these scenes were shot. Later I verified that they were indeed filmed in an area of Detroit where I worked for over twenty years.

MM: From your fiction, one might imagine that you grew up in gloomy Gothic surroundings, like the House of Usher. How close is that fanciful notion to reality?

LIGOTTI: I lived in Detroit for the first couple years of my life, and I visited my grandparents there quite often during my childhood. They lived in a bungalow. I also spent a lot of time in the '60s hanging out in a dope house district of Detroit's east side. For the most part, though, I was raised in an upperclass suburb of Detroit called Grosse Pointe. My family didn't live in one of those grand old piles down by Lakeshore Drive, but I had friends who did. It's a shame that every one of the original Victorian mansions in Grosse Pointe was torn down before I was born, but their replacements were still architecturally daunting.

MM: Tell us about your inspirations for your short story collection *Grimscribe*.

LIGOTTI: There was no single inspiration for the stories in that collection. The publisher wanted to try

and pass off a collection of stories as a sort of novel, so I went along with this really embarrassingly transparent ruse. It would be too boring for the majority of the readers of this interview to go through the stories one by one.

MM: The stories in that book are all fascinating and far from boring, but you're right—at first glance, it does look like a novel. Recently, the story "The Frolic" from your collection *Songs of a Dead Dreamer* was made into a short film.

LOGOTTI: My script collaborator Brandon Trenz and I knew a producer named Jane Kosek. She used to work with us at a publishing company in Detroit. Then she lit out for Hollywood. She and Brandon went to see an agent in LA about shopping some of our scripts around, but that led nowhere. She'd worked with a number of directors and suggested to one of them doing "The Frolic" as a short film. That didn't work at all because the director had all these loopy ideas for the film. Some years later, she showed the story to another director, Jacob Cooney, and he was amenable to doing something that was closer to what Brandon and I had in mind for the film version.

MM: Have any of your other works been optioned for movies?

LIGOTTI: All of the stories in *The Nightmare Factory* are part of an exclusive option to-buy agreement with Fox Atomic. So they can do pretty much anything they want with them until the option runs out. That's how the comic book versions of some of my stories came about. I think that *My Work Is Not yet Done* is the

most viable thing I've written for the purposes of a movie adaptation. Actually, the story was originally conceived as a film script. A paperback version of the book came out in June 2010 from Virgin Books.

MM: *The Nightmare Factory* has a crumbling asylum in it. Was that based on a real facility?

LIGOTTI: No. The title of that book was just something I came up with. Later I discovered that same title had been used for a poetry collection by Maxine Kumin.

MM: *The Agonizing Resurrection of Victor Frankenstein and Other Gothic Tales* is a very hard book to find these days. What inspired you to write about the world's most famous mad scientist?

LIGOTTI: A woman named Tina Said was doing a fanzine that used only short prose. She asked me to contribute something and I wrote "One Thousand Painful Variations Performed upon Divers Creatures Undergoing the Treatment of Dr. Moreau, Humanist." Then I wrote two more pieces for a fanzine called *Grimoire* that the prose poet Thomas Wiloch, another friend of mine from work, was doing, and that we ended up putting out together. After that, I just kept writing miniature variations on famous horror stories and films until I got tired of doing them. I tried to take the variations into even more tragic and nightmarish territory than the originals. One critic described the pieces in *Agonizing Resurrection* as an "apotheosis of torment." That's what I was going for—the absolute worst doom that I could imagine for the main characters in these stories—although most readers

thought they were just jeux d'esprits. Some of them were published by Harry Morris in his Silver Scarab Press edition of my first collection, *Songs of a Dead Dreamer*.

MM: What was the first horror movie you ever saw?

LIGOTTI: *Tarantula*.

MM: How often do you watch horror movies? What was the last one you watched?

LIGOTTI: I rent horror movies whenever I think they might be good, or at least watchable. The last one I rented was *The Ruins*. The author of the book on which the movie was based did the screenplay, so I thought there was a chance it would be okay, since he also adapted his previous book, *A Simple Plan*, into a terrific movie. There was a lot of "intense gore" in *The Ruins*, but I don't respond to that sort of thing no matter how intense it is. They're only movies, after all. I don't think I would have rented *The Ruins* at all if I didn't get it out of one of the "movie cubes" at the local supermarket for a buck. On the whole, I'm not a fan of horror movies. I'd rather watch political thrillers, courtroom dramas, caper films, plain old suspense, and the like.

MM: What was the inspiration for *My Work Is Not Yet Done*? And do you see a lot of yourself in the protagonist Frank Domino?

LIGOTTI: The character's surname is actually Dominio. It's only his boss who mockingly mutilates his name into Domino. I used this moniker because in one of its meanings is a domino, a kind of hooded

costume that resembles the figure of death. At the time I wrote *My Work Is Not Yet Done* I was having some troubles at work very similar to those of the protagonist. Naturally, these situations, which are very common in workplaces, inspire certain fantasies. Rather than just fantasizing, I wrote a story in which I took those fantasies several steps further than anyone could in real life. None of the characters in *My Work Is Not yet Done* is based on the persons I was having trouble with. But I did think of Frank Dominio as a psycho killer version of myself, although he didn't start out that way. The whole experience taught me that forgetting is the best revenge. I also concluded that murder is a really lame form of vengeance. Non-existence is just too good for some people.

MM: *My Work Is Not Yet Done* and your story "The Shadow at the Bottom of the World" are thematically similar. Do you see them as companion pieces?

LIGOTTI: I really don't see the resemblance myself. "The Shadow at the Bottom of the World" is a horror hymn to autumn, or that's the way I thought of it. "Shadow" is one of those stories in which the people of a small town share the same barbaric impulse, although the reason for this impulse is left a mystery. It would have undermined the point of the story to give the reason for this bloodthirsty impulse. There is no reason I could have given it anyway because it's wholly irrational. Blood sacrifice in certain ancient cultures seemingly had a profit motive in appeasing gods or whatever.

But it's quite apparent that people of all times have been drawn to murder in any form, real or fictional.

This is no great psychological or sociological observation. It's only a fact. We are lovers of havoc and evil. A tranquil existence is intolerable to us. Think of the famous cuckoo clock soliloquy spoken by the character Harry Lime in the movie *The Third Man*. The rest of the world holds in contempt any country that is not populated by ambitious bloodletters. Think of all the jokes about Canadians or Scandinavians. Of course, the citizens of these lands once had their day. I suppose that since *My Work Is Not Yet Done* exults in supernatural mayhem, it's another example of this impulse. But this impulse is also explored as a force beyond our control in the form of a Schopenhauerian Will that is at the source of what we are when we're not playing at being "civilized." Frank Dominio gradually comes to realize this in the course of the narrative.

MM: *My Work Is Not yet Done* is 42,000 words, the closest you've come so far to writing a novel. Have you ever thought about expanding it into a novel?

LIGOTTI: After I abandoned doing *My Work Is Not Yet Done* as a screenplay, my plan was to write it as a novel of 300 pages or so. But that would entail far too much material that is extraneous to the core of the narrative. In its present form, *My Work Is Not yet Done* is a short novel, which is a separate genre from a novella. It has the structure of a novel, but not what most people would consider the length. Plenty of books that readers think of as novels are really short novels. Albert Camus' *The Stranger*, James M. Cain's *The Postman Always Rings Twice*, Truman Capote's *Breakfast at Tiffany's*, Robert Louis Stevenson's *The Strange Case of Dr. Jekyll and Mr. Hyde*, Ray

Bradbury's *Fahrenheit 451*, Thomas Pychon's *The Crying of Lot 49*, J.D. Salinger's *Catcher in the Rye*, Voltaire's *Candide*, Lovecraft's novels, William Hope Hodgson's *The House on the Borderland*, and the list goes on. The short story is still the best form for horror fiction, but the short novel isn't bad either. It keeps horror writers from letting the kernel of their narratives wander too far out of sight. The American poet and short novelist Howard Nemerov wrote an interesting study of the short novel in a collection of his critical essays. I mean, I don't care if *My Work Is Not yet Done* is called a novella, a short novel, or roach trap. But there is such a thing as a short novel.

MM: Your work has been compared many times to that of H.P. Lovecraft. How do you feel about the comparison? If Lovecraft were still alive, do you think you two would get along?

LIGOTTI: I think the comparison with Lovecraft is always meant to be a compliment to me. I would say there is a likeness between Lovecraft and me in that our narratives are focused on a supernatural or weird element and nothing else. Lovecraft said as much of his own stories, and I feel intuitively that he was right. As for getting along with Lovecraft, it wasn't too long ago that I had a conversation with Jason Van Hollander about this. Both of us agreed that we would probably find Lovecraft a difficult person to be around because his gentlemanly behavior would get on our nerves. Of course, I can't be sure of that because Lovecraft had such a great sense of humor, and my own views are compatible with his on just about every subject. But if Lovecraft visited me, I think I would

have to watch my words and not say anything like, "Fuck me, I ran out of cigarettes." It's not that I think Lovecraft was prudish. From reading his letters, one can tell that he wasn't shockable. He just had firm ideas about how people should present themselves, and that didn't include using profane language or tobacco, two things I find impossible not to do. I can't fault him for that.

MM: Dreams play an important role in many of your stories. What do you dream about?

LIGOTTI: It's been my experience that mostly I dream about what I've seen and what I've done. So I have a lot of dreams about things like not being able to find my car in a parking garage. But I also have the kind of strange dreams that everyone has. The first "dream monologue" in "The Bungalow House," where the protagonist feels a sense of ecstatic terror while standing in the dim and rank living room of the eponymous structure and sensing all those insects around him, was based on a dream I had. I also dreamed about those weird locales in "Gas Station Carnivals." And the literally feculent building in "The Night School." Perhaps the most affecting dream I've ever had was the one that led to my writing "The Cocoons." I'd had recurrent dreams for some time about humans being transformed into some bizarre life form that served as food for other bizarre life forms. When I woke up from that dream, I felt I had gone mad and would remain that way.

I have to say that I find dreaming to be among the most wretched experiences forced on human beings. It denies you the relief of sleep, which is supposed to

knit up the raveled sleeve of care. But if you always wake up with a dream in your head, it feels like you've been dreaming all night, and that you've never gotten any respite from conscious existence. Every time I go to bed, I think, "What kind of inane or traumatizing trash am I going to get into tonight?" But if I thought too much about dreaming, I'd never get to sleep. To top it off, I have night terrors in which I'm awake but am paralyzed and feel as if I'm having a heart attack. The only way I can wake up is by screaming, which takes a lot of effort. And then there are those dreams in which I find myself in a place that's supercharged by the presence of something evil that never makes an appearance. How can anyone tell someone to have "sweet dreams?" I know that there are dreams that are pleasant and that one regrets awaking from. And that is regret indeed.

MM: Puppets and dolls also figure into your fiction with some frequency. Do you find them frightening?

LIGOTTI: I did when I was a child, but not since. However, I still find puppets to be uncanny things. For me, the puppet emblemizes the entrapment and manipulation of human beings by forces beyond our control. Obviously, there are a lot of things that people are aware they cannot control in their lives. As Fireside Theater brilliantly said, "Your brain is not the boss." In my world, this is an everyday experience because I've been long besieged by abnormal psychological states that cause me to be constantly aware that I have no control over who I am and how I'll act. Most people don't feel this way or they don't notice the controlling forces because they're very subtle. Having any kind of

control over your actions or feelings is everybody's illusion. No one can make themselves what they are. It's a totally absurd notion, because if you could make yourself what you are, you'd first have to be a certain way and be able to choose what that way would be. But then you'd also have to be able to choose to choose what way you would be, and on into infinity. There are always determining powers, and those make us the way we are whether or not we realize it. I realize that there are philosophers who have reconciled determinism with free will on paper, and that everyone feels as if they're in control of themselves and take responsibility for their actions. But how many of us can say that we're always, or even often, in control of our thoughts? And if you're not in control of your thoughts, then what are you in control of?

If you doubt this, just see if you can attain an empty mind in the course of meditating. It can be done, I know, because I did it for about thirty years. But it's not easy, and I never found it to do anything more than effect a state of temporary relaxation. And many people can't do it at all because they can't control their thoughts. If anyone out there has achieved a significant alteration in their consciousness due to meditation, I'd love to hear about it. Initially I practiced Transcendental Meditation. You have a mantra that you run through your head to keep thoughts from interfering with your meditation. The mantra is supposed to be a secret word that only you know. Then one day some Hari Krishna guy came up to me on the street and told me my mantra. He used to teach Transcendental Meditation and said that it was all a hoax. Then he tried to convert me to his form

161

of hoax. But I kept meditating using what were more traditional and supposedly more effective methods.

MM: Are you a techno-savvy person? Do you "do" cell phones, iPods, Blackberries?

LIGOTTI: I have no use for any of those devices, but if I did I would use them. I can't imagine living without a computer with a high-speed modem. There is so much great stuff out there to keep one from thinking about suffering and death.

MM: Do angels or demons exist?

LIGOTTI: Not in my experience. But I can imagine someone becoming involved in spiritualism of one kind or another to the extent that he or she would start to believe in all kinds of supernatural things and experience their presence. I once took a series of classes in reading other people's minds, and sure enough I was able to read other people's minds. It's hard not to give in to the influences that are brought to bear in an environment like that. The only thing you can do to break free is to remove yourself from that environment, or have someone else remove you from it. As Blaise Pascal said, "Men are so necessarily mad that not to be mad would amount to another form of madness." I've tried as hard as I can to become sane, but I've never gotten there.

"My favorite type of fiction has always been horror. I read horror novels, watch horror movies, write horror stories. Artistically, I find the supernatural to be expansive enough that it enables me to deal metaphorically with any issue that concerns me."

—Bentley Little

THE HAUNTED

BENTLEY LITTLE

Bentley little has been writing sophisticated horror novels that explore more serious ideas than merely to scare. Throughout his career, stretching close to three decades now, the former Arizonan, now California writer has raised frightening fiction to the next level, where events are spooky and smart at the same time.

This is evident in the twenty novels he has written, such as *The Disappearance, The Policy, The Walking, The Town, The Store, The Ignored, University, His Father's Son, The Haunted, The Influence* and the short story collection entitled *The Collection.*

An episode of *Masters of Horror* was based on his

short story "The Washingtonians," directed by Peter Medak (*The Changeling* and *Species II*).

MICHAEL McCARTY: *Dispatch* is about the power of the written word. Agree or disagree and why?

BENTLY LITTLE: *Dispatch* is definitely about the power of the written word (it's sort of my companion piece to my short story "Estoppel," which is about the power of the spoken word, which is included in *The Collection*.) As a writer, of course, words are very important to me. As I thought about that subject, I realized that words are very important to everyone; our society, that all societies are based on words. The foundation of our nation, after all, is the Constitution. The words written on that parchment govern every aspect of our lives. And the words written in The Bible, The Koran and other religious texts define the moral and spiritual existence of millions of people across the globe. The Bible is even referred to as "the Word of God." So, in my small way, and as a person coming from the "pen-is-mightier-than-the-sword" school of thought, I decided to address this issue in *Dispatch*.

By the way, the novel was originally called *The Letter Writer*, which I still feel is a better and more accurate title for the book. My publisher came up with the title *Dispatch*, using the reasoning that messages are sometimes called "dispatches" and that "to dispatch" someone means to kill them.

MM: What was the inspiration for *The Burning?*

LITTLE: I'd just finished *Dispatch*, one of my periodic "message" books, and was planning to write some sort

of a straight-ahead horror novel. I had no idea what I was going to write about, and my son said, "Write a story about a haunted train!" He's a huge train fan. At the time, we were driving between the towns of Payson and Pine in northern Arizona. At the halfway point, off the side of the road, are two old graves from the late 1800s or early 1900s. On one headstone is the word "Mother." On the other is the word "Daughter." They're pretty creepy, and my son again piped up: "Write a story about those graves!" So I did. *The Burning* includes both a haunted train and those creepy graves.

MM: Did Stephen King's *The Shining* inspire *The Resort*?

LITTLE: *The Resort* was not inspired by *The Shining*, but, of course, when I decided to write the novel, King's book was towering very threateningly over me. Just as anyone who writes a vampire book these days has to contend with the specter of *Salem's Lot* and *Interview with a Vampire*, or any author doing a haunted house story has to take into account Shirley Jackson's *The Haunting of Hill House* and Richard Matheson's *Hell House*.

The Shining is an intimidating precursor for a writer even considering a haunted hotel novel. What I tried to do to differentiate my resort from Stephen King's hotel was to make The Reata as unlike The Overlook as possible. So it's outside, it's open, it's crowded, it's summer. It's everything The Overlook wasn't.

MM: In *The Resort*, The Reata offers a cheaper rate

during the summer. Is this something that really happens, or was it fictionalized for the novel?

LITTLE: Most resorts in Arizona cater to wealthy people from the East who pay exorbitant amounts of money to escape the cold during the winter. During the summer, however, these luxury hotels used to remain empty because no one wanted to spend hundreds of dollars a night to stay in a desert with triple-digit temperatures. So these resorts started offering summer rates to attract locals and families. Since the hotels were just sitting there empty during the off-season, the owners figured they might as well make a little money.

I've stayed at quite a few of these resorts, but the genesis of the novel was an incident that happened on my wedding night. My wife and I got married in Tombstone during the afternoon, but we were going to have a Chinese banquet in Tucson that evening and stay that night at a local resort. When we finally drove back to Tucson, we didn't have enough time to unpack, so we just checked into the hotel and then went to the banquet. When we returned, sometime around midnight, we went to our room and started to open the door, but it was chain-locked from the inside, and when I tried to push the door open, a strange man yelled at me. The hotel somehow screwed up and booked the room to us and to someone else. I changed this incident slightly and used it in the novel.

MM: Did you decide to write about insurance companies with *The Policy*?

LITTLE: I wrote it because insurance companies are

ubiquitous and I find that a little creepy, especially in this era of conglomerates and corporate mergers. I live a very simple life, yet I still need to have health insurance, dental insurance, life insurance, car insurance, and homeowner's insurance. And in order to insure me, these companies not only ask for my money but require me to divulge detailed personal information. I started thinking about that, and, to my mind, it was a horror story waiting to happen.

MM: In *The Policy*, the protagonist is named Hunt. Did you choose this name because insurance companies and its customers engage in a game of the hunter and the hunted?

LITTLE: You caught me. I very seldom have names in my novels that mean anything. Generally, I steal the names of people I know or glance around my room and take names from the spines of various books that are within my sight line, but every so often I'll make a token effort to come up with names that reflect the theme of the novel or that try to make a point. I did it in *The Store* and several short stories and I did it here.

MM: If you could be any monster, which monster would you be and why?

LITTLE: I'd be Leatherface (from the *Texas Chainsaw Massacre* films), because I've always wanted to slaughter a group of young people and slam meat hooks through their necks and cut them up with chainsaws!

No, seriously, I wouldn't want to be any monster. From my point of view, the life of a monster is far too limiting. All of them have severe restrictions that I

would find intolerable, even those who might possess certain qualities like immortality that I would love to have. Also, I've never been one of those readers who really identified with monsters, even ones that are sympathetically portrayed. I'm not that much of an outcast. To me, they are creatures to be feared, rather than emulated.

MM: What other things do you do during the rest of the year when you're not writing? What does Bentley Little do for fun?

LITTLE: Throughout the nineties, I wrote a novel about every six to nine months and then filled out the year writing twenty or thirty short stories. This pace slowed considerably after the birth of my son in 1999. My wife works and I stay home, so taking care of a little boy every day drastically cut down on my writing time. For the past several years, it's taken me at least a year to write each novel. Now, however, my son's in kindergarten and next year he'll be in first grade, so my writing time is again opening up. I doubt that I'll go back to my previous pace, but I should be able to get a lot more work done now.

When I'm not writing, I just lead a normal life. I collect records, listen to music, read books, watch movies, go to concerts, play with my son, hang out with my friends. As a writer, I have a very flexible schedule, so we take a lot of vacations and do a lot of traveling.

MM: Your books *University, The Store, The Association* and *The Policy* all dealt with the loss of personal freedoms. Is this a fear of yours, too?

LITTLE: I'd put *The Ignored* and *The Mailman* on that

list as well, and yes, it is very definitely a fear of mine. Although, until recently, I was not one of those people who feared that the government was going to take away our freedoms. We live in a democracy, for Christ's sake. We are the government. I've always been more afraid of unchecked corporations than elected officials. I'm very individualistic and independent, so it doesn't really affect me, but I think the most insidious evil is peer pressure. I'm not worried that the government will crack down on a lone nonconformist and force him to toe the party line, but I am worried that his friends and community will ostracize him and make him conform by putting social pressure on him. A lot of my work deals with the horrors of group-think and a mob or herd mentality.

MM: Is *University* your tribute to horror?

LITTLE: Yeah. I think it's my defense of the field against the mainstream literary critics. I think horror doesn't get the respect it should. I wanted to show mainstream readers and reviewers that horror does have some literary respectability.

MM: My favorite book of yours has also been *The Store*. How would you describe the book?

LITTLE: Thanks. *The Store* is about the Wal-Martization of America. It concerns a small Arizona town that is initially ecstatic because a chain retail outlet builds a brand new superstore in their community. But happiness turns to dread as The Store puts local merchants out of business, as opponents of The Store mysteriously die or disappear, and as it becomes clear that the mysterious corporation that

owns The Store has dark and unfathomable designs on the town.

Considering all the mergers and corporate takeovers that have taken place, the book is still timely.

MM: One of your childhood friends, Stephen Hillenburg, grew up to create the cartoon *SpongeBob SquarePants*. What was Stephen like as a kid?

LITTLE: Stephen was always very artistic and into science, two interests he combined in *SpongeBob*. He was an excellent artist, and he had the best bug collection of any kid at our school. We used to make 8mm horror movies together. One was about a monster chasing a kid through a park until the monster's mother makes him come home. One was about ivy taking over the world. On one of those reels, I even have Stephen's first cartoon. It's about twenty seconds long and shows a fat man walking into a steam room. Steam pours out from between the cracks of the door, and when the man emerges he is skinny. I could probably sell that on eBay for a fortune.

MM: There is a rumor that Stephen King was reading your book *The House* at the time he was hit by a van a few years ago. Is there any truth to this?

LITTLE: I don't think he was reading it, but he was carrying it. An article in *USA Today* mentioned the name of the book and sales just took off. It was the best press I ever got. After that, I thought about linking my books to other celebrity accidents. I thought if I could just say that one of my books was in Princess Diana's car and one was in JFK Jr.'s plane, I'd have it made.

MM: What about horror makes it a good genre for you to work in?

LITTLE: I like it. That's the bottom line. My favorite type of fiction has always been horror. I read horror novels, watch horror movies, write horror stories. Artistically, I find the supernatural to be expansive enough that it enables me to deal metaphorically with any issue that concerns me.

MM: Of all the books you've written, which one do you consider your scariest and why?

LITTLE: Scariest? That's tough. I can't really separate myself from the work enough to look at it objectively. Based on the fan letters I received, readers seem to think *The House* is my scariest novel.

MM: Richard Laymon was a good friend of yours. What is one of your fondest memories of Dick?

LITTLE: Richard Laymon was one of the few friends I had in the horror business, and I miss him greatly. I suppose my fondest memory is of the first time I met him, which was at Dean Koontz's house. At the time, I'd had stories published in genre magazines and small press publications, and all of a sudden I was given the opportunity to meet with two of my idols on an equal footing, as a peer. It was very exciting. Not only that, but I got a brainful of shoptalk: personal behind-the-scenes information about editors and writers and critics. It was thrilling, fun and hilarious. I was in hog heaven, and it was a combination of the circumstances and the genuine kindness and normalcy of Dean, Richard, and their families that made it a night to remember.

Michael McCarty

MM: Phillip Emmons has been a minor character who keeps popping up in several of your novels. Do you see him ever being the main protagonist in a future novel?

LITTLE: I've considered eventually writing a novel titled *Phillip Emmons*, where I tell his story, but I haven't decided whether or not to do that. Right now, I'm content to let out small details of his life and work here and there in other novels.

MM: Last words?

LITTLE: Garmonbozia!

"I wasn't at all bothered by Tony Curtis playing Harry Erskine (in The Manitou). In fact he was just about as close to how I imagined Harry as anybody could be. I can't think of any other actor who could play him as well as that, except perhaps Bruce Willis."
—Graham Masterton

THE MANITOU MAN

GRAHAM MASTERTON

GRAHAM MASTERTON IS one of the most eclectic and prolific horror writers around. With over 60 books to his credit, he has written about a variety of subjects—from supernatural thrillers to sex instruction books, from historical sagas to even movie-ties.

In 1975 Masterton turned to horror. His first novel, *The Manitou*, was turned into a movie in 1978 starring Tony Curtis, Susan Strasberg, and Burgess Meredith. Three of Graham's horror stories were adapted by the late Tony Scott for his Showtime TV Series *The Hunger*. Over the years he has published five short story collections, several which have garnered awards, and has penned the novels *Charnel House, Revenge of*

the Manitou (followed by *Burial* in the Manitou series) *Prey, Flesh & Blood, The House That Jack Built* and *The Chosen Child*. Recent publications include *Holy Terror, The Red Hotel* and *Innocent Blood*.

He has been awarded a Special Edgar by the Mystery Writers of America, two Silver Medals by The West Coast Review of Books, the Prix Julia Verlanger for the best-selling fantasy novel in France (the only non-French winner) and was nominated for a Bram Stoker by The Horror Writers Association in 1998. The British Fantasy Society published *Manitou Man: The Worlds of Graham Masterton*.

Graham Masterton currently lives in Surrey, England. His wife and agent Wiescka died on April 2011 at the age of 65.

MICHAEL McCARTY: What is the secret to your longevity? What are some of the changes you've seen in the publishing business the last four decades? How did you manage to survive the '90s when the suits pronounced horror dead?

GRAHAM MASTERTON: The only secret to longevity is to keep on writing. Some of my novels have been spectacularly successful and others haven't. You just have to take the knocks and start on the next book, chapter one, page one. I have never restricted myself to horror alone, and that has helped to keep things going when horror took a nosedive in the late '80s.

I have written thrillers (*Plague, Famine*), historical sagas (*Rich, Maiden Voyage*), as well as short stories, humorous articles and "how-to" books on human relations. What publishing has lost for me is the

personal touch, when your editor was your friend as well as your employer.

Also I deplore the reliance of editors these days on the computerised sales figures of an author's last book before commissioning the next. Any professional writer is bound to produce an occasional book which doesn't sell so well, but the result has been that many excellent mid-list authors with huge popular followings have been unable to survive.

MM: When you started writing in the '70s, you wrote a number of non-fiction sex instruction books, and worked the UK edition of *Penthouse* Magazine. When you began writing *The Manitou* did you feel that was risky, because you were already publishing these non-fiction books and had a good track record? What did you think of the film?

MASTERTON: The same thing happened to sex instruction books in the mid-70s that happened to horror in the '90s. If you'll excuse the phrase, the bottom fell out of the market. That's why I turned to fiction writing. I was probably mad, but if you don't throw yourself off an occasional cliff in this life, you end up never achieving anything. I think the movie, for the time, was quite good, and very close to the book. I wasn't keen on the Star-Warsy ending, but *Star Wars* was making a huge impression in Hollywood at that time, and I don't blame Bill Girdler (director of the film) for trying to give it a cosmic climax. I liked Bill, and I was very sorry when he died.

MM: What sort of reaction do you get from people when you tell them you write horror fiction for a living?

MASTERTON: These days, horror is acceptable to almost everybody. The landlady of my local pub, who looks as if Irish butter wouldn't melt in her mouth, is so keen on my horror novels that she insists on reading the manuscripts before they're published.

MM: You've written a number of books about haunted houses. Why do you like this theme in novels?

MASTERTON: Haunted houses are always good as a background because you can use them to introduce the tortured history of those who lived there before. You have instant atmosphere. They can be claustrophobic, full of creaks and cries and strange noises, and I think that most of us have been in an empty house at one time or another and felt a chill of uncertainty. I went to look at a 15th-century priest's house in Sussex once and in one room the feeling of dread was so intense that I had to leave in a hurry. I am also interested in vernacular architecture . . . *The House That Jack Built* is firmly based on a real house.

MM: What was the inspiration behind *The Chosen Child*?

MASTERTON: My books are very popular in Poland, and usually make the best-seller lists in Warsaw. My wife Wiescka is Polish and we have visited Poland several times. I thought that Warsaw would make a very interesting setting for a horror novel, since I like to set stories in living, realistic backgrounds . . . it makes the supernatural parts more believable. I first learned about the story of the Polish Home Army in the sewers from Andrzej Wajda's film *Kanal* which is well worth hunting out by anybody interested in the Warsaw Uprising.

MM: My favorite short story of yours is "Voodoo Child." Did you have to do a lot of research for that story? Are you a big Jimi Hendrix fan? Did you ever see him when he played the U.K?

MASTERTON: I didn't have to do any research for "Voodoo Child" because I met Jimi on several occasions when he was living close to me in Notting Hill, in London. His music made a huge impact on people of my age. I saw him play at the Saville Theatre in London in 1967—he was amazing.

MM: Any advice for beginning writers?

MASTERTON: Take the advice that William Burroughs once gave me—"pick up your typewriter and walk"—which meant that you should forget the mechanics of writing and tell your story as if you're speaking it.

A writer should be invisible to the reader: don't show off with fancy similes and metaphors, they hold up the story. Make your characters complex and real, give them real-life difficulties to deal with that don't necessarily have anything to do with the main plot. Sit at your desk and let the room melt away around you; be inside your story. So many writers write as if they're always staring ahead of them. Turn around—hear voices behind you. Feel the wind in your hair. Be there.

MM: What's the hardest part of being a professional novelist?

MASTERTON: Nothing. It's the cushiest job in the universe. You can get up when you want, you don't have to travel to work. You can write what you want

Michael McCarty

for as long as you want and then you can go to the pub and enjoy some craic with your friends.

MM: You've done a number of books that were published internationally. Are there certain themes or elements that work better in the U.S. than in England or Poland? Is horror universal?

MASTERTON: Horror is universal, although they don't like it very much in Germany, for some reason. I tend to set most of my books in America because U.S. readers find it hard to identify with, say, a British setting, whereas American TV is so universal that British readers feel quite comfortable reading about U.S. settings. So long as a story is entertaining and believable, I don't think the theme matters, although I have noticed that U.S. readers seem to like vampires a lot. That sucks.

MM: Telos published the 25th anniversary edition of *The Manitou*. Do you think the book has stood the test of time after a quarter of a century? What do you think contributes to the book's longevity and popularity? And does Telos have any plans to re-publish the sequels *Revenge of the Manitou* and *Burial*? (Author's note: Since this interview, he published "Spirit Jump" (short story) and the novels *Manitou Blood* and *Blind Panic*)

MASTERTON: I think *The Manitou* has managed to remain fresh after 25 years because it is really a very simple story, directly told. An Algonquin wonder-worker is reborn after 300 years, intent on wreaking supernatural revenge on the white man. The white man uses his technology yet again to crush him and all

his gods. It could almost be an allegory of the political situation in the world today—ancient frustrations being overwhelmed by technological superiority. What undoubtedly contributed to the novel's popularity was the character of Harry Erskine, the fake fortune-teller who tried to deal with every disaster with a quip. In most previous horror novels, like Dennis Wheatley's, all of the protagonists were frightfully serious (and mostly upper-class) whereas Harry is a chancer and a fraud. But the truth in his character is that he reacts to fear with nervous laughter—which is a response that everybody recognizes.

MM: I have a couple questions regarding Harry Erskine. Tony Curtis played him in the 1978 film. Mr. Curtis was considerably older than your character in the book. Did that bother you? If you could have chosen any actor to play Harry, whom would you choose?

MASTERTON: I wasn't at all bothered by Tony Curtis playing Harry Erskine. In fact he was just about as close to how I imagined Harry as anybody could be. I can't think of any other actor who could play him as well as that, except perhaps Bruce Willis.

MM: Harry was in all three of The Manitou novels— *The Manitou, Revenge of the Manitou* and *Burial*. He was also in the non-Manitou book *The Djinn*. Do you think you'll ever write another novel with Harry in it?

MASTERTON: Twenty-five years have passed and Harry is very much older now. I may bring him back but you have to understand that I am also 25 years older and I am looking for new challenges in my work.

Michael McCarty

My most recent novels *Trauma, A Terrible Beauty* and *Unspeakable* are all much more realistic, although there is still an unsettling hint of the supernatural in them. These days, I am more interested in creating characters who suspect that the supernatural may be true, and that it is threatening them and affecting their lives, rather than saying—right, here's Misquamacus, returned from the dead, and here's a demon who's taken on flesh. I am working on a little more psychological fear than I used to. Having said that, I tell a complete lie, because I have just finished *The Devil in Gray* which is an out-and-out horror novel rooted in the American Civil War and that has more demons than you can shake a stick at.

MM: *The Manitou, Dreams in the Witch House, Wells of Hell* and *Prey* all featured characters inspired by H.P. Lovecraft's creations. What is it about Lovecraft that you keep returning to him for the source of inspiration?

MASTERTON: What first attracted me to H.P. Lovecraft was that all his mythology was completely American, free of Old World Satanism and Eastern mythology. Since my earlier novels were written entirely for the US market, I was looking for a tone of voice that Americans would find familiar and I found it in good old H.P.

MM: Did living in Ireland prove fertile material for your horror books?

MASTERTON: Ireland is not a quiet, restful, atmospheric country to live in. Its deep sense of history, ancient and recent events, were very inspirational.

The first novel I wrote in Ireland was *A Terrible Beauty* (the title borrowed from W.B. Yeats) and that concerned the Irish demoness Mor-Rioghain, and the fight by a woman detective from An Garda Siochana to track her down. This gave me a tremendous opportunity to contrast old Celtic legend with modern Irish politics, and I was very pleased with the result, although some people have found the novel rather too bleak. I have written other stories set in Ireland (notably "The Irish Question") and I have plans for further novels with an Irish background. There is still much in the Irish psyche to be explored!

MM: Is there a difference between American and English ghost stories?

MASTERTON: Yes, in the English stories the ghosts are frightfully polite.

MM: Last words?

MASTERTON: It is difficult to predict where horror writing is taking us, since the horrors of the real world are becoming more immediate to all of us. In *Burial*, for example, I imagined New York skyscrapers collapsing into the ground, brought down by Native American magic. But what I didn't foresee was that America's enemies would use her own technology against her, instead of ancient wizardry. Terrorists have learned the lesson that *The Manitou* taught, and now they are using the Unitrak computer instead of the Great Old One. The genie has been let out of the bottle, and the bottle can never be re-stoppered. How horror writers will tackle this will remain to be seen. I think we will have to become therapists rather than

Michael McCarty

scaremongers—explaining terror rather than trying to incite it.

"To aspiring writers I have the same thing to say that Ray Bradbury has said for years. It's nice to have encouragement. Ray was very encouraging to me at the beginning. But, fundamentally, writing classes, writing seminars, can be a waste of time. If you want to be a writer, you've just got to sit down by yourself in a quiet room."

—Richard Matheson

I AM LEGEND

RICHARD MATHESON

RICHARD MATHESON IS a legend in the speculative fiction field. He has been called "one of the most important writers of the 20th century" by Ray Bradbury, and his work has inspired the giants of the genre such as Stephen King, who sites Matheson as "the author who influenced me most as a writer." Dean Koontz adds, "We're all a lot richer to have Richard Matheson." And for over sixty years, he's created magic on the page and silver screen.

Many of his classic novels have been turned into major motion pictures: *I Am Legend* (filmed three

times, as *The Last Man On Earth, The Omega Man* and *I Am Legend*), *Bid Time Return* (filmed as *Somewhere in Time*), *What Dreams May Come, A Stir of Echoes, The Shrinking Man* (filmed as *The Incredible Shrinking Man*), *Hell House* (filmed as *The Legend of Hell House*). His short stories "Button, Button" was turned into *The Box* and "Steel" was filmed as *Real Steel*.

He also wrote the scripts for some of the most memorable episodes of *The Twilight Zone, Star Trek, Amazing Stories, Masters of Horror* and *Night Gallery*. His screenplays for television include *The Night Stalker, The Night Strangler, Dracula, Dead of Night, Duel, Trilogy of Terror* and *Trilogy of Terror 2*.

With a career spanning over six decades, Matheson has won numerable prestigious awards including the World Fantasy Award and Bram Stoker's Life Achievement Award, the Hugo, the Edgar Allan Poe Award, The Golden Spur, and the Writer's Guild Award. In 2010 he was inducted into the Science Fiction Hall of Fame.

Gauntlet Press has been publishing several of his books recently, including Richard Matheson's *Nightmare at 20,000 Feet,* and *Richard Matheson's Kolchak Scripts*. This is a collection of all three screenplays he wrote for TV movies ("The Night Killers" was co-written with William F. Nolan) and *Matheson's Uncollected Volume 2*. For more information go to www.gauntletpress.com.

Matheson was also the subject of the books *The Richard Matheson Companion* edited by Stanley Wiater, Matthew R. Bradley and Paul Stuve, and the

anthology *He Is Legend: An Anthology Celebrating Richard Matheson* edited by Christopher Conlon, which won the Bram Stoker Award for Best Anthology of 2010.

Richard Matheson passed away on June 25th, 2013 at the age of 87.

MICHAEL McCARTY: When you were writing *I Am Legend*, did you imagine it would still be popular five decades later? What do you think contributes to the novel's longevity?

RICHARD MATHESON: No, I never dreamed it would do that. If it is attributable to anything, it would be because it's a good story. It's an interesting story. It's an approach to vampires that wasn't taken before. Actually, although most people doubt it—I think it is the only genuine science-fiction book I have written. I base the book on psychology and physical facts—that are actually so. It seems to make sense to me.

MM: Is the title *I Am Legend* a Biblical reference to Legion in the Book of Mark: "I am legion?"

MATHESON: No, I just made it up. Sometimes when they review it, they call it *I Am A Legend* which destroys the rhythm of it.

MM: Is there a third movie still being made? (Author's note, the third movie was made, called *I Am Legend*, starring Will Smith).

MATHESON: They keep talking about it. One night I ran across *Night of the Living Dead,* and thought, "Oh you son of a gun—you." I was working on a story idea

that I had for him when he (George Romero) met me. He backed off, holding his arms up for protection and said, "It never made any money."

I don't know what's the point of making the movie. They never made it the way it should have been made. They just keep getting further away each time.

Some guy wrote a script, it was a good script, but it was totally removed from my book. I don't think there will be any vampires anymore. Not from my book anymore.

MM: In the summer of 1950, when you were 23 years old, your story "Born of Man and Woman" appeared in the third issue of *The Magazine of Fantasy & Science Fiction* and two years after *I Am Legend* was published. *The Incredible Shrinking Man*, which was a screenplay by you, based on your book *The Shrinking Man*, hit the silver screen. Was that an exciting time for you? In a period of six years you went from a short story to a movie.

MATHESON: I wanted to call the movie *The Shrinking Man* to have some kind of a metaphor, but they changed that. I was disappointed with the film for many years. I began to appreciate it more and realize it was very unusual for its time.

MM: Several of your novels have been adapted to the silver screen since *The Incredible Shrinking Man*. What are some of your favorite movies based on your work?

MATHESON: I liked *The Comedy of Terrors*, that Jacques Tourneur directed for American International Pictures. It had the grand old timers in it—(Vincent)

Price, (Boris) Karloff, (Peter) Lorre, (Basil) Rathbone and Joyce Jameson. I liked that very much. *Somewhere in Time*, of course—that turned out very satisfying.

Most of my satisfying films were on television. There was *Duel*, (Steven) Spielberg's first film. There was *The Night Stalker, The Night Stranger*. There was *The Morning After* with Dick Van Dyke about alcoholism—which I think is a marvelous piece of work. There was *The Dreamer of Oz* about the writing of the *Wizard of Oz;* John Ritter played (L.) Frank Baum. There's *Dying Room Only*—I said this many times—it's the only film I ever had that got better than it deserved.

MM: Are there any other Richard Matheson books that Hollywood is currently interested in?

MATHESON: Spielberg is supposed to be reading a screenplay that I wrote from my last novel, which was published last year, which they called *Hunted Past Reason*—which I wanted to call *To Live*. I don't know why they changed it. That is the first time a publisher has done that to me. I called the screenplay *To Live*.

MM: *Richard Matheson's Kolchak Scripts* from Gauntlet Press had three of your TV movie scripts: *The Night Stalker, The Night Strangler* and *The Night Killers* (which you co-wrote with William F. Nolan). *The Night Killers* was never filmed. What can you tell us about that script?

MATHESON: The main reason it wasn't filmed was because Dan Curtis and Darren McGavin had become alienated—so that killed it right there. They were also

in the works for setting up the *Kolchak: The Night Stalker* series. They didn't want to do another TV movie; it was too bad. It had an idea, for its time, that was very unique, but it has become terribly hackneyed as the years went by—which is the idea of famous political figures being replaced by androids. It was a new idea at the time and it was very funny. It takes place in Hawaii.

MM: *The Night Stalker,* when it aired January 11, 1972, had over 75 million viewers, making it one of the highest rated TV movies of its time. Did that surprise you? That the show would be so popular?

MATHESON: Sure, but it surprised everybody. It was very well done. But I don't think anybody expected that.

MM: Over the years there have been a lot of comparisons between *Kolchak* and *The X-Files*. What are your thoughts on the subject?

MATHESON: Chris Carter has admitted openly that his series was inspired by *Kolchak*. He even had a Senator Richard Matheson as a character in one of the shows. He was the one Senator who sympathized with the *X-Files* program.

Chris Carter has agreed to write an introduction for *Richard Matheson's Kolchak Scripts*.

MM: You worked with Dan Curtis on several projects. Why do you think you guys work so well together?

MATHESON: He liked my writing very much. We got along. Although he has a temper, he never showed it

to me or Bill Nolan, who has also worked with him. Dan has an excellent sense of humor—which tapered off any kind of tense moment there might be. He has a very good story sense. He is very willing to communicate with you. He is also a marvelous director.

MM: What is the most perfect Richard Matheson book you have written?

MATHESON: *Bid Time Return* filmed as *Somewhere in Time*. It's probably the best written book that I have ever done. *What Dreams May Come* is the most telling, the most important—if you want to call it that. Those are in the later series of books.

I'd also put *I Am Legend*, *The Shrinking Man* and *Hunted Past Reason*.

MM: Was *Abu and the 7 Marvels* fun to write?

MATHESON: Yes. It just won the Benjamin Franklin Award for the best published Child's Book of the Year. As much to Barry Hoffman's and Bill Stout's credit as to mine.

MM: Wasn't William F. Nolan originally involved with *Abu and the 7 Marvels*?

MATHESON: The title page, when I submitted it, said: "novel by Richard Matheson, story by Richard Matheson and William F. Nolan." If the book goes into a second printing, publisher Barry Hoffman promised this would go on the title page.

MM: You lived and wrote for the most part of the 20th century and now we are in the 21st century. What do

you think are humanity's prospects in the 21st century? How do you see the world heading along from here?

MATHESON: I put together a book called *The Path*. It included all the quotations of the man who I regarded as one of the most important metaphysicians of the 20th century, named Harold Percival. I wrote in the introduction that I felt the last decade of the 20th century was the most important in the history of mankind. Man had to come to the realization of what he really is and what he represents in life, or things were going to go really bad. Things are going really bad.

MM: You have written in an astounding variety of genres, yet you are renowned for your science fiction and horror. What is it that science fiction and horror does that mainstream literature can't do?

MATHESON: A straight-line novel is more demanding. The films now are mostly based on comic books. There are some wonderful adult movies being made, but they all are being made by independents, which usually only make a few dollars before disappearing.

The genre appeals to younger fans where there is not that audience for straight novels.

MM: You expanded a quartet of Edgar Allan Poe's work for Roger Corman/American International Pictures. How was it writing adaptations of Poe for the silver screen?

MATHESON: The first, *The House of Usher* came

closest to the story, but even that had to be expanded. As it went on, the deviation became more extreme all the time. Finally, I got tired of writing about people being buried alive. I had to make a joke out of it, which was *The Comedy of Terrors*. *The Raven*, supposedly based on a poem by Edgar Allan Poe—was rather far removed. "The Pit and the Pendulum" which was a very short story about a guy on a torture table during the Spanish Inquisition, and "The Raven" is just a poem. I had to make those into full length films—it absolutely required that I make up a story.

MM: You have a very talented family.

MATHESON: Yes. Richard has a script now that is going to be made into a pilot film for Showtime and they just signed Frank Pierson to direct it. It's about an evangelical family. They are going to shoot it in Utah this summer. It is an absolutely brilliant script called *Paradise*.

My daughter Ali and her husband are also very successful writers. They live in Vancouver, Canada. They sold a pilot which is going to be shot this summer. Originally they had a commitment for eighty-eight hour-films. Now, sensibly it's down to twenty-two.

My son Christian is also an excellent writer, who, along with his (former and now again) partner (Ed) Solomon (who wrote *Men in Black*) wrote the Bill & Ted films together. He's now working on a musical about Joseph Smith, the founder of the Mormons. Martha Davis, from The Motels, has written songs for it. He has also written a marvelous script called *Wallace in Wonderland*.

They are all very, very talented.

MM: Do you have any anecdotes about your friend William F. Nolan you would care to share?

MATHESON: I have known Bill for fifty years. He was in the original California group of Charles Beaumont, Ray Russell, Ray Bradbury, George Clayton Johnson and myself. Bill is very inventive, he has written very interesting stories and books, and he has a major study about Dashiell Hammett, which he is just finishing up for some major publisher. He's written a lot of non-fiction books, which he is really good at. He worked for Dan Curtis on a number of projects, including *The Turn of the Screw*, and *The Norliss Tapes*.

He's a great artist, as well. When I first met him, I used to go over to his house. He studied at an art institute for a long time and has some beautiful oil paintings. Whenever he writes me a note, he'll dash off a little cartoon, which is just marvelous. Ray Bradbury and William Stout are also great at that.

Art talent is something completely out of my world. I admire it, but I can't do it.

MM: Any advice to beginning writers?

MATHESON: To aspiring writers I have the same thing to say that Ray Bradbury has said for years. It's nice to have encouragement. Ray was very encouraging to me at the beginning. But, fundamentally, writing classes, writing seminars, can be a waste of time. If you want to be a writer, you've just got to sit down by yourself in a quiet room (or some writers, like my son Richard, put on music to do it with—I could never do that) and you just have to write.

Bradbury says, "God bless you, you write fifty-two stories a year." You'll certainly be a much better writer than you were at the beginning of the year. You can be inspired by various writers; we were all inspired by Bradbury at the beginning, we were all pseudo-Bradburys. But we all evolved our own styles. But that is what it all comes down to: writing, writing, writing. It's the only way.

"The first thing I see is the theater marquee: "AFI Dallas and Texas Frightmare 2008 Present George Romero and Night of the Living Dead." There are people in full zombie costumes and camera crews and security everywhere. The show doesn't start for another two hours and already the parking lot outside The Landmark is a zoo. People are lining up to catch a glimpse of the huge turnout of Romero's celebrity friends, among them Tom Savini, Malcolm McDowell, Dee Wallace Stone, John Russo and Bill Hinzman."

—Joe McKinney

APOCALYPSE OF THE DEAD

JOE MCKINNEY

By Michael McCarty & Holly Zaldivar

JOE MCKINNEY IS a Patrol Supervisor for the San Antonio Police Department who has held a number of positions, including homicide detective, as well as helped run the 9-1-1 Center for the SAPD. When he's

194

not busy doing police business, he spends his time writing in the genres of horror, science fiction and mystery. The author of such work as *Dead City, Quarantined, Apocalypse of the Dead, Flesh Eaters, Lost Girl of the Lake* (co-written with Michael McCarty), *The Savage Dead, Inheritance, Mutated, Dog Days, Crooked House, The Plague of the Dead* and many more.

Joe currently lives and works in the San Antonio area with his wife, two daughters and two cats. His website is at http://joemckinney.wordpress.com

MICHAEL McCARTY: *Inheritance* is a very unusual novel for you, considering your other works. Its haunting development seems more personal in nature, and the distance between you and Paul feels particularly close. How does this novel affect you? Do you feel a closer connection to Paul and all he goes through than some of your other novels?

JOE McKINNEY: This may be a function of the time it took to write the book, rather any sort of autobiography. Some of Paul's adventures on the job are based on mine. His first car chase, for instance, getting pelted with paper balls his first day at his new substation, and his deep and abiding love for the Texas Hill Country. Also, a lot of the characters he works with are drawn from officers I have known over the years. But for the most part Paul is definitely not autobiographical. I'm glad he comes across as so close to me, though. That's actually more gratifying than you know.

MM: You take the zombie concept in a completely

different direction in your novel, *The Savage Dead*. What's the underlying motivation for this novel? Is it going to become a series?

McKINNEY: It will be a series, yes! In fact, I've already written the précis for the next three books. Kensington is interested, so we will see those coming out in the next few years.

I wasn't thinking about a series when I wrote *The Savage Dead* (funny, but that's how my first series got started!). My initial desire was to write a zombie apocalypse that nobody believed actually happened. I wanted to piece together a sort of epistolary narrative of first hand survivor accounts, military after action reports, emails, and book excerpts, much like the narrative format Stephen King used for *Carrie*. My thought was I could have a zombie outbreak on a cruise ship, and the cruise ship would eventually crash into the ports at Cozumel, exploding in a huge fireball that destroys all evidence of the zombie outbreak. Once eyewitness accounts of survivors starts to leak out, they'd be dismissed as idiots or gold diggers. Fortunately, that original idea proved less than satisfying in the initial telling, so I decided to turn back to one of my long time interests, the history and cultural traditions of the Texas-Mexico border. Obviously the drug cartels are a big deal in that area, and it occurred to me that once the cartels started borrowing strategies from the terrorists of the Middle East, the War on Drugs would go to a whole new level. Once I started thinking of the cartels as terrorists, the rest of the story sort of came together in a flood.

MM: I know you've asked this question of other

authors, but I'd like to hear your answer. The best and most effective horror is trying to investigate what we think of ourselves and what it means to be us. Washington Irving's tales, for example, generally wrestle with the question of what it means to be an American in the post-Revolutionary War period. Nathanial Hawthorne battled with the intellectual promise of a nation rising to international credibility while simultaneously choking under the yoke of a Puritan past. Stephen King made a name for himself chronicling the slow collapse of the American small town way of life. What do you think the zombie and its current popularity is telling us about ourselves?

McKINNEY: Gosh, now that I'm staring that question in the face I think I need to go back and apologize to all the authors I've asked it to! Okay, well, I'll give it a go. I have heard from a few other writers I admire that the zombie is a manifestation of our self-loathing, that we are so disgusted with ourselves as a society that we not only want to turn everyone around us into a miserable wreck, in our survivalist fantasies we take it a step further by shooting the faces off of those same miserable wrecks. However, I don't buy that. I do think our world is in the process of rattling itself apart, and many of us go through our day to day lives feeling like we're one slippery step away from everything crashing down to the ground. But I am at heart an optimist, and I believe that survival horror is ultimately a genre of hope. I know that may seem strange at first blush, but it shouldn't be.

Consider this: the zombie is the first modern monster. We've had plenty of revenants in literature,

from the Epic of Gilgamesh to the Bible to the ghost stories of the early Gothic novels to Frankenstein's creature. That's nothing new. But if you look back on all our past revenants, they've all been single entities. In your average ghost story, there's just the one ghost. Dracula has his brides, but again, he carries most of the narrative as the sole revenant. The creature asked Victor Frankenstein for a bride, but there again, he was the only living dead dude in the book. The zombie is different, because there isn't just the one zombie. There are hundreds, or thousands, or even billions, and they just keep coming. I think, ultimately, that endless tide of the dead is a metaphor for the cyclical nature of our lives and our jobs. There's something entertainingly familiar about spending all weekend playing first person zombie shooter games, then going into work on Monday morning and plowing through all the emails and files and voicemails that stacked up from the week before. I think that's what the zombie, and by extension, the survival horror genre, is telling us about ourselves. We are looking for hope amid all the clutter that piles up in our lives, and we're willing to fight our way out of it if necessary. In the zombie, I think, we've simply put a face on all the intangible troubles we face day to day so we can in turn blow those troubles away.

MM: What do you think begins the zombie apocalypse? What causes people to turn into zombies in the first place and why does this occur?

McKINNEY: If I had to guess as to how the zombie apocalypse would start, I'd narrow it down to two general scenarios. The first I've kind of explored

already in my Dead World series. The zombies would be living people inflicted with some kind of disease. We hear every day about some rare bacteria or worm or whatever that turns ants into zombies and all that. It's not too much of a stretch to imagine some new bug doing the same to us. The other approach is, I think, far more likely, and that is the out of control mob. Look at the protests in Syria and Greece, the riots in Rio de Janeiro, the hideous cost of tribal warfare in the Sudan and Eastern Africa, even the scourge of ISIL across the Middle East. People in crowds, caught up in mob violence, behave with a mindless cruelty unequaled by any of the zombie books I've read. You ask me, that's how it will begin.

MM: How much of the zombie behavior in *Dead City* was mapped out in advance? Did you establish what behaviors zombies could and could not do? Do you have an example of this?

McKINNEY: Pretty much all of it, actually. One of the critiques I heard after the book had been out for a few months was that the zombies were supposed to be living people infected with a disease, yet there were scenes of zombies walking around with their intestines hanging out and a bunch of other hideous stuff. People seemed to think that wasn't possible. Well, in my day job I'm a cop for the San Antonio Police Department, and over the last two decades I've seen some pretty crazy stuff. I once carried on a conversation with a man who was holding his intestines in his lap. The man wasn't very lucid, but he was talking. The human body can take a tremendous amount of punishment and still keep moving. I definitely took advantage of that in the book.

One of the other characteristics of the zombies in my book is their strange ability to mass on a survivor seemingly out of the blue. This is another characteristic I borrowed from my police experience. I've been on a quiet street in the middle of the night, chasing a burglar on foot through the dark. As soon as you tackle that burglar though, you can guarantee that within two minutes the street will be filled with people looking to catch the free show. Happens all the time.

MM: Do you have more of a sense of humor than your readers might realize?

McKINNEY: Absolutely! I love stupid jokes. I recently took my kids to see an exhibit about all the gross things that go on inside the human body. They had a machine there that made different kinds of fart noises. I must have laughed for thirty minutes. Laughed so hard my sides hurt.

MM: With each successive zombie novel, the female characters seem more active. For example Emergency Ops sergeant Eleanor Norton in *Flesh Eaters* and Kyra in *Apocalypse of the Dead*. Was that a conscious decision, or just the way it worked out?

McKINNEY: Thank you! I wish I could say it was a conscious decision, and maybe it was, to some small degree, but for the most part writing about strong women characters has just become something I like to do. Somehow they seem to belong in the stories I write. I'm actually reminded of Lily Harris, the female lead and narrator from my second novel, *Quarantined*. Stephen King wrote something once that I'm going to have to paraphrase here because I can't remember it

word for word. He said something like: "For every writer, and hopefully it comes early in their career, there is a moment when they have to make the choice to write what they are comfortable with, or take a chance and do something way beyond what they think they're capable of." For me, that moment came with *Quarantined*. I knew I could write about cops. Being one, I could do that all day long. But at the same time I was wondering about my craft and where I could take it. I decided that I wanted to try to write a novel from a woman's point of view. Now I know a lot of female cops, and over the years I've watched policing grow more and more comfortable with women cops. But that wasn't always the case. When I first started out, most of the women I worked with had to contend with a lot of sexist crap, not only from the men they worked with, but from the public they served. I remember these two female officers I worked with in my early days. Both women were petite, maybe a hundred ten pounds apiece, with all their gear on. One night the two of them are fighting this enormous drunk guy in his front yard, and he's throwing them all over the place. Well, a little old lady from across the street comes running up and says, "Don't worry! I called the real cops!" But it wasn't just that stuff they had to go through. The big ones, the not so attractive ones, surely they were bull dykes. And the pretty ones, surely they got their cushy desk jobs by spending a little time under the captain's desk. For years I watched a lot of talented female police officers endure that vitriol and abuse, and still hold their head high when they showed up to work each day. It made me proud to see, and when I sat down to write Lily Harris, I channeled the

pain and indignation of those friends of mine who had to live it. Not only did I get the satisfaction of articulating the quietly heroic struggle so many women have made to improve my beloved profession, but I felt like I learned a great deal about the craft of writing. Thinking like a girl made me a better writer. And it gave me the confidence to push my craft a little further with each new book.

MM: Where do you see mankind being one hundred years after the zombie apocalypse?

McKINNEY: Still in the process of rebuilding. I can see a lot of isolated settlements, perhaps with the ability to talk with one another remotely, perhaps not, but still isolated by many miles and the reality that long distance travel is a daunting proposition without planes, trains and automobiles. I've actually been really fascinated by this question of late. In fact, my next novel, *Plague of the Dead*, is set thirty years after the zombie apocalypse. I follow the adventures of an expedition sent out from a colony that has not only survived, but thrived, and now finds it necessary to expand beyond their walls. In my vision of a post-zombie world, the zoos have been emptied into the rural heartland of America. Elephants once again roam the American prairies. Big cats hunt in the tall grass and swamps of Louisiana and East Texas. Giant snakes roam the Florida peninsula and feed on alligators and deer. In general, it's an ecological disaster of nature run amok and cities crumbling into oblivion.

MM: What process do you go through when writing a novel? How does the idea come to you? How do you

prepare to write it? How long does it usually take you to write a novel?

McKINNEY: I wish I could tell you how the idea comes to me, because then I could go do that—whatever that was—a little every day. The truth is, ideas come from everywhere. Sometimes they come from reading the works of others; sometimes from the things I see and experience; other times from some random lightning strike out of a clear blue sky. The truth is I just don't know. But once I get that idea, I tend to sit on it and let it age a bit. I mull it over, consider it, start to think it's stupid, then suddenly love it again. It can go through half a dozen rocky false starts before it ever turns into something I want to write about. But once we get there, I usually spend about two months drafting out the story in outline form. I outline everything I do, and sometimes my outlines for novels will run seventy to ninety pages. By the time I'm ready to start writing I've been through the story enough that I could write chapter five today, chapter thirteen the day after that, and then come back to chapter seven on the third day. That doesn't work for everybody, but it works for me, and in the end, whatever gets the novel written is the right way to do it.

MM: Have you read either *Apocalypse Cow* by Michael Logan or *World War Z: An Oral History of the Zombie Wars* by Max Brooks? If so, do you have any thoughts on the books?

McKINNEY: I've read both of those and loved them. *Apocalypse Cow* made me laugh. Excellent book, and very intelligently written. But I can't let it eclipse

WWZ, which is probably my favorite zombie novel ever written. I can't tell you how many times somebody has told me they loved the movie and then asked if they thought they should read the book, only to be greeted with a long sigh from me, and an apology for the harangue they are about to endure. That book, and especially the story about the female supply plane pilot who crashes in the Louisiana swamps, represents a high water mark in zombie fiction.

MM: What started you writing *Quarantined?*

McKINNEY: Well, stories of towns and cities getting cut off from the rest of the world by some sort of huge catastrophe or malevolent force are nothing new. Writers have been cranking them out for years. It seems we get a crop of these stories whenever our collective sense of paranoia reaches a zenith. In 2009 we've had my novel *Quarantined*, Stephen King's *Under the Dome*, Brian Keene's *Darkness on the Edge of Town* and Jonathan Lethem's *Chronic City*. My guess is that we are all plugged into a vague feeling of discontent with the world. We look for ways to cut the dangerous, the ridiculous, the frustrating, out of our lives, and in the process we dream up these insular worlds where the nightmare remains outside, which only ends up corrupting the world inside. Maybe there's some sort of archetypal structure involved here. Maybe it's nothing more than a pressure cooker, meant to show that, deep down where it counts, we're simply not capable of playing nice together. But whatever it is, every one of these stories plays off the paranoia and fear and exhaustion that come with living inside quarantine. The set-up is different, but the struggles on the inside are the same.

But you asked why I started writing *Quarantined*. Well, the birth of the story was in a quote by George W. Bush. He was on the news, discussing viable options for dealing with a pandemic flu outbreak, and he made the offhand comment that we might want to consider the possibility of a military quarantine around a major population center as a way of nipping the problem in the bud. Now, my professional training as a San Antonio police officer is in disaster mitigation, and one of the specific disasters we trained for—but thankfully never had to implement—was what to do in a pandemic flu outbreak. This is an issue I happen to know an awful a lot about. When I heard Bush make that remark, the disaster mitigation specialist in me thought, "Oh my God, that's horrible!" At the same time, the horror writer in me was thinking, "Oh my God, that's horrible!" The book's apocalyptic images, such as the mass burial sites and the riots and the insipient starvation, all came from the initial horror at Bush's comments.

MM: How long did it take you to get your first novel *Dead City* published?

McKINNEY: *Dead City* was kind of a fluke. A lucky fluke . . . but a fluke nonetheless. I had been writing quite a bit before then, but never with the intent to publish anything. I just wrote stories for fun. I'd scribble them down on a notebook paper, staple them together, and then they'd sit on the corner of my desk for a week or two before going into the trash. I have no idea how many of those stories are currently being read by landfill rats, but the number is probably high.
Anyway, I decided to write a novel, and when it was

done, I thought it was actually pretty good. I typed it up and sent it off to five or six publishers and got politely worded rejection form letters. But I knew it was a good story, despite the rejections. So I sent off a few queries to agents and found one who was interested. He sold it in less than a week to Kensington, who, humorously enough, was one of the publishers that initially rejected the manuscript.

Another interesting thing about the book was the cause of the zombie outbreak. In *Dead City*, I swamped the city of Houston, Texas, beneath the tidal surge of a hurricane. The flooded streets were filled with dead bodies and chemicals from Houston's many refineries and that nasty soup cooked in the Texas summer fun for a few days, eventually giving rise to the necrosis filovirus, which turns people into zombies. The evacuation of Houston and the surrounding area brought some of the infected survivors to San Antonio, where *Dead City* takes place. What to do with the evacuees from a major coastal city after a hurricane was another of the disasters I trained for as a San Antonio police officer, and a good deal of the set-up for *Dead City* came from that training.

Keep in mind, that was early August, 2005. Well, as the editorial process got underway, my editor at Kensington contacted me and said that he really liked the story, but that he wasn't completely sold on the whole hurricane thing. I figured, "Whatever."

He's from New York City. What does he know about hurricanes? And then, on August 23, 2005, Hurricane Katrina hit. My editor called me. I could hear the TV blaring in the background on his end of the phone. He said, "Are you watching this shit on TV?

Oh my God. We're doing *Dead City* as is." It was a strange experience, definitely.

MM: If you could be a monster, what would you be?

McKINNEY: Wow, that's a hard one. A werewolf, probably. You get to run full speed all night long. You get to hunt. You get to rip things to shreds. And in the morning, all you have to do is find your clothes. It's kind of like college.

MM: In *Lost Girl of the Lake*, co-written by me (and published by Bad Moon Books), the protagonist goes skinny-dipping. Is this something you have also partaken in?

McKINNEY: (Laughs) I can't answer that, my mother is going to read this book.

MM: Have you seen a lot of zombie movies?

McKINNEY: I have seen every zombie movie ever made. I love 'em. Even the bad ones. But when they're done right, zombie movies are simply the best. *Shaun of the Dead*, for example, was a work of genius.

MM: You had a close encounter with the cast of the original *Night of the Living Dead*. Tell us about that experience.

McKINNEY: I have a good friend named Matt Staggs, and Matt used to have this online magazine called *Skullring*. Sometimes I would do a little writing for it. Well, one day I get this call from Matt and he says, "Joe, George Romero and almost the entire original cast of *Night of the Living Dead* are going to be in Dallas for the 40th Anniversary of what is, arguably, the

greatest zombie movie ever made—if not one of the greatest horror movies ever made. Period. What do you think? Would you like to go cover the movie's premiere for *Skullring*?"

Now, I love zombies. Hell, I love this movie. In fact, I blame *Night of the Living Dead* for starting me on my love affair with horror. For some folk it's ghosts, or werewolves, or vampires. For me, it's zombies. So I'm standing there in my kitchen, the phone next to my ear and Matt is going, "Joe? Joe, you there?" and I'm thinking that Christmas has just come early to the McKinney household. I tell Matt, "Well, let me see here. It's going to take me about twenty seconds to pack, another five hours to get there. I can call the wife on the way and tell her I won't be coming home for a while. Yeah, sounds great! I'm on the way!"

Needless to say, I'm excited when the weekend finally arrives. I show up in Dallas earlier in the day and check into my hotel room. I get my camera and my notebook and voice recorder and I set out for the beautifully restored Landmark Inwood Theater in Dallas' Arts District.

The first thing I see is the theater marquee: "AFI Dallas and Texas Frightmare 2008 Present George Romero and *Night of the Living Dead*." There are people in full zombie costumes and camera crews and security everywhere. The show doesn't start for another two hours and already the parking lot outside The Landmark is a zoo. People are lining up to catch a glimpse of the huge turnout of Romero's celebrity friends, among them Tom Savini, Malcolm McDowell, Dee Wallace Stone, John Russo and Bill Hinzman. Ordinarily, I'd be stuck out with the groundlings

waiting in the cold to catch a glimpse myself, but Matt Staggs has pulled an ace out of his sleeve and handed it to me. He has secured a spot on the red carpet. Not only will I be able to meet and greet the celebs as they make their way into the theater, but I will also be attending the exclusive premiere, the question and answer session afterwards, and the restricted-access after-party. I think to myself, "Matt, you rock!"

So there I am, on the red carpet, camera ready, leaning over the ropes in anticipation, and I wait. There's an old newspaperman standing next to me. He's dressed for the cold night air. I'm not. I look at his camera. It's a big, fancy digital camera. Mine is a little P.O.S. my wife won at her work's annual Christmas party. I look around. Every journalist in the place has got some variety of big fancy digital camera. I frown at my camera. I turn to the old newspaperman next to me and say, "I think I've got camera envy."

He laughs. He says, "Don't sweat it. Just keep the camera warm so your battery doesn't crap out on you."

I frown at my camera again. I didn't know camera batteries did that when they got cold.

He says, "I'm John."

"Joe," I tell him, and we shake hands.

"Who are you with, Joe?"

"*Skullring*," I tell him. "We cover all things horror and then some. And you?"

"*Dallas Morning News*," he says. He could have added something like, "We cover all things. Period." But he doesn't. He's not snooty about it at all. If anything, he's got this faraway look in his eyes, like he's looking a long ways back into his past. He says, "I

first saw this movie when I was seventeen. It was in a drive-in in Waco, Texas. I'll never forget it."

"It made an impression?" I ask.

"Well, yeah," he says. "The movie was pretty good, I guess. But what I remember is that it scared Mindy Watson so badly she finally agreed to climb into the backseat with me and let me get a hand under her bra."

We talk for a good while after that as we wait on the celebs to make an appearance. John tells me what it was like, watching *Night of the Living Dead* back in 1968. He says there had never been anything like it. Sure, there were monster movies, but there had never been anything like all those zombies lumbering out of the dark, dragging the torn and rendered remains of their victims, munching on femurs. "And that little girl at the end, eating her parents down in the basement." He trails off there with a shudder.

And then that little girl from the movie, an all-grown-up-now Kyra Schon, makes her way down the red carpet. Kyra Schon is a radiant, beautiful woman these days.

I watched the 40th anniversary of *Night of the Living Dead*. I enjoyed it immensely, because the movie really has stood the test of time with its mature treatments of racial inequalities and paranoia. Instead of appreciating the movie solely as a creature feature, I found myself appreciating the film's other dimensions. During the question and answer period that followed the film, George Romero said that the obvious racial themes in the movie were strictly an accident. That sounds like a load of hogwash if you asked me. You've got a young angry black man fighting for control of a house already occupied by a middle-aged white guy and his family. Meanwhile, there's this

210

ring of paranoia constantly closing ranks around the house. How much more do you need to realize *Night* is an allegory of racial relations in 1960s America? I mean, come on. *Night of the Living Dead* was recently honored by the Library of Congress as one of the hundred most important films of the 20th century. That's a big honor. And well deserved, too. But I can tell you it didn't get there just because it was gorier than anything else before it. It got there because it told us something about the way we were in 1968, and continue to be today.

MM: What inspired *Apocalypse of the Dead?*

McKINNEY: *Apocalypse of the Dead* is the sequel to *Dead City*. When I first came up with the idea for *Dead City*, I thought it would be great to do it as a series. *Dead City*, after all, sets up a lot of interesting locations and situations (such as the flooded city of Houston, the military that ends up quarantining most of the Gulf Coast, the financially crippled United States with the bread-basket of its domestic oil and gas and chemical industry underwater, etc.). At the same time I've always hated books that exist solely to form links in a larger story arc. So, as a result, I wrote each book in the *Dead City* series as a stand-alone novel. They are tied together by the same world, the same characters, etc, but each stands alone. With *Apocalypse of the Dead* I wanted to take the devastation the Gulf Coast experienced in *Dead City* and make it global. So, that's what we've got here. The quarantine around the Gulf Coast has collapsed, the zombies have broken out, and the rest of the world just became a zombie buffet table.

Kensington's behind the series in a big way. They're re-releasing *Dead City*, and that should be coming out at the same time as *Apocalypse of the Dead*. Both will have large print runs, a big marketing campaign, and I'll be doing a book tour along with the release. It should be an exciting year.

MM: Last words?

McKINNEY: I started getting invited to conventions back in 2007, the year after my first novel, *Dead City*, came out. And even back then people were asking when I thought the bottom was going to fall out of the whole zombie craze. Well, here we are, all these years later, and we're still as zombie crazy as always. The word Zombie has even wormed its way into our language in a way that has legitimized it and bound it to us at the molecular level. We are now stuck with zombies. I won't always be writing about them, but they'll always be with me, and they'll always be ready to flood out of my head again.

"I think it's all about tension and recognizing the absurd. Laughter is a way of relieving tension, and being in a horrifying situation can certainly be fraught with tension, but there's also the recognition of just how absurd it is, for example, to be trapped inside a shopping mall by a bunch of brain-eating animated corpses. You have to laugh."
—Christopher Moore

LAUGHING ALL THE WAY TO THE BLOOD BANK

CHRISTOPHER MOORE

RAISED ON THE works of Ray Bradbury, Richard Matheson, Kurt Vonnegut, Bram Stoker and John Steinbeck, the San Francisco comic horror writer Christopher Moore has been selling international and New York Times bestsellers. Besides getting rave reviews, he has established a loyal cult following.

After reading Douglas Adams' *A Hitchhiker's Guide to the Galaxy*, Moore figured he could do the

same thing Adams did, but instead of science fiction and satire, he would mix horror and dark fantasy with zonked-out humor to create highly entertaining books.

Christopher Moore was born in Toledo, Ohio and grew up in Mansfield, Ohio. His father was a highway patrolman and his mother sold major appliances at a department store. He attended Ohio State University and Brooks Institute of Photography in Santa Barbara. The horror and humor writer moved to California when he was nineteen years old and lived on the Central Coast until 2003.

He burst onto the scene with *Practical Demonkeeping*, published in 1992, a road adventure with an odd couple that gets odder. The plot involves a one-hundred-year old seminarian named Travis O'Hearn and a green demon named Catch who has the nasty habit of eating most of the people he encounters.

Moore's dozen novels cover a wide spectrum of creatures, including vampires, trickster gods, death merchants, sea monsters and stupid angels. He is the author of books such as *A Dirty Job; Island of the Sequined Love Nun; The Lust Lizard of Melancholy Cove; Lamb: The Gospel According to Biff, Christ's Childhood Pal*; *Fluke: Or, I Know Why the Winged Whale Sings* and *Sacre Bleu*.

He also authored the San Francisco Vampire trilogy: *Bloodsucking Fiends, You Suck* and *Bite Me*. The three books feature the vampires Jody Stroud, a saucy redhead and C. Thomas Flood, who is fashion impaired (he wears a flannel shirt most of the time), cheats on his tan and recruits a minion (a perky Goth girl named Abby Normal).

He also penned *Fool,* a bawdy and perplexing

214

tragic comedy based upon William Shakespeare's *King Lear* but told through the eyes of the Fool, and tells of the adventures of Pocket the court jester with *The Serpent of Venice.* .

Moore's websites are www.chrismoore.com and www.myspace.com/authorguy

MICHAEL McCARTY: Regarding *The Stupidest Angel*, were any of these works influential to you and if so, how?

Gift of the Magi by O. Henry

Night of the Living Dead

Return of the Living Dead

CHRISTOPHER MOORE: As for the *Gift of the Magi*, I actually used that plot, or a version of it, in *The Stupidest Angel*. The other two were less influential. I think the scene from *Living Dead*, where the survivors are barricaded in a house, has sort of become iconic in zombie films (and stories), so I'm not sure if that counts as an influence or not. I suppose, indirectly, it does.

MM: In *The Stupidest Angel* you warned about the book because this Christmas tale had cuss words, cannibalism and people in their forties having sex. Do you believe the combination of all three is what Christmas is all about?

MOORE: We put a stuffed fruit bat on our tree every year instead of an angel, and my girlfriend is half Jewish, so we also have a menorah with Christmas lights in it, so my take on Christmas may be a little

untraditional. So, while I don't think you have to have cannibalism and zombies to make for a perfect Christmas, I think it all helps.

MM: Your mother died (and your girlfriend Charlee Rodgers lost her mother) before you wrote *A Dirty Job*. Was it hard to find humor after losing your own mother or was the book cathartic for you to write?

MOORE: Actually, humor is how I deal with things, and the more dire, the more I'm tempted to crack wise. Charlee is the same way. We met during a flood in the small town where I used to live. We both had friends who had businesses on the main street, the water was rising fast and they were trying to get their stuff to high ground. It was two in the morning and everyone was wading around, carrying cases of wine and whatnot, and Charlee and I were both joking and cracking up. I was all, "Hey, I can hang with this girl." So when our mothers died, I don't think I lost the sense of the absurd and the funny even during the events. Of course it was somber and sad at times, too, but even in the back of my mind I was taking notes, thinking about what I could bring to a story about death.

MM: In *A Dirty Job,* Charlie Asher is going around collecting souls, and encounters a beautiful young woman whose soul is trapped behind her breasts implants. If Charlie was in someplace like Omaha, do you think he'd have the same problem?

MOORE: Actually her soul is "in" her breast implants. And yes, I think that he might have encountered that in Omaha, although it's less likely. Vanity, however, isn't confined to the coasts. I have a friend who flew to

216

Oklahoma City (from Los Angeles) for hair transplants. He researched it and said that doctor was the best. I've been to Oklahoma City, and just being there would seem to take the edge off male pattern baldness. I mean, you can wear a hat until you get the hell out of Oklahoma City—then do something about your hair.

MM: Your books *The Stupidest Angel, Island Of The Sequined Love Nun, Lamb: The Gospel According To Biff,* and *Christ's Childhood Pal* all have religious elements to them? Did you get any flak from religious people?

MOORE: Nope, not at all. In fact, *Lamb* is being taught in several seminaries.

MM: Why do you think horror and humor go together so well?

MOORE: I think it's all about tension and recognizing the absurd. Laughter is a way of relieving tension, and being in a horrifying situation can certainly be fraught with tension, but there's also the recognition of just how absurd it is, for example, to be trapped inside a shopping mall by a bunch of brain-eating animated corpses. You have to laugh.

MM: Who is the next Christopher Moore?

MOORE: I don't know. I mean, I'm not sure who the current Christopher Moore is. There are a lot of talented young writers out there sort of combining supernatural elements with humor, but I think they'll find their own niche, be their own person if they make it. I mean, I've been compared to Tom Robbins,

Michael McCarty

Douglas Adams, and Kurt Vonnegut, and I'm honored to be mentioned in the same sentence with them, but I don't write anything like those guys. The thing we have in common is that no one is sure what any of us is (or was) doing and our stuff is funny. So the next writer to put on the goofy mantle will be his or her own person, carving out his or her own niche. That said, there's a guy named A. Lee Martinez, out of Texas, I think. I read his first book, *Gil's All Fright Diner*, and it shows great potential. I haven't read his other books, but he seems to have something going on with this horror/humor thing.

MM: You have your email BSFiends@aol.com at the back of your books. Do you receive a lot of email? Do you feel it is important to stay connected to your fans?

MOORE: I put that on my book *Bloodsucking Fiends*, back in '95, before my publisher was sending me on national tours, just so I could have some contact with my readers. I get anywhere from fifty to one hundred emails a day from readers and I try to answer all of them. Obviously, because I need to get my writing done as well, the answers can be pretty short, but I really make an effort to touch base with my readers. Writing, like any art, is about communication, and I think communication should be a two-way thing.

MM: Does corresponding on the internet take away from your novel-writing time?

MOORE: Yes, absolutely. The internet is a huge time suck. And if I write a blog, for instance, my brain tells me that my writing is done for the day and I can't come up with anything for the current book. I think I have a

218

mild case of Crow Syndrome, which I define as being somewhat like ADD, except you're susceptible to distraction by anything shiny. With the internet, you're only a click away from the next shiny thing.

MM: You've done a number of books with your fictional town of Pine Cove in it. What do you like more there: 'The Head of the Slug' or 'Brine's Bait, Tackle, and Fine Wines?'

MOORE: I liked the uniqueness of Brine's better. The Slug is like any number of small town saloons, but Brine's, a place run by a gourmet Zen fisherman, is something truly different. It is based on the general store in Cambria, California, which was owned by a guy who really did endeavor to carry the best in red worms, as well as fine wines, cheeses, freshly baked bread, and jumper cables. It's since turned into a more generic convenience store, but the original is preserved in fiction.

MM: Was *Practical Demonkeeping* a satire or a pastiche of H.P. Lovecraft's work? And if H.P. Lovecraft were alive in the 21st century, would he be a screenwriter?

MOORE: It's hard to say. Lovecraft was a recluse, and screenwriting is very much a collaborative craft. It involves an awful lot of meetings and pitches and suffering assholes. I'm not sure Lovecraft had the constitution for that. I think he might be more like Stephen King—squirreled away in a mansion in Maine somewhere, cranking out enormous, scary novels.

MM: How many publishers saw *Practical*

Demonkeeping before it was published? Was it a hard book to sell?

MOORE: I really don't remember. *Demonkeeping* had already sold as a movie to Disney before it even went out to market in New York, so it wasn't out to market long with publishers. That said, I know it was rejected by a number of them and eventually picked up by St. Martins for a very modest advance. There was no frenzy about it the way there was with the film rights (and no, it's never been made and isn't even close).

MM: There are a number of characters who keep recurring in your books. Let's talk about what it is you like about each of these characters and if they were real, what would you say to them? Let's start with the Emperor.

MOORE: The Emperor—I like that he's homeless and crazy, yet feels enormous empathy for the people of San Francisco, his subjects. If I met him I suppose I'd give him some money and thank him for his concern.

MM: Inspector Rivera?

MOORE: He's a homicide inspector. I like that he has the ability to accept the high improbability of the situation he's in. In other words, if it looks like a vampire, and sounds like a vampire, the best way to deal with it is as if it's a vampire. He's tough and adaptable that way, yet not so self-assured that he doesn't question his own sanity at times. I don't know what I'd say to him. Maybe suggest he take a vacation somewhere.

MM: Tommy Flood?

MOORE: I like his earnest passion for life and the city. Tommy is based on me when I was nineteen, so it would be like talking to myself back in time. I guess I'd tell him to not lose a sense of what he wants to do, and warn him that it's going to take a lot of patience to get where he wants to go.

MM: Jody?

MOORE: Jody is just smoking hot—smart, pretty, funny, a little dangerous (the vampire thing does that). I like almost everything about her, but in the books, I like the way she finds her own power in the night, after realizing that she's always been just a wee bit afraid. If I met her I guess I'd say, "Well, hello."

MM: The Animals (turkey-bowlers)?

MOORE: These guys are based on the night crew I worked with in a grocery store when I was a kid. You have to love their ability to roll with the party, and find a celebration in every event. They're like a crew of not particularly dangerous pirates. I guess if I met them I'd say, "Put the bong down and back away slowly, reality may hit you any moment."

MM: Abby Normal?

MOORE: Abby is all about the Goth girl voice. She's smart and very self-important, which makes her voice very funny. She passes judgment on everyone, despite having almost no experience to base her opinions on. I don't think I'd have anything to say to her, besides, she'd never hear it coming from a crusty dweeb like me.

MM: Lily?

MOORE: Lily is just Abby with a few more pounds on her. I like her sense of loyalty to Charlie, her boss, and her ability to go morose at the speed of dark. Again, I'm not really cool enough to talk to Lily.

MM: Raziel?

MOORE: Raziel, *The Stupidest Angel*, is sort of like a golden Lab. He's very simple and literal, and seems to have no sense that he is this powerful, supernatural creature. Again, I'm not sure what I'd say to him. He's just, so, so, stupid.

MM: Mavis Sand?

MOORE: Mavis is the ultimate survivor, like a cockroach with a drinking problem. Nothing short of nuclear war can kill her. She's been around, well, almost forever, and never seems to have a sense of what a hag she's become. I like that she's ancient, but still is kind of slutty. I don't think Mavis is the kind of person you "tell" anything to. I think you just ask questions.

MM: Tucker Case and Roberto the Fruit Bat?

MOORE: I like Tuck because he's a geek in a cool guy's body, and Roberto because he's a fruit bat. I think I'd tell Tuck he'd be a lot better person if he quit drinking and I'd tell Roberto to get off the Christmas tree.

MM: What are some of your favorite vampire books and movies?

MOORE: My favorite vampire books are *Fevre Dream*

by George R.R. Martin, *Dracula* by Bram Stoker, and *The Hunger* by Whitley Streiber. Movies probably *Near Dark, Fright Night* (the original) and *Buffy the Vampire Slayer*.

MM: Why the *Near Dark, Fright Night* and *Buffy* movies?

MOORE: *Near Dark*, because the director, Kathryn Bigelow (*Strange Days*), just took a concept and ran with it: vampires in Winnebagos. Lance Henriksen (*Millennium, Pumpkinhead, Aliens, Alien vs. Predator*) as Jesse, the Civil War era vampire, is terrific. Bill Paxton (*Apollo 13, Spy Kids 3-D: Game Over*), as the over-the-top redneck vampire, is scary and—well—scary.

Fright Night, because Chris Sarandon is the perfect charming vampire next door. This is a great example of a story where nerds become heroes.

Buffy the Vampire Slayer: I don't know how Joss Whedon felt about this movie, but he should be very proud of having brought the concept of a narcissistic cheerleader who is "the chosen" vampire slayer, into the world. We all know that Sarah Michelle Gellar made the role her own, but Kristy Swanson was an awfully good Buffy, as well.

MM: *Bloodsucking Fiends* was published in 1995. It was over a decade before you wrote the sequel *You Suck*. Was it easy or hard to get back into the storyline, characters and situations, after a ten-year absence? And how are the fans reacting to the return of C. Thomas Flood and Jody Stroud?

MOORE: It was harder to get back into it than I

223

thought it would be largely because of Tommy's character. He is sort of autobiographical, in that he is based on me when I was nineteen. Now, twelve years later, it was harder to get in touch with that nineteen year old person and put him in context.

MM: By having Tommy Flood become a vampire in *You Suck*, do you believe this strengthens their relationship and give them more in common? On the jacket he is referred to as Thomas C. Flood; was that a typo?

MOORE: I believe making Tommy a vampire added a new aspect to the story. Jody certainly thinks it gives them more in common. Who knows? Yes, it's a typo the book was moved up four months. A lot of mistakes made it into print).

MM: Are family newspapers running the title of your book as You ****? And how do you feel about that? Does it make the title seem dirtier than it really is? If you decide to do another vampire book, I have a title suggestion: *Bite Me*. What do you think?

MOORE: I proposed *Bite Me* as the title of the next one over three years ago, so good call. *The New York Times* was the only paper I know of that had trouble with the title, and that was in an ad my publisher bought.

MM: I feel a little like the Amazing Kreskin, getting the title right before it is even published. What can you tell us about *Bite Me*? Is it a sequel to *Bloodsucking Fiends* and *You Suck*?

MOORE: Yes, it is a continuation of that story, and all I know about it beyond that is the title.

MM: What was easier to satirize: vampires, demons, or angels, and why?

MOORE: Vampires were easier, because there are so many conventions and rules that people know about them, and there is such a mystique around them.

MM: What was the inspiration for the strange squirrel people in *A Dirty Job*?

MOORE: I saw some sculptures by a costumer named Monique Motil at a shop in San Francisco. They were little animal skeletons dressed in elaborate costumes. I thought they'd be great in a book.

MM: In *A Dirty Job* you have death merchants. In recent years there have been a lot of TV series devoted to death like *Dead Like Me* and *Six Feet Under*. Why do you think the American public might be fixated on death?

MOORE: I think it's about time. We've swept death under the carpet in this society for hundreds of years. I think it makes for good storytelling. (William) Shakespeare calls death "the undiscovered country." I think that writers are just exploring that territory.

MM: Was *Fluke: Or, I Know Why the Winged Whale Sings* a parody of *Moby Dick* by Herman Melville?

MOORE: No, not consciously. I read *Moby Dick* before I wrote the book, but I usually read every important book in a field before I write something in that field.

MM: Of your collected works, which book is your favorite and why?

MOORE: I think probably *Lamb: The Gospel According to Biff, Christ's Childhood Pal* because it was such a huge project to take on, and I'm amazed I pulled it off.

MM: When do you decide to use the elements of humor in your work: before or after the plot or characters are in place?

MOORE: It's just what I do. My default setting is humor, so that develops as I plot. A plot almost never sounds funny, however, so it would seem more like a mathematical equation, but since I plot from character, the situations I come up with tend to lend themselves to comedy.

MM: What do you do for fun when you're not writing?

MOORE: I take pictures and make up goofy captions for them. I go out to dinner. I play computer games. And I watch movies.

MM: What was the first horror, science fiction or fantasy book you remember reading as a child that had a major impact on you?

MOORE: The first book to seriously influence me was *The Mysterious Island* by Jules Verne. It completely engaged me for about a month. I was in fifth grade and it seemed to take forever to read that big book, but I loved it.

MM: What was the first book of yours that hit *The New York* Times bestseller list? Did you do anything when it reached the top?

MOORE: *A Dirty Job* debuted at #9. I was in Denver

on tour at the time, and I took some friends out for dinner and bought them a really nice bottle of wine (I don't drink).

MM: Has Hollywood showed any interest in your books?

MOORE: All of the books have been optioned or bought at one time or another. Some really big names have been involved. None has gotten past the script stage. I don't know why. I don't make movies, and evidently, neither does anyone else.

MM: Have you ever considered writing a screenplay?

MOORE: I have written a screenplay, *The Griff*. I think it's available from my website www.chrismoore.com.

MM: If you could be any monster, which monster would you be and why?

MOORE: I'd like to be Godzilla, because Tokyo tastes like Cheetos, and I love Cheetos.

MM: Advice for writers?

MOORE: Get a real job. (Laughs) Nah, always remember you are writing for an audience, and if you don't entertain them, all your other ambitions will be unrealized, no matter how important the ideas you want to convey.

MM: What advice would you give to someone who just published their first novel?

MOORE: Write another one. A better one. I mean, send query letters to agents and do all the stuff the *Writer's Market* tells you to do, but keep writing.

Michael McCarty

MM: Anything you'd like to add?

MOORE: Nope. It's all you.

MM: Last words?

MOORE: You put what in my coffee?

NIGHT OF THE LIVING DEAD CREW

John Russo, Kyra Schon & Russell Streiner

"I told George (Romero) we'd make the point that these things are weak, and the flesh is dead and dry and would go up pretty easy. Yet if nobody catches on fire, it was going to look stupid. We didn't have an asbestos suit and we couldn't afford one or a stuntman. George said, 'Who is going to do it?' And I said, 'Oh Hell, I'll do it.'"

—John Russo

JOHN RUSSO TALKS ABOUT LIFE WITH THE LIVING DEAD

By Michael McCarty and Mark McLaughlin

Michael McCarty

EARLY IN HIS career, John Russo was one of the co-creators of the 1968 horror classic, *Night of the Living Dead*, and since then, the living dead have played a major role in his creative life—zombies have figured into many of his projects.

But zombies and horror aren't the be-all and end-all of John Russo's career. For example, many folks don't realize he has also worked on comedies. He is a remarkably versatile, creative individual. Over the years, he has been a movie writer, director, actor, editor and producer—and even stuntman, as you'll soon learn. He is also a novelist and has written book versions of some of his movie projects, including *Night of the Living Dead, Midnight* and *The Majorettes*. He is currently mentoring film students from around the country at John Russo's Movie Academy.

John recently shared some of his behind-the-scenes memories of *Night of the Living Dead* with us and told us about some of his other projects, too.

Visit his school's website at www.movie-emporium.com.

MICHAEL McCARTY: Back when you were making *Night of the Living Dead*, what was your level of creative input? Which concepts were yours and which were George Romero's?

JOHN RUSSO: George (Romero) and I were both working on script ideas—we stayed late after everybody was gone. We were the two who stayed at the studio, usually, and slept on the fourth floor if we

had to. He was working in one editing room on a typewriter and I was working in another.

I said I thought the film should start in a cemetery, because people found cemeteries spooky. I wrote two pages where kids were in a cemetery and things were happening. Then Christmas vacation came up. George went away and wrote part of a story that wasn't in screenplay form—it was in story form. Essentially it was the first half of *Night of the Living Dead*. It started in a cemetery, as you know.

We all read it and liked it. There was no explanation of what these attackers were or what they were after, so I asked George, "You know, this is pretty good, but who are they? What are these things?" In a script that I had started, it was going to be aliens from another planet, in search of human flesh.

George said he didn't know who they were. I said, "It seems to me, they could be dead people. They behave like dead people." And he said, "That's good. Let's make it that."

I said, "What are they after?" He said he didn't know. I said, "Well, why don't we use my flesh-eating idea?" And that is how it happened. Then we kicked some ideas around with our small group of associates who were going to be a part of the thing. People pitched in different ideas.

I took all that material and all those ideas. Most of the ideas for the second half were mine. I took all that material and re-wrote the first half, putting it in screenplay form, and finished the screenplay.

MM: Tell us about the Washington, D.C. scenes in the movie. Why were those added in?

RUSSO: It was my idea to go to Washington, D.C.—that wasn't written into the script. We'd already filmed part of the picture and we were talking about what remained to be filmed. This was supposed to be taking place all over the Eastern part of the United States, but we had nothing to indicate that except for a voice on the radio.

And I said, "Well, let's go to Washington, D.C, it's only five hours away." We got into the caravan and went. Karl Hardman (one of the producers, who also played the part of Harry) fixed up one of his cars—he was a collector of cars at that time. He put a couple of flags on the car. I put my Army uniform on and was the General's driver. We went to Washington, D.C. and filmed it.

MM: Besides the General's driver, what other parts did you play in *Night of the Living Dead?*

RUSSO: I was the zombie who got the tire iron to the head. I also did the stunt as the zombie who got set on fire.

When we were ready to shoot that stuff, I told George we'd make the point that these things were weak, and the flesh is dead and dry and would go up pretty easy. Yet if nobody catches on fire, it was going to look stupid. We didn't have an asbestos suit and we couldn't afford one or a stuntman. George said, "Who is going to do it?" And I said, "Oh Hell, I'll do it."

I put my Levi's jacket on and my Levi's pants, and over that a loose-fitting brown suit. We made a puddle of gasoline and Karl Hardman made a trail of gasoline from the puddle up my leg and back. Karl threw a match off camera—I just staggered until I felt my hair

being singed. I rolled over a hill where people were waiting with blankets to smother out the flames.

We got three takes on that. Everybody was kind of worried, but they all had these gleeful looks on their faces. They were getting good stuff.

MM: That scene did look great in the film.

RUSSO: Thanks.

MM: The reason for the zombies coming to life in the film could have been either supernatural or scientific. Why did you pick scientific?

RUSSO: We didn't. We never say what causes them to come back. Somebody speculated about a Venus probe that might have brought something back to Earth, some kind of germ or whatever—we never definitely explained anything. I didn't want to.

It is more mysterious if you don't explain it. We're making a horror film, so why should we spell it out for people? I didn't want to have any explanation at all. Once we'd accepted the outlandish premise that the dead can come back and turn on the living, then we wanted everything to be logical. We wanted people to behave like real people behave, should such a thing really happen, and we wanted to have a logical story.

Karl Hardman said in one of our meetings that all horror movies at that time had an explanation and people needed to have one. So we hinted that the Venus probe might have been involved somehow—we didn't say that was definitely the answer.

MM: As one of the producers of *Night of the Living Dead*, what were your various duties in the movie?

RUSSO: All of us, we all pitched in and did what needed to be done. George was tied up, so it fell to me to finish the script. I didn't want the project to die and it would have. So I did that.

At one point it was going to fall apart because there was too much bickering. We didn't have a farmhouse . . . what farmhouse were we going to use . . . blah, blah, blah.

I said to George, "This movie isn't going to get made unless all this shit stops." And he said, "Why don't you take charge?" I said, "I'll do it, only if I have complete authority to make it happen." He said, "You got it."

I started calling people up and said, "All the bickering is stopping and we're going. I'm making the decisions." We got moving. Harry and Vince (Survinski, also one of the producers) and I, we went to a Good Will place and started moving in rugs and furniture. We got a whole load of furniture for fifty dollars, which you can't do now. Vince made a fireplace where there was none. He made a bridge to get to the farmhouse.

Russ (Streiner, one of the producers, who also played the part of Johnny) and I shot most of the 16mm footage. That was all the footage that you see on the television (in the movie). Russ and I filmed the truck explosion with three cameras. George was shooting on 35mm and Russ and I were shooting on 16mm, to make sure we got it covered.

George did most of the editing. We all helped with the sound work. We shot 35mm and reduced it to 16mm because all the editing gear was in 16mm. We edited it in 16mm. Then the 16mm had to be conformed to a 35mm negative, which I did. I did all

the splicing and Gary Streiner (Russ's brother, one of the producers and the chief soundman) helped. I remember there were 1,056 shots, because we pulled all of them.

I was coughing up blood from exhaustion because it was on deadline. At that point, I put the jump cut in the basement scene because they wanted a couple of minutes cut out and there wasn't any way to fix it. George said, "There is no way to fix it," and he left. I said, "This thing is going to play at the drive-ins. When they see a jump, they will think it is like any other drive-in picture–it had to be spliced together because something tore." So I did it. Then George got mad. (Laughs)

MM: That scene was fixed in the 30th Anniversary Edition of *Night of the Living Dead*, wasn't it?

RUSSO: I wrote and directed the new scenes on the Anchor Bay DVD. Bill Hinzman (who played the ghoul that attacked Johnny in the cemetery) actually found a way to fix the jump cut. We fixed a lot of mistakes— bad screen direction, etc.

Kyra Schon, Karl Hardman's daughter, played the dead body upstairs. The face came from a mannequin, and George used some clay to make it the dead face. We had to have a body to drag out–Ben dragged it down the hall and Kyra laid on that blanket, but then you could see *her* face, you could see that it wasn't the decayed face. We fixed that by cutting it in the shot later . . . We fixed a lot of things like that.

The movie rose above all its flaws because it just riveted people. I always say, zombies weren't heavyweight fright material before *Night of the Living*

Dead. We were inventing zombies. Before, zombies would just walk around and grab somebody and throw them against the wall or something like that. Zombies weren't as scary as vampires or werewolves. When we made them flesh-eaters, we gave them that extra dimension that was just as terrifying as aspects of the werewolf and the vampire. The zombie had the werewolf and the vampire all rolled up into one. They don't die, they come back . . . they turn on the living. Flesh-eating is a primal fear in human beings—we had to be terrified of wolves and bears through most of history.

I went to all the horror films that I could see that came into town. I always wanted to see a real good horror film and I didn't see any, other than the original *Frankenstein* and *Dracula*—I mean, those are great films. Most of the movies at that time were gigantic grasshoppers and shit like that. They weren't satisfying—until I saw the original *Invasion of the Body Snatchers* and that knocked me out. I kept saying, we had to leave people with those same stunned looks on their faces as when they left *Invasion of the Body Snatchers.*

MM: Was there some controversy among some of the fans about the 30th Anniversary Edition?

RUSSO: I get these idiots on the internet yapping at me for messing with George's film. In the first place, it wasn't just George's film, as you can tell from my comments.

Second of all, George was fully aware that we were going to do this. We got $200,000 to do the additions. George and I were both going to write the new scenes

and he was going to direct them. He got side-lined by some project, so I ended up writing and directing the scenes. We had fun doing it.

Three-quarters of the money went to fixing and refurbishing the original negatives. We totally cleaned them up, refurbished them, and saved them from deteriorating. That was part of our motivation to use the money. We had to satisfy the distributor, Anchor Bay—they weren't going to put up $200,000 for nothing.

MM: Why was the character Ben shot at the end of the film?

RUSSO: That was my idea. Pennsylvania is a big deer-hunting state. Every year, there are ten or twelve hunters shot. And I said, "If we have these vigilantes, these people who aren't used to weapons and they are in the woods . . . a zombie looks a lot more like a human being than a deer does. Somebody or probably several somebodies would get shot by accident, and what if one of them was Ben?" Everybody said "Yeah," so we did it.

In the first version of the script I wrote, the girl Barbara didn't die. She makes it to the basement with Ben. When he hears the helicopter and all the sounds, he sneaks up to see what is going on. He gets shot. After he gets shot, the sheriff and the deputy look down the cellar steps. They almost shoot her, until the sheriff spots a tear rolling down her face and realizes she's human.

In the last scene, she's huddled in somebody's overcoat and they are giving her coffee and she is shaking. She sees Ben's body being carried out to the fire in the background.

I can't remember whose idea it was, but someone suggested that her brother Johnny should come back as a zombie and drag her outside. So we did that. We debated that because Johnny had his head slammed against a tombstone, so he wasn't necessarily dead. I said, "People will believe he is dead because he had his head bashed hard enough. But he hasn't shown up yet." We thought that would work.

We hadn't shot the cemetery scene yet–that was actually the last scene shot. Russ (Streiner) came up with the idea that he would wear the driving gloves. Russ said, "We'll establish the driving gloves in the cemetery. That will be the first thing you'll see when I come through the door (as a zombie, later in the movie). That will tie everything together." We wanted to make sure the audience knew he was the brother. That makes for a powerful moment. So that is what we did.

The whole film was pretty much a collaborative effort. Once we got going, everyone was following behind George as the director, more so than any other project I had worked on. There is a lot of in-fighting and back-stabbing in moviemaking, and ego problems. That movie, we were all behind George—he was the best one to direct it. He did a hell of a job under very difficult circumstances. Everybody did an excellent job.

MM: What are some of the other movies you've worked on, since *Night of the Living Dead?* In what capacity did you work on the projects?

RUSSO: After *Night of the Living Dead* we made a romantic comedy, sort of like *The Graduate* or

Goodbye Columbus. Russ and I co-produced and George directed and I wrote some of it. It was called *There's Always Vanilla* and released under the title, *The Affair*. It didn't get wide release—it was a small company that released it. If you look at it now, it was a real good look at how the Seventies were. It has really good production values.

I then did a sex-satire called *The Booby Hatch*. During the Seventies, everybody thought all this sexual freedom would bring happiness, but it didn't. It's a film about product testers at a factory that makes sex products. It's pretty zany but it suffers from a low budget.

I then did *Midnight*. We did that whole film on $70,000. It was shot on 35mm. It was pretty successful. I also did *The Majorettes* and *Heartstopper,* a vampire movie I made with Tom Savini and Moon Zappa—it got really good reviews, even in England. It's out under the title *Dark Carving* from Media Blasters.

Children of the Living Dead was an awful film (which Russo co-produced). It was supposed to be my script and I was supposed to direct it. It ended up being the producer's daughter's script (Karen Wolf).

Return of the Living Dead—I wrote the original script with Rudy Ricci and Russ Streiner. There are two novels—one based on our script, which is dark horror, which most people really like. But the movie didn't get made that way. Instead they hired Dan O'Bannon to put some comedy into it, and I novelized his script.

I also co-produced, with George Romero and Russ

Streiner, the *Night of the Living Dead* remake in 1990 that Savini directed.

MM: Tell us about your school, John Russo's Movie Academy.

RUSSO: The first semester is commercial films, industrials, biographicals and documentaries. Savini's (Tom Savini's Special Make-Up Effects Program) is a sixteen-month diploma course and so is ours. We are fully licensed by the state of Pennsylvania.

The classes include Screenwriting 1, 2 and 3; Screencraft 1, 2 and 3; and Moviemaking 1, 2, 3 and 4. Screencraft converts to a career guidance course and Screenwriting converts to a business practices course. You learn everything—how to form your own company, how to form limited partnerships, negotiate with distributors, and how to market.

You make everything from thirty-second TV spots to music videos to documentaries—all the way up to features. You end up writing your own feature script and shooting scenes for it. These are all comprehensive courses—we use real professionals to teach and there are guest lectures.

"The arm-eating scene was much more satisfying. They smeared Bosco (chocolate) all over my mouth and I got to lick it all off at the end of the scene."
—Krya Schon

NIGHT OF THE LIVING DEAD GIRL

KYRA SCHON

By Mark McLaughlin and Michael McCarty

OUNTLESS PEOPLE HAVE gazed into the eyes of Kyra Schon without even knowing her name. Kyra played the little zombie girl in *Night of the Living Dead,* and her undead urchin visage has appeared upon thousands of movie posters and T-shirts over the years.

Kyra's all grown up now and has many fond memories of her appearance in that classic fright film. To see pictures of Kyra socializing with fans and

celebrities alike at various horror conventions, check out her website, The Ghoul Next Door, at www.ghoulnextdoor.com.

MICHAEL McCARTY: How did little Kyra get the role of little Karen Cooper?

KYRA SCHON: I was in the right place and at the right age, at the right time. The part had originally been written for a boy, but when those involved failed to unearth any boys that age (they were primarily using friends, acquaintances and family rather than searching far afield for cast members), they changed "Timmy" to "Karen" and I got the role. The fact that my father Karl Hardman was also involved in the production certainly helped.

MM: What role did your real-life parents, Marilyn Eastman and Karl Hardman, play as the producers? What did they contribute to the production?

KYRA: Karl and Marilyn played the roles of my parents, Harry and Helen Cooper, the ill-fated, bickering couple in the basement. Karl is my real father, but Marilyn is not my real mother. Karl co-produced along with Russ Streiner and he also did the sound and makeup. Everyone served double and triple-duty on the film because of budget constraints.

MM: Alfred Hitchcock used chocolate syrup for blood in *Psycho*. What did *Night of the Living Dead* use?

KYRA: We also used Bosco chocolate syrup. It was smeared all over my mouth and onto the "meat" for the scene in which I ate my father's arm. They also

used black paint on the walls and on Marilyn's dress for the stabbing scene and for other bloody scenes.

MM: How did it feel, killing off and/or eating your parents on film?

KYRA: The stabbing scene was not nearly as dramatic as it appears on film. Marilyn wasn't even in the room at the time, and I stabbed the trowel into a pillow. I remember asking how long I should continue stabbing the pillow and my father told me, "Just keep going." I guess I thought it was excessive. The geeks, I mean "film enthusiasts," who count such things have told me that I stabbed that poor pillow fourteen times. The arm-eating scene was much more satisfying. They smeared Bosco all over my mouth and I got to lick it all off at the end of the scene.

MM: Your only line in the movie is "I hurt!"—did you have any other lines that ended up on the cutting room floor?

KYRA: Yes, I had a heart-wrenching soliloquy that lasted well over twenty minutes and by the end of it, the whole crew was in tears. Had that particular piece of film been kept in, I'd have won an Oscar. Just kidding. "I hurt" was my one and only line.

MM: Where did they get the name "Karen Cooper?"

KYRA: I honestly don't know. I don't think it had any particular significance, though, or I would have heard about it. In my mind, she's Alice's little sister.

MM: Do you still have your Karen Cooper dress? Have any collectors offered to buy it?

KYRA: Unfortunately, that dress is long gone—I'd hoped my mom had kept it, but I've been unable to find it in her house. I do still have the bandage I wore, the music box that provided the sound for the one in the film, and some makeup from the production.

MM: Do you play one of the zombies outside the house? If so, did you have to eat anything yucky in your zombie role? Did Marilyn or Karl also play any of the zombies?

KYRA: I didn't play any outside zombies, but I was the dead body at the top of the stairs. Aside from Karen Cooper, I didn't play any other ambulatory corpses. Marilyn was the bug-eating zombie outside the house. I don't believe my dad played any other zombie roles. He was the voice on the car radio when Johnny and Barbara arrived at the cemetery, and all the clips of the TV station were filmed at his recording studio, Hardman Associates.

I didn't really have to eat anything yucky, unless you consider chocolate-covered meatballs yucky. Someone had ordered a meatball sandwich for lunch on the day that we shot the arm-eating scene. There was some left over, so they used it to smear on the stump and I held the rest of it in my hands, sans the bread, of course. I only held it up to my mouth, so I didn't have to taste it. It really did seem rather yucky.

MM: Have you seen the Tom Savini remake of *Night of the Living Dead*? What did you think of the girl who played your part? Do you think a remake was necessary?

KYRA: I didn't think a remake was necessary, but I feel

that way about most remakes. There have been a few that I've loved (*The Fly, The Thing*), but generally I think they're a waste of time. The young girl in the remake (Heather Mazur) was called "Sarah," not "Karen." I've been unable to find out why they renamed her, as she was the ONLY character they renamed. I think she did a great job, though.

MM: Tell us about your website and your sideline selling movie memorabilia.

KYRA: In 1997 I built a website called *The Ghoul Next Door* (www.ghoulnextdoor.com) and I have bits of trivia, photos, a chat room and a listing of events on the site. I also have a gift shop where I sell memorabilia and some of the jewelry that I make. I also have a website called *SpiffyCards* (www.spiffycards.com) where I sell all-purpose greeting cards featuring Spiffy, my pointer/greyhound soulmate.

Since June I've been a member of The Horror Channel web staff (www.horrorchannel.com), writing a weekly advice column called "Ghoulish Guidance." Spiffy also imparts her vast knowledge of pets for the column. Spiffy and I have become the "Advice Mavens of the Living Dead."

MM: You attend a lot of horror conventions. Any fun convention stories you'd like to share?

KYRA: All conventions have their moments, but there are two moments that really stand out. The first was when I'd cut my hand at a convention and was bleeding buckets. Before I could grab a tissue and a Band-Aid, a guy asked me if I would sign his photo for

him and put some of my blood on it, too. I thought it was kind of an odd request, but I did it for him. He ended up going to Tom Savini's makeup school and I saw him last year at another convention. He brought the same photo with him to show me. The blood is really disgusting looking now and I don't know how he can stand to have it around him. However, if anyone ever wants to clone me, they should contact him.

The other was when a fan asked me to bite him on his arm so he could have my teeth marks gone over by a tattoo artist. He hounded me all weekend and finally caught up with me in the bar at the very end of the weekend. We were packed up and getting ready to leave when he caught up with me and again begged me to bite him. I'd had a couple of beers so I bit him. He thanked me profusely and raced off to get his tattoo. I never saw him again so he may have died of rabies. I've never had my shots, you know.

MM: A lot of child actors over the years have come to bad ends. How did you end up so well adjusted?

KYRA: I owe it all to Bosco.

Actually, I owe it all to the fact that I grew up in Pittsburgh, NOT acting for a living. I had a completely average and uneventful childhood and *Night of the Living Dead* was the only film I did. I had absolutely no interest in pursuing a career in acting, so I suffered none of the disappointment or rejection that other "child actors" experience along the way. "Show business" is the most cut-throat, back-stabbing industry I've seen (from the sidelines, thank God) and kids are simply not emotionally equipped to deal with it. From what I've seen, the kids who have the biggest

problems are the ones whose parents treat them like they're a commodity.

MM: Tell us a little about your day job. You work with a lot of children. Have any of them ever seen your movie?

KYRA: I'm a middle school pottery and sculpture teacher. Many of my students have seen the movie and they are amused by the fact that I'm in it. A couple of years ago when some company was selling fabric patches with my face on them (for which I was NOT compensated, I might add), one of my 6th grade students walked into my room and announced, "Look, Ms. Schon, I have your face on my jeans!" That was a bizarre moment. I'm just relieved that she didn't ask me to bite her.

MM: Did playing that scary role as a child give you any nightmares?

KYRA: No, but I hear it gave a lot of other people nightmares.

MM: What does it feel like to be part of such a grand movie tradition? Will you be in the fourth "Living Dead" movie folks have been talking about?

KYRA: I feel unbelievably lucky to have been a part of the original *Night of the Living Dead*. As I write this, the fourth film, *Land of the Dead*, will be wrapping in a few days. They shot the whole thing in Toronto, a HUGE disappointment to Dead fans in Pittsburgh. As a result, I had no part in it. If it had been shot here (Pittsburgh), I would have loved to play an anonymous zombie, shambling through the streets of downtown

247

Pittsburgh. Regardless, I can't WAIT to see it! It's high time we had the fourth installment of the series.

MM: Last words?

KYRA: I hurt.

"The entire cemetery scene was written and filmed pretty much as you see it in the finished film. As an actor, I changed the specific line of 'They're coming for you!' to 'They're coming to get you—Barbara!' to make it more menacing for Barbara. I also added the mock Boris Karloff reading to the line to further annoy Barbara."

—Russell Streiner.

RUSSELL STREINER SAYS "THEY'RE COMING TO GET YOU!"

By Michael McCarty and Mark McLaughlin

MOST PEOPLE KNOW Russell Streiner as Johnny, the bespectacled brother of Barbara in the horror classic, *Night of the Living Dead*. His character eventually became a zombie, but Russ went on to enjoy a long, active career in the movie industry.

Russ, who is still a favorite at fan conventions, took

a moment from his busy schedule to answer some questions about *Night of the Living Dead* and his more recent adventures in filmmaking.

MICHAEL McCARTY: In the beginning of *Night of the Living Dead*, you tell your movie-sister, "They're coming to get you, Barbara!" Was that line improvised? Were you doing a Karloff impression?

RUSS STREINER: The entire cemetery scene was written and filmed pretty much as you see it in the finished film. As an actor, I changed the specific line of "They're coming for you!" to "They're coming to get you—Barbara!" to make it more menacing for Barbara. I also added the mock Boris Karloff reading to the line to further annoy Barbara.

MM: Have you been in any other movies, or been involved with any other productions since *Night of the Living Dead*?

STREINER: I make my living by producing and directing in the film and video business. I literally work in production or teaching production every day. I have acted in a few feature films but I concentrate 99 percent of my effort on the production side of the camera. There are a few acting jobs that I have been approached about and I am considering doing them. We'll see how schedules and opportunities work out during 2005.

MM: We've heard you were up for the part of Ben in *Night of the Living Dead*. Is that true?

STREINER: I was not being considered to play the

part of Ben by anyone, including myself. However, an actor friend of George Romero's, John Russo's and mine, was. His name is Rudolph Ricci. Rudy worked on the film with us in spurts but he was not "on set" every day. Rudy was in on several of the brainstorming, creative sessions. He was one of the key zombies in the scene where Ben, Tom and Judy make the escape to the gas pump. Rudy is also one of the original ten investors in *Night of the Living Dead.* He agreed that Duane Jones should play the part of Ben once we saw Duane's acting audition.

MM: As one of the movie's producers, what were your various duties? Were you involved in casting and if so, how did you recruit people to play zombies?

STREINER: As a producer, I was literally involved in every phase of the creative and production work on *Night of the Living Dead,* from the beginning of the project to the completion and distribution of the film. I am still involved with *Night* every day, along with John Russo and Karl Hardman—the three of us are the corporate trustees of Image Ten, Inc, the company that owns *Night of the Living Dead.*

In terms of duties on *Night,* we all had to do whatever needed to be done. My specific jobs ranged from making the deal to lease the farmhouse location to keeping The Latent Image, Inc. (our commercial [bread and butter] business) operating. I worked "on set" at the farmhouse most days. I did the filming of the sequence in Washington, DC because George Romero and John Russo were in the scene as actors. I also filmed the alleged "News Studio" sequences that appeared on the farmhouse TV set. We all did

whatever we had to do, with George doing the majority of the directing and camera work. Casting was handled like casting on any film. We knew certain actors from among our friends and work associates here in Pittsburgh, PA. We knew Karl Hardman and Marilyn Eastman from working with them as actors and creative people on other projects. We felt they would be ideal for the characters of Harry and Helen Cooper. They read for the parts, they were great and we cast them. Karl was also the real-life father of Kyra, and since the Cooper's had a young daughter, that is how Kyra got involved. That turned out to be another stroke of good fortune. Kyra was exactly right for the Coopers' daughter.

Zombies were recruited from everywhere around Pittsburgh. They were friends, work associates, neighbors, family members and people we met during our filming stay in Evans City, PA. George Kosana (the Sheriff) was a friend of John Russo's. George Kosana also had a gun collection and he supplied many of the guns used in the filming. Judith O'Dea (Barbara) and I first met in Drama School in Pittsburgh and after she graduated, Judith worked with Karl and Marilyn on some of their productions—we auditioned her and she became Barbara. When you're making a film, the word gets around pretty quickly and it generates a lot of interest for participation.

MM: There's a naked zombie in *Night*. Who had the idea for one to be naked? Was that in the script or decided on the set? Did that performer take some convincing to do that?

STREINER: The naked zombie was written into the

script. Because our zombies were "recently" dead people it made sense that some of them would be "naked." So we hired an art school figure model, tied a DOA tag on her and assumed she came from a morgue. Since she was an art school figure model anyway, she had no problem with the nudity.

MM: You and George went to Columbia Pictures to pitch a distribution deal. When that deal failed, what kept you going on after that major blow?

STREINER: Independent filmmakers can't take no for an answer. When Columbia passed on *Night* we had already lined up other distributor screenings. We knew we had a good picture and it was only a matter of time before we got a distribution deal. What kept us going was the fact that we knew we had a good picture.

MM: The movie is said to have had copyright problems. Did any of the producers make any profit off of it?

STREINER: We have had a dispute with the copyright office for years. Image Ten, Inc. is the proper and lawful owner of *Night of the Living Dead*. Hopefully, we will resolve the dispute with the copyright office soon. Make no mistake, we are the rightful owners. And "yes," we have made money from *Night,* but money, a lot of money, has been stolen from us and we plan to correct that.

MM: *Night* has been released in various editions over the years. Which is your favorite and why?

STREINER: My favorite version is the "Original." It will always be the original and it is "one of a kind."

MM: What is George Romero like? Have you worked with him on any other projects since *Night?*

STREINER: I'm proud to say that George Romero is a friend of mine. Over the years we have been roommates and business partners. We still work on projects together and we are neighbors. He is terrific and one of the most creative people I have ever worked with.

MM: *Night of the Living Dead* has been a fan favorite for a long time. What factors have contributed to this movie's longevity?

STREINER: *Night of the Living Dead* has been in distribution for over forty years now because it is a very good film that audiences keep rediscovering. That, plus the fact that fans and film reviewers have judged it a "Classic."

MM: You attend fan conventions. Any interesting fan stories?

STREINER: I do participate in a few conventions each year. I like to attend as many conventions as my schedule will permit because it is a great way to meet fans one-on-one and to say thank you for the support they have shown for our film.

MM: Last words?

STREINER: Last words—Thanks to all *Night* fans for their ongoing support and I hope to meet many more fans at upcoming cons this year. And remember, "They're coming to get you—Michael!"

"That's part of creating genuine terror on a page. What scares my readers and viewers scares me. If a writer fails to scare himself or herself, then that writer is faking it and the reader can always tell."
—William F. Nolan

THE LOGAN MAN

WILLIAM F. NOLAN

By Connie Corcoran Wilson and Michael McCarty

LIKE HIS PROTAGONIST Logan in *Logan's Run*, William Nolan isn't afraid to journey to different worlds. The Southern California writer has written successfully in a variety of genres including science fiction, horror, western and mystery.

Best known for coauthoring the acclaimed dystopian science fiction novel *Logan's Run* with George Clayton Johnson, Nolan is the author of more than 2000 pieces (fiction, nonfiction, articles, and books), and has edited twenty-six anthologies in his fifty-plus year career.

Of his numerous awards (over 30 and counting), there are a few of which he is most proud: being voted a Living Legend in Dark Fantasy by the International

Horror Guild in 2002; twice winning the Edgar Allan Poe Award from the Mystery Writers of America; being awarded the honorary title of Author Emeritus by the Science Fiction and Fantasy Writers of America, Inc. in 2006; receiving the Lifetime Achievement Award from the Horror Writers Association in 2010; and recipient of the 2013 World Fantasy Convention Award along with Brian W. Aldiss. Nolan won another Bram Stoker Award—for Superior Achievement in Nonfiction—in May 2014 for his book about Ray Bradbury, called *Nolan on Bradbury: Sixty Years of Writing about the Master of Science Fiction*—his second Stoker award at 86 years old and still going strong.

A vegetarian, Nolan resides in Vancouver, WA. The official William F. Nolan's website is: www.williamfnolan.jasunni.com.

MICHAEL McCARTY: When did you start writing?

BILL NOLAN: Very early, in Kansas City, Missouri, my hometown (moved to California in '47, here ever since).

I was nine when I wrote a poem about a fireman my mother carefully preserved (as mothers will). At ten, I was heavily into fiction, and wrote several lurid stories with such titles as *Vulture of the Wolf Patrol*. Filled two entire school tablets with them—all about cowboys and G-Men and magicians and air aces. One was about a mysterious crime-fighter who could turn himself into a snake. I called him The Serpent. Terrible stuff, really. They show no evidence whatever that this young fellow could ever make it as a writer. Naturally,

all my relatives in Kansas City thought the stories were great. That's what relatives can do to you!

MM: What was your first published work?

NOLAN: Well, if you mean professionally published, that would be a chapter on Max Brand in the book *Max Brand: The Man and His Work* in 1952, the same year I wrote and published my "Ray Bradbury Review." But my first paid-for work was a short story in *If: Worlds of SF* in the summer of 1954, "The Joy of Living," which, much later, became my first produced teleplay.

If you count non-pro works, I had a lot of stuff in my school paper and in amateur magazines starting from age thirteen.

MM: If you had to pick three favorites from your *Dark Universe* collection, which would you choose and why?

NOLAN: The first would be "The Ceremony," which was chosen for *The Year's Best Horror*. It is a particular favorite of mine, because it deals with an evil protagonist who is given his just deserts in a small town when he is trapped by these cult people who are worshipping a new form of Halloween.

Another story I like very much is "The Partnership." It deals with a very ordinary fellow, a very likeable man who works with a demonic creature that lives in the water under the old funhouse. This fellow meets people and lures them out to the funhouse, takes their money and drops them into the lower part where this creature comes out of the water to devour them. It's about the strange partnership between a good ole boy and creature who lives beneath the depths.

The third one that comes to mind would be "The Halloween Man." It's about a demon that only comes out on Halloween night in small towns with his bag, capturing the souls of young children he encounters along the way. This young girl in the story hears about him, knows he is coming and battles against the Halloween Man.

In the end, her father turns into the Halloween Man or seems to. The ending is very ambivalent. You don't know if whether the father is really the Halloween Man or if the girl's imagination has turned him into the Halloween Man. I leave the story open-ended.

Those are the three I would pick out.

MM: What is the inspiration for "He Kilt It with a Stick" and "Lonely Train A-Comin'," both stories from *Dark Universe*?

NOLAN: Both "Lonely Train A-Comin'" and "He Kilt It with a Stick" were developed from dreams. I woke up with them inside my head.

With "Train," I had the dream-vision of a cowboy sitting alone in a boarded-up depot on the plains of Montana, waiting for the train that killed his sister—waiting there to destroy it.

With "Kilt," the whole story—beginning, middle and end—came from a dream. I just put down what happened in my dream, and I had my story. I could never write a cat-killing story like that today, since I have cats of my own and love them dearly!

Dreams, however, remain of value. They reflect the fears of the subconscious and can provide wonderful story material.

MM: There are several scary stories in *Dark Universe*. Are there times when you manage to even scare yourself with what you write?

NOLAN: Oh, sure. That's part of creating genuine terror on a page. What scares my readers and viewers scares me. If a writer fails to scare himself or herself, then that writer is faking it and the reader can always tell.

MM: Who are some of your favorite writers of fright fiction?

NOLAN: Ray Bradbury, of course. His first book, *Dark Carnival*, is still beautifully frightening—a real classic in the genre. Then there's Stephen King and Peter Straub.

I'm also fond of the subtle horrors of Robert Aickman, the best of Shirley Jackson, and that terrific first collection *A Tree of Night* by Truman Capote. There are many others—far too many to mention here. Every writer of worth has been influenced by a host of other writers. It comes with the territory.

MM: *Logan's Run* was a bestseller, turned into a movie and TV series. Were you surprised by the success?

NOLAN: Not really. I knew the idea was unique and would find wide public acceptance. I also knew that *Logan* would make a great movie. And I wrote the pilot show for the TV series. Right now, Warner Bros. is working on a major high-budget, high-tech remake of the novel—so *Logan* continues to run. The fact that *Logan's Run* was my first novel and took off the way it

did was very nice. Most first novels sell maybe a dozen copies and are never heard from again. I was very fortunate with *Logan*.

MM: Can you give us more details about this remake of *Logan's Run*?

NOLAN: For the past five years, Warner Bros. has had a new film version in development, but they don't, as yet, have a satisfactory screenplay, nor do they have a cast. They do have a producer, Joel Silver (*Die Hard, Lethal Weapon, Matrix*, etc.), but you must realize that things move very slowly in Hollywood when it comes to production of big-budget, high-tech films.

The writer/director is Skip Woods. I had several conversations with him. He grew up reading *Logan's Run*, he loves the novel and considers it a classic. He told me in a three-hour meeting at a coffee shop that he wanted to restore the novel to its original form, put back Crazy Horse Mountain, the sky gypsies and all the things that MGM left out.

It's still in an embryonic form. Warner Bros. is still going to do it. I don't think there is a script, there is a treatment that has or hasn't been approved—I don't even know that—with a $100 million dollar budget.

That is what I really can't answer. I know it is in the works, I know that Skip Woods is going to write and direct it. But beyond that—it's in the lap of the gods, when it's going to happen.

MGM took eight years to produce their version of *Logan's Run*, so it may be several more years before we see the new Logan picture in release. But they do intend to make it, and with today's great special effects

(which didn't exist in 1975 when MGM did their film) it should be worth waiting for.

MM: *Logan's Run* was a collaborative novel you co-wrote with George Clayton Johnson. What are the pros and cons of working with another writer on a novel?

NOLAN: As to working with another writer on a novel, it can be done, but with difficulty. Each novel is a very personal journey into one's inner self. I don't mean to sound pretentious—but novel writing is often a search for one's soul. It's tough, dividing your soul with someone else. George and I tried to write a sequel to *Logan's Run* together, but it didn't work out—so I went ahead and wrote *Logan's World, Logan's Search* and *Logan's Return* on my own.

MM: In the 1970s *Logan's Run* movie, Logan is on the edge of turning thirty and is about to be subjected to euthanasia. But in the novel, he was twenty-one. Was this because of the "don't trust anyone over 30" era or were there other reasons?

NOLAN: There were other reasons. The main reason was casting. MGM told me at the time, they couldn't cast a film with 21-years-or-under's as major stars and supporting cast. They had to move the death-age up to 30 so they could cast Jenny Agutter and Michael York who looked older than 21 in the film.

It just happened, coincidentally, with the period of the *Logan* film, there was that slogan "don't trust anyone over 30." But that didn't have anything to do with MGM decision to move the death age from 21 to 30. That was a decision made strictly through casting.

MM: What's the story behind the unproduced script for *The Night Killers* written by you and Richard Matheson?

NOLAN: It was to become the third *Kolchak* Movie-of-the-Week. Dan (Curtis) asked me to write the first draft and set up the basic plot and characters. This was in late 1973 after he and Matheson had done *The Night Stalker* and *The Night Strangler*. I wrote the 100-page first draft in just seven days. The original story was mine. Then Matheson took it over for the final teleplay, adding and cutting. Curtis and the network okayed our final and we were all set for the shoot in Hawaii when we were informed that *Kolchak* had been sold as a weekly series. This killed our Movie-of-the-Week and, until last year with its inclusion in Gauntlet's publication of *Richard Matheson's Kolchak Scripts*, our teleplay has remained buried. At least now people can see what it would have been like on the screen, had the script been produced as planned.

MM: *The Norliss Tapes* was based on a story by novelist Fred Mustard Stewart. How did the story and your screenplay differ?

NOLAN: I'm sure that I read the story outline by Stewart, but I can't recall it. It had something to do with a walking dead man. Beyond that, everything in the teleplay is mine. I wrote it without any references whatever to the Stewart story.

MM: You did the adaptation of Henry James's *The Turn of the Screw* that was filmed in London with Lynn Redgrave in 1974. Was James's story easy or difficult to adapt?

NOLAN: Difficult, in that I had to "extend" the material from a novelette to a two-night mini-series. I wanted to retain the mood and period atmosphere and to remain faithful to James' concept and characters. Apparently I pulled it off, because the critical reception to my teleplay was very positive. It remains one of my best scripts.

MM: What kind of research did you have to do on Machine Gun Kelly to write *Melvin Purvis: G-Man?*

NOLAN: Luckily, I own many books dealing with the gangster era of the 1930s, and I know quite a lot about those days, so it was no big deal to dig out some basic facts on Kelly. My version was largely fictional, anyhow. Dan let me play a bit in this one, which was shot up in the Sacramento area. I got to die on the roof of the gang's roadhouse in a hail of FBI bullets with a "Tommy gun" in my hands. I'd always wanted to fire a Thompson sub-machine gun and, even with blanks, it was a great experience.

MM: Was *Kansas City Massacre* a sequel to *Melvin Purvis?*

NOLAN: Yes and no. It was produced as a direct follow-up Movie-of-the-Week since the network wanted to take advantage of the original. *Purvis* had topped the ratings. So I was asked to write the second one, which also did very well. The network wanted yet another, so I did an outline for Dan titled *The Great Dillinger Manhunt*, but it somehow never jelled (by the way, John Dillinger was not killed by the FBI outside the Biograph in Chicago in 1934. A look-alike "patsy" was set up and killed so Dillinger could make

his final escape. He retired from crime and died many years later in Upper California).

MM: Karen Black starred in all three stories in the first *Trilogy of Terror*. Was that planned when you wrote the two teleplays, along with Matheson's for the show? And what did you think of Black's performance?

NOLAN: She was extraordinary in those multiple roles. Very impressive. And, yes, Dan wanted the same actress to star in all three tales. My two were totally eclipsed by Matheson's *Prey* featuring that evil little (Zuni Fetish) doll. That's the one that everyone remembers. It made a terrific impact.

MM: What are your thoughts on *Terror at London Bridge*?

NOLAN: Well, I had always wanted to write a story about Jack the Ripper, but the problem was to find a totally fresh approach. That problem was solved when my wife (Cameron) and I visited the London Bridge in Lake Havasu, Arizona. A wealthy American bought the bridge from England, had it torn apart and shipped over, stone by stone, to the U.S. They rebuilt it in Arizona and diverted a section of the Colorado River to run under it. When my wife and I arrived there it was late at night and all the other tourists were gone. We were the only people in this British village built around the bridge. I stood there, looking up at the dark stone structure. Then I said, "I'll bet Jack the Ripper walked over this bridge after his murders in Whitechapel." And that did it. I had my fresh approach. My idea was that Ripper had been shot on the bridge and had been crushed by a stone that fell

with him into the river. It's found at the bottom of the Thames a century later and brought back to Arizona to be fitted into the structure and a drop of tourist's blood brings him back to start his reign of terror all over again. It worked out beautifully. Prime popcorn entertainment.

MM: What was the inspiration for *Burnt Offerings*?

NOLAN: The studio asked Dan Curtis to direct a film version of the novel, and Dan said "yes," and called me in to write the screenplay. We threw out the first section of the book (which was set in downtown New York) and started in the country when the family arrives at this haunted house. Most critics panned the film, but the public loved it. I happen to think it has some really scary scenes.

MM: What led up to you, Richard Matheson and Dan Curtis working together again for *Trilogy of Terror 2*?

NOLAN: Richard Matheson had nothing to do with the second *Trilogy*. Dan simply re-shot Matheson's *Bobbie* from his earlier script and put it in as the middle story. Then he and I wrote the other two as a team. I had always wanted to have a crack at writing about the Zuni doll (since it was all anybody ever talked about from the first *Trilogy*), so it was very satisfying being able to do it at last.

MM: You say that you've written 19 unproduced scripts. What are some of the best of these, and why weren't they produced?

NOLAN: That's a tough one to answer because I'm fond of all of them. Most people are not aware that in

Hollywood only about one of ten accepted scripts ever gets produced. The others are assigned, paid for, written in blood, and then, for one reason or another, put on the shelf. I worked my ass off on every one of my 19 unproduced scripts.

For *Murder on the Istanbul Train* the network sent me overseas, where I rode this train across Europe into Vienna and turned in a really exciting script. But the actress who was to star in it, and for whom it was written, took on another project. My train was dead on the tracks. George Clayton Johnson and I sold an original half-hour teleplay *Dreamflight*, to (Rod) Serling at *The Twilight Zone*, but they went to hour scripts for the season and that was that. I wrote a neat, moody screenplay for director Billy Friedkin (who flew me down to the Gulf of Mexico to scout locations), but before we could get *De Pompa* produced, Billy was off to New York to direct *The French Connection*. A producer at MGM called me in to write an action Western I called *The Nighthawk Rides*! They decided, once it was done, that it was "too close to Zorro," so it never got made (it was later printed in *The Best of the West*). The irony here is that they had originally asked for a "Zorro-like" script! Buck Houghton, who worked for Serling in producing *The Twilight Zone*, hired me to write the pilot for a new TV series, *Just before Dark* (a clone of "Zone"), and I based the script on my oft-reprinted story "The Small World of Lewis Stillman," but the producer died before the cameras could turn.

And I've written before about the ill-fated story behind my two-night miniseries based on Peter Straub's *Floating Dragon*. I spent six months adapting his novel, and finally had a shooting script everyone

loved at the network (NBC). It was green-lighted for production, and just eight days before the first day of principal photography all of the execs at NBC were fired and their projects scrapped. End of the Dragon!

I could go on with other sad tales about aborted scripts, but it's too painful. I must stop.

MM: What does the F. in William F. Nolan stand for?

NOLAN: The F. is for Francis, a name I've always disliked. Which is why I called the villain Francis in *Logan's Run.*

MM: What things about the small press do you like?

NOLAN: The raw enthusiasm, for one thing. Many of the big New York publishers are jaded, often cynical, and approach new books with little or no excitement. The small-press people put their hearts into each book and appreciate the writer. Three of my best collections, *Logan: A Trilogy, Things Beyond Midnight* and *Night Shapes* have all been issued by small press houses and I take great pride in these books. Each was a labor of love. Having worked with over 70 publishers around the globe, I happen to know that small-press people really care.

MM: If you could be any monster, which monster would you be?

NOLAN: Count Dracula, of course. He gets to sink his fangs in all those beautiful women.

MM: Critics have always been down on horror. What's your perspective?

NOLAN: Critics are always worried about something.

They delight in predicting doom and gloom. The truth is horror, like the mystery, will always be with us, and the writers who do it really well (King, Koontz, Barker, Rice, Straub and company) will continue and prosper. Only hack writers with marginal talent are falling away, unable to find new markets. The good writers (and, all ego aside, I count myself as one of them) will survive and do well. People enjoy being frightened. Always have, always will. But the quality must be there.

MM: Do you prefer to be known as a writer of science fiction, horror or mystery?

NOLAN: None of the above. I'm just a writer. Period. I've worked in the fields of fantasy, horror, SF, hard-boiled, technical writing, biography, mystery, western, auto racing, aviation, and what have you. Two thousand items in all. I like to stay fresh by switching genres. That's how I keep surprising myself with what comes out of my head. If I'm never bored, I'll never bore my readers. That's the key to long-term success in this game.

MM: Any advice for beginning writers?

NOLAN: Sure. Stay tough. If you know you have talent (and it takes a while to find out) then hang in there. Don't be put off by rejection. I wrote for 15 years before I made my first sale at 25.

Beyond talent, a writer needs to be persistent. Have the strength to bounce back. Whenever I receive a rejection in the mail or from a producer, I begin a new story or project that same day.

Don't let the bastards get you down!

MM: Last words?

NOLAN: I would like to thank all the legions of readers throughout the decades who have contacted me, written me, phoned me and who have read my work and encouraged me all the way. This is what it's all about—pleasing the reader. People ask me what I'd like on my tombstone, I just want four words: "He was a storyteller."

"Probably the greatest service the cinema has done for horror writing is to give it a face. It is also the greatest disservice, however. Mary Shelley wrote a description of a man-made man in Frankenstein. Universal gave it a face. The two are poles apart, but it is Universal Studios' Frankenstein that's remembered."

—Ingrid Pitt

COUNTESS DRACULA

INGRID PITT

SOMETIMES REAL LIFE can be more frightening than cinematic scares. Such is the case of Ingrid Pitt. She experienced her share of real-life horrors while still a child. She was born on a train bound for the hell of a concentration camp during World War II. She emerged from Nazi-occupied Europe destined to rise from the ashes of her past to the lights of the silver screen.

Made famous by her roles in such Hammer films as *The Vampire Lovers, Countess Dracula* and horror films *The House That Dripped Blood* and *The Wicker*

Man, she has appeared in more than forty films and TV series.

Besides co-starring with horror luminaries including Peter Cushing and Christopher Lee, she has worked with the likes of Clint Eastwood, Richard Burton, Orson Welles and Sir Laurence Olivier.

She has also lent her ceaseless energies to the written word in the form of short stories and non-fiction books. Her latest publishing venture is *The Mammoth Book of Vampire Stories by Women* edited by horror maven Stephen Jones. Not only does Ingrid's photo grace the cover, but she wrote the introduction, as well as a story for the bloody brilliant collection of stories.

Her later roles included *Sea of Dust, Minotaur* and *The Asylum* (with her daughter Steffanie Pitt).

Ingrid Pitt passed away on November 23, 2010 at the age of 73.

To find out more about Ingrid Pitt visit her web site at: www.pittofhorror.com.

MICHAEL McCARTY: You've become something of a horror sex symbol in a career spanning more than four decades. How do you feel about that status and has that feeling changed over the years?

INGID PITT: Old! (Laughs)

MM: In the United States we tend to hold our cinematic idols, especially the femme fatales, very dear. Is the fan support from, say, Great Britain, Spain and other parts of the world as enduring?

INGRID: I suppose my main support comes from the

USA and Britain—and my Zimmer Frame—in equal proportions. I am eternally grateful. I find it incredible that people still remember me after all this time.

Spain? I occasionally get a letter if there is a re-run of one of my old Spanish films, but the rest of Europe you can forget. Although, when I go anywhere to a festival or convention I'm always surprised at the turnout. Perhaps they just can't write.

MM: You've written, at last count, nine books, including *The Ingrid Pitt Bedside Companion for Vampire Lovers* and *The Bedside Companion for Ghosthunters*. Are you an enthusiastic reader of horror fiction? What are some of your favorite horror tales and authors?

INGRID: The few horror books I have managed to browse through when I have been asked to review them have been distinctly third rate. I suppose the few exceptions are Stephen King, James Herbert and Stephen Laws. I'm sure there are other writers out there writing first class horror—I just haven't come across them.

I must confess that I'm not much of a reader just now. I spend most of my time writing. I've always been a great fan of the classics, especially Russian. In a lighter vein, I suppose I prefer biographies. My favorite author, I guess has to be (Leo) Tolstoy—although I do have a sneaking admiration for Jeffrey Archer. There! I've said it!

MM: After having made such fantastic films as *Where Eagles Dare* you went on to star in the vampire classics *The Vampire Lovers, Countess Dracula* and

The House that Dripped Blood. Did you feel, at some point, you were becoming typecast? Was this a concern at the time or did you welcome the status?

INGRID: I can't see that there is anything wrong with typecasting. I know people like Chris Lee disagree with me. He hates it that he is mainly remembered for his Dracula films. It has never been a problem for me. All someone has to do is toss a script in my lap and wave a check in the breeze and I'm theirs.

MM: What are your thoughts concerning the impact of horror films on the written form, on books and magazines? Have films aided in the sales of books or have they desensitized the audience? Jaded them?

INGRID: Probably the greatest service the cinema has done for horror writing is to give it a face. It is also the greatest disservice, however. Mary Shelley wrote a description of a man-made man in *Frankenstein*. Universal gave it a face. The two are poles apart, but it is Universal Studios' *Frankenstein* that's remembered.

MM: How do you feel about slasher type films/stories as opposed to the more subtle movies and books? Are you a fan of the classic gothic novel, *The Haunting of Hill House* by Shirley Jackson?

INGRID: I've always thought slasher movies were the pits. Still do. The only experience I have had with this type of movie was in Belgium. I spent the best part of two weeks with Robert Englund (Freddy Krueger) and his wife, Nancy. Both of them are among the most charming people I have ever met. But, I still don't like slasher movies.

I haven't read Shirley Jackson's novel, but I have seen *The Haunting* (1963 film, directed by Robert Wise and starring Julie Harris and Claire Bloom) which was based on it. It is one of the best pure horror films I have ever seen.

MM: On to another aspect of horror—sex . . . *The Vampire Lovers* was the first Hammer picture to feature nudity. Were you reluctant to reveal your, um, attributes? How did you feel about being semi-nude in front of the cameras? Any memorable anecdotes you'd care to share with the class?

INGRID: Nudity didn't bother me particularly. I thought I looked pretty good in the buff and didn't mind flaunting it. And what's this 'semi-nude,' bit? I did the full monty.

I did ask for a closed set at one time. More because Maddie Smith wanted it than from any sense of modesty on my part I'm afraid. The producers weren't too keen. They considered a little voyeurism on the side a part of the producer's perks. I happened to walk down the corridor as I was going to the set and met them coming from their offices. I was wearing only a dressing gown. They looked so sad I thought I'd give them a flash. That put a spring in their step!

MM: You did bath scenes in *Countess Dracula, The Vampire Lovers* and *The Wicker Man*. Off screen would you say that you're more of a bath or a shower person?

INGRID: Don't be daft! After Psycho there are still women that insist on showering? (Laughs)

MM: You worked with Jon Pertwee in *The House that Dripped Blood* and the *Dr. Who* television series. Any fond memories of Jon?

INGRID: For me Jon was THE Doctor. I really regret that I never did have photographs with him when we did "The Time Monster" episodes. In *The House that Dripped Blood* I was initially down to do one of the other segments. I met up with Jon and he suggested that we ask the director, Peter Duffell, if I could play Carla. He agreed. The play was pretty straight forward until Jon got to work on it. He turned it into a great little comedy piece. Jon was a great joker. It was even extended to his funeral. As his coffin slid towards the furnace a straw effigy of Jon, in his Worzel Gummidge guise, slid off the top just as it reached the doors. Someone said in a loud voice, "Just like Jon. Always knew how to get out of a sticky situation."

MM: In the film, *The Vampire Lovers*, Peter Cushing cuts off a likeness of your head. How was it to watch that happen? Did it creep you out or was it all in a day's work?

INGRID: That was quite funny. I was in make-up and the bloke doing me said I should go and see what Peter was doing to me on the set. Being the obedient type I did as I was told and managed to creep in at the back without getting caught.

I saw Peter reach into the coffin and pick up what looked like a big turnip and swish at it with his sword. When he turned around I could see it was my head. That was a definite, gulp, situation. Peter was lovely. He apologized and I cringed when I think that I

replied, "Yes. I'm a bit cut up about it, too." Later, when my mother saw the film, she laughed. Strange!

MM: You've overcome the experience of some real life horrors, such as growing up in a concentration camp. What place do you believe fictional horror plays in our lives? Especially in the light of all the gruesome reality that is the human condition, why would you, personally, or the world at large, turn to horror for entertainment?

INGRID: Don't know the answer to that one. The horror of my childhood has nothing to do with the horror of screen and book. However degrading some of the worst of the horror genre might be, it is done for entertainment. The Nazis did it for real. There is nothing entertaining about dashing a baby's brains out against a wall.

MM: You worked with your daughter Steffanie, in *The Asylum*. What was it like to be part of introducing her not only to the film industry, but to the world via the big screen? What do you think of the current state and the future of the horror genre? Will there be as loyal and loving a following for her career as there has been for yours? Do you have plans to work with her again?

INGRID: Steffka has done a number of films, one with Peter Cushing. She has also presented DJ Kat for a couple of seasons as well as working with such luminaries as Judi Dench, Michael Cain, Roger Moore, Topal and Charlie Bronson. At the moment she is a full-time Mum and has no immediate wish to work again. She'll get over it.

It was great working with her on *The Asylum*. I

suppose it's sort of a wish-fantasy fulfilled. There is the suggestion that we do another film together next year for the same company. We'll see. I think it will be hard to get Steffka away from the baby for anything as inconsequential as a film.

MM: Last words?

INGRID: I'm not THAT old! (Laughs)

> *"Quentin Tarantino and I had the same manager for years and then he got big."*
>
> —Linnea Quigley

QUEEN OF THE SCREAM QUEENS

LINNEA QUIGLEY

LINNEA QUIGLEY IS one of the horror industry's most beloved "scream queens." She has made close to one hundred movies, has appeared in *Fangoria* magazine a number of times and is still a big draw at horror conventions across the country. She was ranked number nine on *Maxim* magazine's 'Hottest Women of Horror Movies."

Linnea Quigley has starred in her share of horror cult classics such as *Return of the Living Dead; Night of the Demons; Hollywood Chainsaw Hookers; Sorority Babes in the Slimeball Bowl-O-Rama; Burial of the Rats* (with Adrienne Barbeau); *Silent Night, Deadly Night* (I have a warm spot in my heart, or

elsewhere for her "Best Impaled-on-Antlers" performance in that film); *Nightmare Sisters;* and *Girls Gone Dead*. Besides producing movies, she plays guitar and sings in the all-girl rock band, The Skirts. She was the first woman inducted into the Horror Hall of Fame by *Fangoria* magazine. This from a lady whose first big break in showbiz was acting in a toothpaste commercial.

She decided to move to Florida to be closer to her parents in the early 2000s. She currently lives in South Florida with her myriad pets and is a big supporter of animal rights.

Linnea Quigley is one of the biggest stars to cross the B-horror movie market. She has co-authored two books with Michael McCarty, *Night of the Scream Queen* and *Return of the Scream Queen*, both available as ebooks and trade paperbacks. She is queen of the B's—long live the queen! Her websites are: www.linneaquigley.net, www.myspace.com/originaltrash and www.linneaquigleycircle.com.

This interview was done via the phone from Linnea's manager Danna Taylor's office.

MICHAEL McCARTY: How did you go from living in Davenport, Iowa to becoming one of Hollywood's most successful "scream queens?"

LINNEA QUIGLEY: Anybody who goes to L.A. gets sucked into the acting trap and then it's like, you're working at some lousy job or something and everybody goes, "Oh you should be an actress or a model, you're very glamorous." You're more attainable than in Iowa,

so I went for it! I started getting modeling gigs and I took acting classes and even though I was real shy, I ended up doing OK and I was totally shocked that it actually all happened.

MM: You made close to a hundred films—that is amazing for someone who "accidentally fell into acting." At which point did you decide you enjoyed it and wanted to pursue a career in moviemaking?

QUIGLEY: I never thought there would be a way for me, it seemed like it was so unattainable. I was born in Iowa. I didn't think I was pretty enough. I was shy. I didn't think I would be able to utter any words or do anything. I wished and wished—it took a lot of conquering my fears; this business is pretty rough on people. In the beginning it was scary. I started out doing extras work, one liners and things like that and learned all about the business. I would help out on different things and learn as much as I could.

MM: Was there an early movie, when you saw yourself on the screen and said, "I'm a professional actress now—I finally made it?"

QUIGLEY: Did you read my old diaries? (Laughs) One of the first movies I spoke in, *Fairy Tales*, I remember writing down in my diary: "Oh my God, I am a star now. I'm in a movie. I went to a theater to see it." It wasn't much of a part. To me, "this is it."

MM: In *Return of the Living Dead*, when you became a zombie, the make-up effect they used on you looks like it was a mask with an open mouth. Did you have a

hard time biting people when you probably couldn't move your mouth?

QUIGLEY: It was horrible. There were two masks made. Dan (Author's Note: Dan O'Bannon, the director and co-screenwriter, passed away on December 17, 2009) had Kenny Myers make them. For the close-up, the mask was way down. They had it when I was going to bite the people, the "Send more cops" scenes and such. They used the mask for the close-ups. He wanted the mask really exaggerated.

MM: In *Return of the Living Dead*, you stripped on top of a crypt that was lit by burning torches and was covered in sawdust that was supposed to be Spanish moss. Were you worried about something catching fire?

QUIGLEY: No (Laughs) But I was getting very dizzy because the torches were those sulfuric acid torches they use when there is an accident (road flares). The fumes from the torches were going right up into my face. We did take after take and they lit them and those fumes were brutal.

MM: In the last half of *Return of the Living Dead*, you portrayed a naked zombie in the rain. Was that uncomfortable?

QUIGLEY: Yes. It was horrible. It was very cold out. L.A. gets cold at night, the temperature drops like crazy. I was freezing. I couldn't sit down because the makeup would rub off. I couldn't put a towel around me because the makeup would rub off. It was just horrible.

MM: What was it like working on the original *Night of the Demons*?

QUIGLEY: I kept telling them I won't go up for the role because the cast was all teenagers and I was sick of going to the interviews and they wanted someone who was twelve. (Laughs) It was weird because everyone was eighteen. I didn't know how to say some of the words in the script, like "wuss," I kept saying "wus."

MM: Were you in your twenties then?

QUIGLEY: Yeah. There was a huge age gap between us.

MM: Let's talk about the remake of *Night of the Demon*. What can you tell us about it?

QUIGLEY: It is many years later and everybody is wearing less clothing (Laughs)—oh no, that doesn't happen. (Laughs) It is a little creepier, there is a lot more money to work with. The writers, the director, everybody is great. Kevin (S. Tenney—the director of the original) approved it—that is a good thing because most people wouldn't want a remake to be out there and be awful. I think people will be happy with the remake. I always hate it when people go, "They shouldn't have done a remake."

MM: Besides the *Night of the Demons* remake. What else are you working on?

QUIGLEY: *Post Mortem America, 2021*—that is going to be real kick-ass. That should be put out very soon. There are a bunch of other ones which are in production. I am doing a lot of writing and producing.

I co-produced *Vampire Theater*, which is coming out any day now on DVD. *The Notorious Colonel Steel* just came out and *Savage Streets* was re-released as a special edition and so was *Hollywood Chainsaw Hookers* (Author's Note: Twentieth anniversary, see interview with Fred Olen Ray).

I also did a scream track for a song called "scream queen" by a band called Rip Snorter. It is going to rock!

MM: What's your secret for continuing to look so good? Do your zombie workouts have anything to do with that?

QUIGLEY: Yes. (Laughs) I must say, living in California though is the best treatment for anyone—that is one of the best workouts.

MM: What is your opinion of CGI (computer generated images) in genre films?

QUIGLEY: I don't like them. I remember watching *Terminator 2* and that was the first time I really ever saw CGI effects. It was like "ugh!" It just wrecks the movie for me.

MM: Any films you regret making and why?

QUIGLEY: No, because it got me where I was going. Sometimes now, I look back at mainly how I was treated, and I think, Danna Taylor, who is my manager—she is amazing, she does things right. Everybody else just kind of sent me out to the wolves—they didn't care what I'd be doing or if I'd be cold or the food I'd eat or anything. The others were such artificial types of people. Back to the question, I regret

Michael McCarty

that I worked on films where they were not treating me or paying me right.

MM: Which films are you the most proud of?

QUIGLEY: Of course, *Return of the Living Dead*—the way it came out and everything. *Night of the Demons,* both the original and remake, I am excited, plus it's really weird seeing another Suzanne—that is going to be weird (the character she played in the original, the role in the remake is played by Bobbi Sue Luther). It makes you realize how much things have evolved and how long I have been in the film business—whoa—scary. (Laughs) I liked doing *Hollywood Chainsaw Hookers.* There are so many. *Hoodoo for Voodoo* was fun. *Treasure of the Moon Goddess* was a blast. *Savage Streets* for me was a hard part. Everybody says, "You didn't have any lines"—it was really hard to do, it was a challenge—not being able to make any kind of noise.

This one I am doing with Cameron Scott, *Post Mortem America, 2021*—it is a really great part. The weird thing is, I met him when he was sixteen. A lot of years later, he always wanted to make a movie and he did it. That is amazing.

MM: Do you still have copies of all of them?

QUIGLEY: No, some I don't, I need to find them. A lot of them are hard to find. A lot of them are "That was a great performance," but I haven't even seen it—I am not sure if it is released or how to get hold of it.

MM: Some of those '80 movies that came out on video aren't available on DVD or Blu-Ray.

284

QUIGLEY: I know it. Those movies, like *Sorority Babes in the Slimeball Bowl-A-Rama*—I liked it, too, it was fun. The crew was like family, it was a blast. It is so different now. It isn't like a family anymore, because there are so many production companies.

MM: You are also a producer. You were the executive producer for *Creepozoids*, *Dead End* (producer), *The Girl I Want* (co-producer), *Linnea Quigley's Horror Workout* (associate producer) and *Murder Weapon* (producer). How did that come about?

QUIGLEY: I really had more hands-on. It came about because I was working with David DeCoteau (the director of such films as *Sorority Babes in the Slimeball Bowl-A-Rama* and *Creepozoids*) a lot and he asked me to co-produce and I said, "Yeah." I jumped on it because I always wanted to do something besides acting.

MM: You've spoken of your desire to produce films. If you had an unlimited budget, what kind of film would you make?

QUIGLEY: Cynthia Garris (director Mick Garris' wife) and I had written a screenplay for a scary movie, kind of the old scary movie type about saving animals in a lab. It was pretty dark, a lot of action, things like that going on. It was a good script, as I remember. We tried at the time, to go to a few places—it was really hard at that time; they were doing movies mostly for two million or down to sixty thousand. I still have the synopsis and everything.

MM: Not many people know you are a writer, too. You

wrote the books *Bio & Chainsaws, I'm Screaming as Fast as I can,* and *Skin,* and co-written the novels *Night of the Scream Queen* and *Return of the Scream Queen* with me.

QUIGLEY: They were fun to do.

MM: You also had parts in *Innocent Blood*, where you played a nurse who gets sprayed with Don Rickle's blood, as well as *Nightmare on Elm Street 4: The Dream Master*. Tell us about working on the fourth *Nightmare* film.

QUIGLEY: I played the soul coming out of Freddy's chest. I got engaged after that (Author's Note: to make-up artist Steve Johnson—who also did the makeup effects for the original *Night of the Demons*—they are now divorced.) The stunt went wrong, the huge Freddy statue fell. We almost got killed. The one lady working the head, the puppeteer (Mecki Heussen) fell onto concrete—she was probably about three stories up.

MM: *Sorority Babes in the Slimeball Bowl-A-Rama* was shot in a bowling alley. Where was it shot at?

QUIGLEY: That movie was directed by David DeCoteau. We shot it in San Marcos (California), at an all-night bowling alley. It was a lot of fun to do.

MM: Have you ever appeared in *Playboy* magazine?

QUIGLEY: Three times: The "Girls of Rock N Roll," a dancing one, and "B-Movie Queens" pictorials.

MM: How long did it take for the makeup artists to apply body paint in *Hollywood Chainsaw Hookers*?

QUIGLEY: Eleven hours with three people. They thought it would only take three hours and then they had to keep calling in people. I even called my ex-husband (special effects wizard Steve Johnson). It was ridiculous. It was a very long day.

MM: Did you like the way the effect came out on the film?

QUIGLEY: Oh yeah. The effect was great but standing there for that long was horrible. I get very fidgety.

MM: What was it like working with low-budget guru director Fred Olen Ray in *Hollywood Chainsaw Hookers* (which he wrote and directed) and *Jack-O* (which he wrote the story for)?

QUIGLEY: Interesting. He's got a very sarcastic way of doing things. He keeps things moving along. He knows what he's doing. He was fun.

MM: One of your co-stars in *Hollywood Chainsaw Hookers* is Michelle Bauer. You've done a number of films with this "scream queen." What is Michelle Bauer like on and off screen?

QUIGLEY: She is great, she is amazing. It is so much fun working with her because she is so down-to-earth. She is never, "I am a star." She is just a happy, go watch football and hangout type person.

MM: How did you get involved with animal rights?

QUIGLEY: I got involved after watching this news documentary when I was twenty-one years old. The show was about the experiments they do on animals. Those images burned into my brain. I had to help out after that.

MM: Why do you think guys are attracted to "scream queens" so much?

QUIGLEY: I don't know. Some of the convention girls call themselves "scream queens" but they haven't done any movies, what I'd consider "scream queen" movies. It has changed a lot, but there haven't been a whole lot of new "scream queens" you've heard about. But they haven't really done any movies.

DANNA TAYLOR (Linnea's manager) & LINNEA QUIGLEY: Right.

MM: What is your take on the current popularity of extreme horror films like *Hostel* and the *Saw* movies?

QUIGLEY: I think it is going back to *Last House on the Left*—things like that. Where movies were really bloody and realistic. They are concentrating a lot on torturing women. It is the monster next door opposed to the monster from beyond.

MM: Any role or part you wouldn't take and why?

DANNA TAYLOR: We turn them down on a daily basis.

MM: Really?

QUIGLEY: I am surprised. I look at the scripts and go, "Oh my God." We hear so and so is going to do that movie and it was offered to us because they had read it. The script is really bad.

MM: Any unfulfilled fantasy about working with big name stars or directors?

DANNA TAYLOR: She has always wanted to work with Rob Zombie.

QUIGLEY: Yeah, Rob Zombie. Quentin Tarantino. Quentin and I had the same manager for years and then he got big. The lady who manages him—Cathryn James, she got him there.

Robert Rodriguez (the director of such movies as *From Dusk till Dawn, Planet Terror* and the *Machete* movies) would be great to work with.

I'd like to work with Mick Garris again. I've known Mick and Cynthia Garris for so long. I have a tape—I have to change it over to DVD. When Mick was struggling to get by, his wife was teaching aerobics classes. Mick wanted to be a moviemaker, he wrote a little something—we all had little parts in it. It is based on a true story of his, it was more comedy. I'd love to work with him—because he's a great guy.

MM: Any advice to ladies looking to break into the horror film field?

QUIGLEY: You got to trust your gut feeling. There are a lot of people I've helped and given advice to, but they don't follow it. You really got to do things—and they don't. You get tired of repeating yourself again and again.

And get everything in writing. Get to the bank with them, maybe bring a Taser if you have to. (Laughs) Turn into the psycho that you are playing. (Laughs) Tell them you want your money or you are calling in Danna. (Laughs) There is a lot of sweeping involved.

DANNA TAYLOR: Yes, I get to sweep up the mess. (Laughs)

MM: Cheech and Chong are making a comeback and you appeared in two of their films, *Nice Dreams* and

Michael McCarty

Still Smokin'. Are they as wild and crazy as in their movies? What was it like being on the set with them?

QUIGLEY: Cheech is really a nice, smart guy. Tommy Chong, I don't know that well; he is more quiet.

Cheech is really into his career, a happy guy, a genuine person. It is so cool that he broke that barrier and got onto *Nash Bridges*.

> *"Ed Wood was a very gregarious, out-going guy. He was very excited that anyone remembered him or would want to hire him to write. It's a real shame he didn't live long enough to enjoy the fame he would later receive."*
>
> —Fred Olen Ray

ONE-MAN MOVIE INDUSTRY

FRED OLEN RAY

By Mark McLaughlin & Michael McCarty

T HE MOVIE TITLES instantly grab your attention: *Attack Of The 60-Foot Centerfold, Scream Queen Hot Tub Party, Dinosaur Girls, The Brain Leeches, Beverly Hills Vamp, Bad Girls from Mars, Invisible Mom, Hollywood Chainsaw Hookers,* and more. You know these movies probably haven't won any Oscars, but even so, they have their place in the hearts of their fans. These are cult classics—campy, vampy and beloved by art-house/drive-in/late-night-cable watchers and adventurous DVD renters everywhere.

291

Michael McCarty

Those titles and more are the brainchildren of Fred Olen Ray, who is practically a one-man movie industry. Over the past thirty-plus years, this prolific producer, director, and screenwriter has made more than a hundred films, and is showing no signs of slowing down.

Born September 10, 1954, Fred was born in Ohio and grew up in Florida, where he worked with film legend Buster Crabbe on the movie *Alien Dead*. Fred later moved to Southern California so he could be closer to the beating heart of America's film industry. He has worked in the genres of horror, science fiction, action-adventure, crime dramas, soft-core erotic films and also some family films.

Over the years, he has used a variety of pseudonyms, including Bill Carson, S. Carver, Roger Collins, Peter Daniels, Nick or Nicholas Medina, Sam Newfield, Ed Raymond, Sherman Scott, and Peter Stewart. A man of many talents, he has even tried his hand at professional wrestling under the name of Fabulous Freddie Valentine.

His early movies—often low on budget but high on energy—appeared at drive-in theaters and Grindhouse venues. Many of his more current movies have been released straight to DVD or to such cable TV channels such as Cinemax, HBO and Showtime. Many of his films are released to DVD by his own company, Retromedia.

MICHAEL McCARTY: Tell us about your upbringing. What inspired you to follow a career in films?

FRED OLEN RAY: Like a lot of kids, I was influenced

by *Famous Monsters of Filmland* magazine and their articles about how other kids were making their own movies using their parents' 8mm cameras. I grew up mostly in Florida in a middle class family.

MM: What was the first movie you remember seeing?

RAY: My earliest memories are *The Alamo* and *Master of the World*, about 1960, I'd imagine.

MM: How did you get into the movie industry?

RAY: I started out in television and radio in Orlando, Florida and made some very bad low-budget features on the weekends while working at the station. I eventually got stale at the station and decided to give California a shot.

MM: Tell us about your current projects.

RAY: I have several shows out and about right now, but the most current is *Dire Wolf,* a prehistoric monster flick with Maxwell Caulfield. It just came out of post-production today. I'm also prepping the third season of *The Lair* for here: TV.

MM: One of your earliest movies, *Alien Dead* was made for $12,000—of which $2,000 went to guest star Buster Crabbe. How did you get Buster Crabbe to come out of retirement for only two grand?

RAY: I was a cameraman for The Golden Age Olympics, which Buster Crabbe was the Grand Marshall of and I approached him there. He had friends in the Orlando area so he was keen to come back on someone else's dime . . . and I do mean dime!

MM: In *Alien Dead* there is the line, "She's deader than Mother's Day in an orphanage." Did you write that or was that Martin Nicholas?

RAY: That was actually a gag tossed in by the actor, Dennis Underwood, who was a funny guy.

MM: You met Edward D. Wood Jr. before he passed away. What was Ed Wood like?

RAY: Ed Wood was a very gregarious, out-going guy. He was very excited that anyone remembered him or would want to hire him to write. It's a real shame he didn't live long enough to enjoy the fame he would later receive.

MM: Why was *Hollywood Chainsaw Hookers* called *Hollywood Hookers* in England? Did they object to chainsaws more than hookers?

RAY: The UK had a thing about the word "Chainsaw." They forbid it. I used to say they were all down with hookers because that's what they had the most of . . . but I was just kidding, of course.

MM: In 2008, you did a 20th anniversary edition of *Hollywood Chainsaw Hookers*. Why do you think the film has held up to the test of time?

RAY: I think it's an honest exploitation film. Definitely a product of its time with a certain awareness of what came before it.

MM: *Hollywood Chainsaw Hookers* and some of your other movies were featured in *Playboy* magazine during the '80s. How did it feel to have your films featured next to Playboy bunnies?

RAY: Any PR is good PR . . . better than being hyped in *Nugget*. *Playboy* was the top of the line as was one of the highest paying mags for writers.

MM: Should directors have previous experience of being actors?

RAY: Probably not . . . actors can be very funky people. I've always likened running a set is like running a day care center. Directing and acting are two VERY different jobs.

MM: Do you think the old black-and-white horror films will be lost to future generations raised on CGI effects? It's sad to think of Lugosi's *Dracula*, for example, fading into obscurity . . .

RAY: I know my kids have always steered clear of anything not in color, but I'm sure a resurgence will happen . . . like with Bogart and Dean. The old films will continue to entertain a certain group.

MM: Who is the biggest star you've ever featured in a production? Who was the most memorable star you've ever featured—meaning, one who made the experience of working with them, for whatever reason, impossible to forget?

RAY: For good, bad and ho-hum I would say Lee Van Cleef, Telly Savalas, John Carradine, Cliff Robertson, Morgan Fairchild, Udo Kier, Tom Berenger and maybe Tanya Roberts.

MM: Does the casting couch still exist in Hollywood today? If so, does this happen with big budget movies or indie movies?

RAY: I couldn't tell you. I've never seen such a thing, but I do know that some directors try to find their next date amongst cast members, but I'm not naming names.

MM: Besides budget and distribution, what are the other major challenges for indie filmmakers?

RAY: Getting the money raised, and getting the money back, are the toughest things. There is no good market right now for small films. Almost everyone is losing their shirt.

MM: Which of your movies would you consider to be your personal best?

RAY: *The Shooter.*

MM: Are vampire movies the cheapest of all horror films to make (with the possible exception of "invisible man" movies)?

RAY: Invisibility films are actually tough, because there are so many effects shots in them. I'd say vampires are even cheaper than zombies, but zombies come close.

MM: You've made some movies with some pretty wild monsters in them. Which one was your favorite?

RAY: Probably the creature in *Deep Space.* It was big and rolled around on a track. I wish that would come out on DVD!

MM: If you could remake any classic movie, no expense spared, which one would it be—and what would you change in your version?

RAY: I'm not a fan of remaking classic films. I wouldn't mind making *Halloween 8,* but I wouldn't want to tackle a remake of John Carpenter's original.

MM: Peers: Roger Corman, George Romero, John Waters—who, if any, do you admire and why? Is there one you'd like to work with someday?

RAY: Always looked up to Roger Corman . . . the perfect blend of business and art. I've liked John Waters' stuff. I would like to direct Christopher Lee in something, but that probably won't happen.

MM: You worked with a number of scream queens over the years. Who do you think were the sexiest? Did any of the girls complain about the nudity?

RAY: My vote always goes to Michelle Bauer for sexiest and funniest. Not too much complaining. I'm a pretty even-tempered guy and never push people very hard during the shoot. I like to hit it and quit it.

MM: Any last words?

RAY: Yeah, I've said it before, but people always ask me what I'd really like to be doing and I tell them in all honesty I have everything I want in life. I have a beautiful loving wife, great children, a dog, a big house and a nice car . . . short of winning the lottery that just about covers it for me. Thanks.

MM: Thank you, too.

"All interesting fiction hinges on loss of control in one variety or another. I've always enjoyed the idea of having nasty children, not because I don't like children, but because there is an interesting thing when you have a child who is doing nasty things. You have to go very, very far before the child becomes unforgivable. If you are playing with children in the kind of fiction I write, you can have the hero also be the villain."

—John Saul

PERFECT NIGHTMARES

JOHN SAUL

FOR OVER THREE decades now, John Saul has been writing superb edge-of-your-seat thrillers that have bulleted to the top of the bestsellers list. His debut novel *Suffer the Children* is one of the scariest novels of the 1970s and still brings chills today.

John was born in Pasadena, grew up in Whittier, California, and graduated from Whittier High School in 1959. He attended several colleges: Antioch, in Ohio; Cerritos, in Norwalk, California; Montana State

University; and San Francisco State College, variously majoring in anthropology, liberal arts, and theater, but never obtaining a degree.

After leaving college, he decided the best thing for a college dropout to do was to become a writer, and he spent the next fifteen years working in various jobs while attempting to write a book someone would publish.

He is the author of thriller classics such as *Nathaniel, Punish the Sinners, Second Child, Guardian, Black Lightning, The Right Hand of Evil* and *Blackstone Chronicles* (originally published as a series of six books, but now published in one volume). His latest works include *House of Reckoning, In the Dark of the Night* and the eBook *The Warning*.

He lives in the Pacific Northwest, both in Seattle and the San Juan Islands. He also maintains a residence on the Big Island of Hawaii.

John Saul is also the subject of the book *John Saul: A Critical Companion* by Paul Bali, published by Greenwood Press. His website is: www.johnsaul.com

MICHAEL McCARTY: *Perfect Nightmare* deals with abduction. Was there a real-life abduction that you studied as research for the book?

JOHN SAUL: No, I just made it all up. I'm not a great one for doing research. Research is for nonfiction writers. I do enough research if someone is using a weapon. Then the weapon is right.

Perfect Nightmare was a very simple idea. It was the basic concept that whenever someone puts their house up on the market, there is an open house held.

The realtor always wants the owner gone for the day. You don't know what happens in your house when you've been gone. You don't even know if everybody left your house. Just about anybody can come wandering in.

I actually went to an open house one day and spotted one of my books on the shelves, so I autographed it. I often wondered if the owner found that book and said, "That's odd. Why did this say, "Nice House—John Saul." (Laughs)

MM: What can you tell us about your new book *In the Dark of the Night*?

SAUL: A family rents a house on a lake for the summer and things go wrong. What can I tell you? But you know that going in. If a family rents a house on a lake for the summer in a John Saul book, things are going to go wrong. (Laughs)

MM: You write supernatural thrillers, techno-thrillers and psychological thrillers. Which kind of thriller is the most thrilling for you to write?

SAUL: Probably the psychological thrillers.

MM: Why?

SAUL: Because usually that is delving deep into the subconscious where you can find the strangest and sickest stuff going on.

With the supernatural thriller, the paranormal stuff, I really have to work hard to convince myself that all this is happening. If I don't believe it is happening, just the way I write it, the reader's not going to believe it, either.

The techno-thrillers are lots of fun. I'm finding that if I write a techno-thriller, someone who really knows the subject will come along and tell me "That's already going on," and that really scares me. I don't want to be writing nonfiction. (Laughs)

I had a wonderful moment years ago in Detroit on a talk show where they were giving me the whole show. It was an hour and an half, which is a novelist's dream. We just don't get an hour and a half on nationwide television. Everyone at Bantam is jumping up and down, and so am I. The book was *The God Project*.

Then they announced that there was going to be one other guest: the Detroit area's leading expert on DNA and genetics.

I thought, "I see. They are going to call in the guy who knows and put a kibosh on the book." Bantam flew their head publicist out to hold my hand during the carnage.

I went into the greenroom. I was introduced to the guy by the smirking host, and I thought, "Yeah, he's out to get me."

My stomach sank further, when the expert said, *The God Project* was the only piece of fiction that he had read in twenty years. He didn't even like fiction. Then he says, "The way I see my role on the show is to provide the technical backup for everything you posited." At that point, the host's smirk disappears and he starts looking terrorized, and I say to the other guest, "There is some?"

The expert said, "I was reading this book and the only thing I wished was that you would have talked to me before you wrote it, because I could have told you where everything in this book is going on and a whole lot more I can talk about on the show."

That was the end of the carnage. It was a great show for me. The host was not happy. I had lucked out; everything I posited turned out to be true, or at least possible. It hadn't all happened, but it was at least feasible.

In *Creature* I had stumbled across steroid rage before the medical community knew anything about it. It was simply an idea: what if people could start designing their own bodies? For the sake of bases, in the book, it was a football team. That's a nice idea, but things have to go wrong, and I thought, "Gee, I wonder if there is a really bad side effect, and that would be uncontrollable rage." And sure enough, two years later it turned out that is actually the side effect. (Laughs)

MM: What is the difference between a thriller and a horror novel?

SAUL: To me, horror novels involve usually the supernatural things and things crawling out of the swamp: vampires, werewolves and that stuff. That's my definition of horror.

Thrillers offer a much wider range. For me, horror is the category, and thriller is the genre.

MM: *Midnight Voices* has been compared to Ira Levin's *Rosemary's Baby*. How do you feel about that comparison?

SAUL: It doesn't bother me at all, especially when you consider that when I was researching *Manhattan Hunt Club* I was wandering all over the west side of New York. Every time I passed the Dakota I would think, *Rosemary's Baby* is not the only thing that ever

happened in that building. Something else is going on in there. It's a natural." (Laughs)

MM: In *Nightshade*, fifteen-year-old Matthew Moore has his Grandmother move in with the family, but he doesn't adjust to the situation very well. In the 1960s and 1970s they talked about the generation gap between parents and their kids. Do you think there is an even bigger generation gap now between grandparents and their grandchildren?

SAUL: Oh boy. I'd say probably so, for no reason other than that families tend to be more spread out more now than they used to be. Often kids will only see their grandparents once or twice a year, because they are living on opposite sides of the country.

I was doing some research on my own family. I discovered that one hundred years ago, there were nine different groups of the same family living within one block of each other in Springfield, Illinois. They were all really close, a close-knit family. I never knew that there were that many of them, let alone that they were living up and down Eighth Street. (Laughs)

You go through old census records, you discover how many parents and grandparents are living with their offspring or their grandchildren. That doesn't happen as much as it used to.

Yes, that would be inclined to create something of a generational gulf, because kids don't know their grandparents and don't form a relationship like they used to.

MM: *Suffer the Children* has been around for over three decades now—

SAUL: That's scary, isn't it? (Laughs) Considering that the average shelf life of a book is about seven days.

MM: What do you contribute to the novel's longevity and popularity?

SAUL: It's a very sick book. (Laughs) I only read it once. That was several years ago when my editor wanted me to do a sequel. When I wrote it, I was under incredible time pressures. I had no time to read it at all. I would simply type it and send everything off to the editor at the end of the week. I only had one month in which to write the novel.

 I think it touches a lot of nerves. I think it touches nerves of kids who feel alienated. I got a very interesting letter from a woman not so long ago, who has read *Suffer the Children* many times. The first time she read it, she was eight years old. I thought, "That is a shockingly young age to read that book." As it turned out, as she read that book, she realized she wasn't the only girl in the world who ever had been abused by her father. As she grew up, she apparently clung to that. She took the trouble to write to me, years later, to say it was one of the things that got her through her horrible childhood; simply having found from *Suffer the Children*, that she wasn't the only one. It's kind of a creepy story.

MM: Do you think the deadline of only a month to write it and the time pressure you had to write the book, might be one of the reasons it is so intense and scary?

SAUL: It may be. Both my editor and my agent have said, "You know, John, the faster you write, the better

it is. When you take more than a month or two, we start worrying."

MM: You don't read in your own field. Why?

SAUL: I have never really been that interested in the fiction I write. I certainly wasn't reading it when I started writing it. When I wrote *Suffer the Children*, the most I read of this kind of fiction was the flat copy on the back of a couple of paperbacks to get an idea of what was going on. It all seemed to be children in jeopardy, and I thought, "I can do that." That seems easy enough.

I actually set out to write comedy. I wanted to write comedy murder mysteries. It turns out there is no market for comedy murder mysteries. Apparently everyone doesn't find murder as hilarious as I do. (Laughs)

As I began writing this kind of fiction, it occurred to me that I didn't want to wind up swiping ideas. Nor did I want to abandon a good idea because somebody else had done it or done something like it. My policy has been to ignore it all.

Every now and then, I get something sent to me for a blurb and I try to read it and, for the most part, it just isn't my kind of fiction. I much prefer historical fiction. I read much more nonfiction than I used to. I just love international spy thrillers back when (Robert) Ludlum was in his prime, which unfortunately was a very long time ago. It's nice to know he is still writing, although dead. (Laughs)

I've read many, many reviews claiming I ripped off the plot of this book or that book or the style of this book or that, this author or that author. Sometimes

I've actually heard of the book. I have never seen one where I had read the book. Usually, I am accused of ripping off authors I never heard of. Fortunately, I can dead honestly say: I never read that book or heard of that person. (Laughs)

MM: What was the inspiration for *The God Project* and *Sleepwalk*?

SAUL: *The God Project*, essentially the idea was to do something with recombinant DNA, where you were able to fiddle with the offspring before birth.

Sleepwalk, that was interesting, too. That was about Nano machines that now exist. I wanted to do something set in the Southwest because, when I was in college, I had a summer job working on an archaeology exhibition in Arizona. I knew quite a bit about the culture and the country out there. My mother was on the Navajo reservation for a while when she was a kid. I thought it would be fun to set something out there. I wanted to do the problems of a kid who was half Native American and half-white. I wanted to get into the whole Pueblo/Kiva society structure a bit, the mythology. That book is one of my favorites. It wasn't anybody else's favorite. (Laughs) I think I like that one too much or something.

MM: Dell originally wanted someone to compete with Stephen King when they published your early books. You've met Stephen King since then. Are you guys friends? What is Steve like?

SAUL: Steve and I aren't close friends. We're certainly acquaintances. We get along just fine. He is a very, very nice guy. He lives in Maine; I live in either Seattle or Hawaii. We rarely see each other.

The last time I saw him, I bumped into him in Boston in front of the Four Seasons Hotel. I promptly took the opportunity to invite him to the Maui Writers Conference and he sort of grumbled back, "Gee, Dave Barry asked me on that, and so did Ridley Pearson." And I said, "Yeah, and none of us are going to let up." He said, "All right. I will come."

Instead he got hit by the van and did not come. I wrote him a note, and I said, "Gee Steve, you could have just said you just changed your mind. You didn't have to go that far. We would have let you off the hook." (Laughs)

MM: You've made a career by writing novels about children in danger from evil adults or adults in peril from evil children. How do you keep this topic fascinating for yourself and the readers? And why do you think people like reading about this theme?

SAUL: All interesting fiction hinges on loss of control in one variety or another. I've always enjoyed the idea of having nasty children, not because I don't like children, but because there is an interesting thing when you have a child who is doing nasty things. You have to go very, very far before the child becomes unforgivable. If you are playing with children in the kind of fiction I write, you can have the hero also be the villain and the person we care about the most committing all kinds of mayhem, and we're still rooting for them to overcome the urge to commit the mayhem. Whereas, if you have an adults doing the same thing, it's time to execute them. There comes a time in all of our lives when we come to an age where we are going to be held accountable for our actions, no

matter what the motivations for them is. Be it far from our control, someone is going to say, "You're old enough to be responsible for what you're doing."

For someone who writes the kind of fiction that I write, kids work really, really well, because you can have them do really nasty stuff, but deep down inside, most of the readers are still rooting for them.

My favorite characters are nasty grandparents. I love to kill grandmothers. They are fun to write. (Laughs)

MM: Do you have a sense if a book is going to be successful or not? What books surprised you by their success?

SAUL: *Nathaniel* surprised me. It was an interesting experience, in that I wrote the first draft and it didn't make a lot of sense. My editor said, "You need to come to New York and we have to have a talk about this." I went. We talked about it. The first question she asked was, "John, what exactly is this book about?" I said, "Oh, gee, I was hoping you might be able to figure it out and tell me what it is supposed to be about."

And she said, "Okay, that is the first conversation, then, isn't it?" (Laughs)

We talked it over for about twenty minutes and finally figured out what it is all about.

I went to work rewriting. I would spend all day every day in an office at Bantam, in Ian Ballantine's office. Ian volunteered to help me write that book.

MM: That's very cool.

SAUL: I thanked him, but I really felt I ought to do that myself. When it was finally finished, I took the last pages into my editor's office. She read them, and then

she gave me the most backhanded compliment I have ever gotten, which was: "Well, I suppose if we had three more months, we could make this into a good book. We don't, so we will publish it this way." (Laughs)

In the fullness of time, *Nathaniel* has outsold the rest of my books.

My editor and I were both figuring this is it, this is going to crash and burn.

As I would go out on tours to colleges, people would call in and talk about their favorite book. Invariably, it was *Nathaniel*. Finally I had to ask what was going on? And why did everyone love *Nathaniel* so much? And they said, "Because at the end you really don't know exactly what happens. You just keep on thinking about it."

I started asking people if they figured out what it was all about, because I never really have. (Laughs) That was a surprise.

MM: Did you get any feedback from people with asthma after *The Presence* was published?

SAUL: *The Presence*: that is the one set in Hawaii. No, actually I didn't. My biggest fear on that one was that I was going to get the Hawaiian culture wrong. The Hawaiians out here tend to be highly separatist. The book critics for *The Honolulu Advertiser* went after me big-time and told me how wrong I had gotten it. As it happens, a friend of mine, whose opinion I was truly terrified of because he is actually Hawaiian and a Hawaiian culture historian, read the book. And I said, "Okay, Kealii, how bad was it?" And he said, "You got it right. You got it perfect. There isn't a problem."

Michael McCarty

And I said, "What about the review in *The Honolulu Advertiser*." And he said, "She just hates you because you are not a Hawaiian." (Laughs)

I didn't hear anything from asthmatics about that.

MM: Have any of your books creeped you out more than any others?

SAUL: The one that gave everyone the creeps, including me, was *The Homing*. The concept of that was what if there was some kind of tiny insect-like creature that could take over the human body and turn us into human hives. As I wrote that, I started itching. It took me years to stop. A lot of people said they couldn't finish the book because they were itching so badly.

"As good as science is, there will always be magic, the unexplained."

—David Snell

PAVLOV'S DOGS

DAVID SNELL

By Holly Zaldivar and Michael McCarty

MERGING FROM DARK fiction anthologies and fright blogs comes short story author and novelist David Snell. His prose has even more bite than a horde of zombies devouring the flesh of a helpless victim. Some of the anthologies where Snell's writing has appeared include Pocket Books' *Blood Lite* series, edited by best-selling author Kevin J. Anderson; and *Chiral Mad*, edited by Michael Bailey. Snell's novella *Mortal Gods* garnered an honorable mention in Ellen Datlow's *Best Horror of the Year,* and his first novel, *Roses of Blood on Barbwire Vines*, also attained critical acclaim from popular novelists such as New York Times best-selling author Jonathan Maberry. His

other novels include the Pavlov Dog series: *Pavlov's Dogs, The Omega Dog, Dog Years*, written with Thom Brannan; and *The Pen Name* and *The Phone Company* written with Jacob Kier under the pen name David Jacob Night. You can find Snell on his blog: www.dlsnell.com. Here Snell interviews authors, as well as editors at book publishers, magazines, and anthologies to help writers tailor submissions for specific markets.

MICHAEL McCARTY: You're no stranger to Horror and Zombie fiction. Would you mind explaining a bit about your fiction? How do you approach the genre?

DAVID SNELL: I've left ruins of bodies all across Syria, bloody pillars and archways and buttresses for shattered stone. I've caught lightning in a Leyden jar. I've reinvented the Industrial Revolution and the Revolutionary War into the birthplace of all Steampunk, and I have bent those stylized Victorian pipes into non-Euclidean worms. I showed how, right down to the source of the very source, the universe can be extra-dimensionally meaningless unless we define it with invention and violence, and the British win anyway.

I've broken promises, I've broken hearts, I've forged legendary swords. I've ushered one evil after another unto the planet Earth, and it has hurt me, it has taken its toll.

Later, I engineered werewolves right from their very birth, through their days as precocious pups to their nights as fanged curs. I've infected one, the meanest one, with a reanimating virus and I've

marched his ass straight down to Chichen Itza, where he becomes a god by eating one. He enters Legend.

That's what I strive for, I guess. For my stories to intersect with Myth.

MM: *Pavlov's Dogs, The Omega Dog* as well as the three Dog Years prequel novels, written by you and Thom Brannan, are probably your best-known works thus far. The mixture of genetic mutations and zombies makes for an interesting combination. What kind of a post-apocalyptic world are you designing here?

SNELL: A weird one. Something like the *Island of Dr. Moreau* meets *Night of the Living Dead* meets every nightmare you've ever had. From mad scientists to ex-druglords, to the shapeshifters of Mesoamerica, *Pavlov's Dogs* bridges an epic span of time in just a handful of tales (heh).

MM: *The Omega Dog*, while a sequel to *Pavlov's Dogs*, can be read as a stand-alone novel because of its location and mythological motifs. As the modern-day viruses continue to mutate, a creature from pre-history becomes a new threat. How does the mythological attributes you explore shed light on scientific and technological advancements in our global world view? Do you think our modern world has placed itself in danger for choosing science and technology as a "religion" over other mythologies?

SNELL: Mythologies to me are like constellations: a way of explaining, through symbol and story, the material and immaterial worlds; complex systems that help describe phenomena ancient civilizations had no other way to conceptualize or explain.

Michael McCarty

In *Pavlov's Dogs*, readers have found the science, the genetic manipulation of the Dogs, very believable—no mythology necessary. But Thom and I wanted to expose that crumbling temple behind the strangler fig vines where science becomes ritualistic magic.

As good as science is, there will always be magic, the unexplained.

MM: *Roses of Blood on Barbwire Vines*, your first novel, is centered around zombies, with vampires and humans as the survivors in the post-apocalyptic world. Its style and development are certainly different than anything you've published since. The writing is lyrical in nature, while maintaining a horrifying plot. What was the catalyst for this work? How has it been received by the public? What was your frame of mind while writing it?

SNELL: I came up with the concept behind *Roses* shortly after reading Richard Matheson's *I Am Legend*. I got the idea to write a short story about the last vampire on Earth competing against zombies for the last human on Earth. You know, because of the irony. What was truly ironic, though, was that I didn't expect the idea to become my first novel. Or perhaps more ironically, that people wouldn't like it as much as I did.

I wanted to make readers hallucinate, so that food was suddenly gore and rape was flowery. That was my goal. To juxtapose beauty with the purplest of all hells, my own Garden of Earthly Delights. A lot of people hated it.

MM: The best and most effective horror is trying to

investigate what we think of ourselves and what it means to be us. Washington Irving's tales, for example, generally wrestle with the question of what it means to be an American in the post-Revolutionary War period. Nathanial Hawthorne battled with the intellectual promise of a nation rising to international credibility while simultaneously choking under the yoke of a Puritan past. Stephen King made a name for himself chronicling the slow collapse of the American small town way of life. What do you think the zombie and its current popularity is telling us about ourselves?

SNELL: That we're stuck in a pointless, self-destructive cycle. That one of our greatest fears is other people. The fear that even our loved ones can turn on us. The dread that we might have to hurt them back.

One of Stephen King's darkest secrets is to take people we're supposed to trust (a father, a sheriff, a neighbor, a child) and turn them into monsters. Most of his books feature this type of antagonist that infiltrates and takes over the people around us. Zombies fit squarely into this category. They're just one more affirmation that any human being, including your most loved and trusted, can turn into a monster.

MM: You and Jacob Kier, under the name David Jacob Knight, recently published The *Pen Name* and will soon publish *The Phone Company*. Each of these novels is horrifying in its own right, even without zombies. Its haunting development seems more personal to you, David, and the distance between you and Ben Little feels particularly close. What do you think makes these novels so terrifying?

Michael McCarty

SNELL: In *The Pen Name*, we have this character we call "the agent." At one point he says to our main character, "Mr. Little, do you know why horror novels usually revolve around the protagonist and his family? Because horror is at its best when the stakes are intimate. There are no higher stakes than the people you love." I think good horror all starts with the characters. Characters you love, characters you hate. Characters you hate to love and hate. Only after you've established good characters can you start building true suspense.

Both *The Pen Name* and *The Phone Company* use suspense to an intense degree, but *The Phone Company* builds it in a much more creeping, insidious, subtle way; you can start to see the characters lose themselves, and you begin to see what they're capable of, so you just know something horrible's coming, but you don't know what. Readers won't realize how creeped out they are until it's too late. Novels are also scary when they probe our secrets, aren't they? When they violate our privacy and our personal space. When they point out that chunk of human skin that's never fit right, over the shape beneath. We've all got a seam. Good fiction points it out.

But perhaps more than that, it's the mystery, I think. Mystery sustains horror. As Stephen King once wrote, explanations are antithetical to the poetry of fear. So I've found that the most effective horror, the kind that really sticks with me long after the book has closed, leaves the story resolved but not fully explained. When it turns "what-if" into "why?"

MM: Do you have more of a sense of humor than your readers might realize?

316

SNELL: No.

MM: Where do you see mankind being one hundred years after—

SNELL: Actually, yes, to answer your previous question. Throughout the *Blood Lite* series, edited by KJA, I've turned in stories about a ghost goldfish, Bigfoot's ghost, Elvis's zombie, and zombie fans who act like zombies for the flesh of, not humans, but zombie books. Wait . . . What?

MM: Where do you see mankind being one hundred years after the zombie apocalypse?

SNELL: Oh! It depends a lot on the type of zombie— fast, slow, smart, brain-dead, or in the case of *The Omega Dog*, shapeshifting. It also greatly depends on the type of infection. How does it spread? How fast does it spread? Where has it spread to already? Is it something we're able to vaccinate or otherwise cure? In *The Omega Dog*, they find out the virus itself has become a sort of shapeshifter. What are the long-term ramifications of that?

Of course, our reaction to the outbreak will also help determine our fate. How fast can we quarantine it? If we can't quarantine it, can we devise strategies to eradicate it? If we can't eradicate it, can we "quarantine" ourselves on some island or farm, or in some hidey-hole? And in isolating ourselves, do we have the supplies and resources we need? Are the resources we have renewable? How long will the supplies last, and are we able to restock?

I do know the human race is incredibly robust. Killing a person can be extremely hard, and it's even

harder to kill off our entire race. Of course, we have weak spots, don't we? Stab me in the heart or hit a major artery. Deprive me of water or air.

But for all that, we're resourceful, we're hardy. Despite our differences, we do have the capacity to work together for the common good. We've been doing it for hundreds of thousands of years, in fact. I imagine we have a good shot at a second chance after zombies.

It just depends on whether or not they hit a weak spot.

MM: If you could be a monster, which monster would you be and why?

SNELL: I think I'm already a monster. We all have our own sharp, ugly teeth. Sometimes they crowd out the normal ones. Sometimes we have them pulled, but there's still a hole. Even if the socket gets reabsorbed into the jaw, it influences the way the mouth grows from there.

MM: In your short story "Elements of the Apocalypse," one of your characters, a bus driver, combusts into flames. Why did you choose the profession of bus driver for your character?

SNELL: No deep reason, really. I just wanted to send a whole busload of people off the side of the road, with my protagonist jammed in there with them. I thought it would be a fun way to kick off global spontaneous human combustion (my theme in that anthology was apocalypse by fire).

MM: Last words?

SNELL: Kchrrtt! Gotcha!

"Bram Stoker was a thorough and meticulous researcher; his notes listed many information source books, but no acknowledgements for inspiration. Neither Carmilla or 'The Vampyre' were listed in his notes, but that certainly doesn't mean he did not read them or that he was not inspired by the work."

—Dacre Stoker

DRACULA THE UNDEAD

DACRE STOKER

DACRE STOKER, a Canadian citizen and resident of the U.S, is the great-grandnephew of Bram Stoker. He is also the godson of H.G. Dacre Stoker, the commander of the AE2 submarine, whose tactics were instrumental in Gallipoli in World War I.

Dacre, who now calls Aiken, South Carolina home, was a member of the Canadian Men's Modern Pentathlon Team, Senior World Championships in 1979 and coach of the Canadian Men's Modern Pentathlon Olympic Team, Seoul, South Korea in 1988. Dacre is married to Jenne Stoker and is the father of two children. He is the Executive Director of the Aiken Land Conservancy.

Dracula: The Un-Dead is Dacre's first novel. The much awaited sequel to *Dracula* was co-written with Ian Holt. The novel was published in the fall of 2009. For more info go to www.draculatheun-dead.com.

MICHAEL McCARTY: Thank you for doing this interview. It is a real honor to have you in *Modern Mythmakers*. In your opinion, do you think *Dracula* would be less dramatic or interesting without his cape?

DACRE STOKER: Bram Stoker describes Count Dracula as being dressed all in black, and as he crawls down the side of his castle, "his cloak spreading out around him like great wings." The Count's sophisticated eveningwear was introduced in the early theatre adaptation of *Dracula*. As scenes and settings were merged, the Count needed to appear more socially acceptable, thus more appealing than the hairy palmed, rank-breathed, pointy-eared horror that the Jonathan Harker describes in the novel.

I think the cape adds a very dramatic touch, and has over the years become one of the defining characteristics of Count Dracula. The formal black cape was appropriate for Victorian evening dress, and not only distinguishes the wearer as elegant and mysterious, it also transforms with a swoop into a massive set of bat wings. The costume was so effective it is now synonymous with Dracula in modern culture.

MM: Did you plan *Dracula the Un-dead* as a stand-alone book, or do you plan to write more books in a series?

STOKER: Ian and I intended *Dracula the Un-Dead* as

a sequel to *Dracula*. But modern readers exposed to the general theme of movie versions of Dracula will get full enjoyment out of our book, even if they never actually read the original 1897 *Dracula*.

Dracula the Un-Dead has everyone asking the question, what's next? Right now, Ian and I are both very busy with other projects, and we made the decision to step away from it, and catch our breath for a while, with the idea of working together again in the not too distant future.

MM: The Horror Writers Association named their award The Bram Stoker. How does your family feel about that?

STOKER: The Horror Writers Association is a well-respected organization, and the Stoker family certainly recognizes and appreciates their tribute to Bram Stoker. We are proud that Bram Stoker's legacy lives on through this appropriate literary award, and believe Bram Stoker himself would appreciate this honor.

MM: If *Dracula the Un-dead* were turned into a movie, who would you like to see play Dracula?

STOKER: I do hope that one day it does get turned into a movie. I think it is well suited for the screen. I have had a few thoughts about just the right Dracula. At the moment, I visualize Javier Bardem as Dracula. It would also be very cool to bring back Anthony Hopkins and or Sir Christopher Lee for roles, and Scarlett Johansson would make a great Mina Harker. Don't get me started . . .

MM: It is said that Bram Stoker had read Sheridan Le

Fanu's *Carmilla*. Do you know if he had read John Polidori's "The Vampyre" also?

STOKER: Bram Stoker was a thorough and meticulous researcher; his notes listed many information source books, but no acknowledgements for inspiration. Neither *Carmilla* or "The Vampyre" were listed in his notes, but that certainly doesn't mean he did not read them or that he was not inspired by the work. Polidori's short story "The Vampyre," first published in 1819, was a part of popular "horror" of the day. This, as well as the fact that Bram Stoker's character "The Count" was temporarily named "Wampyre" before Bram changed the name to Dracula. This leads me to believe that he probably did read and gain inspiration from "The Vampyre."

MM: Have you read any of Bram Stoker's other works such as *The Lair of the White Worm*, *The Lady of the Shroud*, *The Jewel of the Seven Stars* or *Dracula's Guest and other Weird Stories*? If so, what are your thoughts?

STOKER: I have read the *Lair of the White Worm*, *Dracula's Guest*, *Snakes Pass* and portions of *Great Imposters and Personal Reminiscences of Henry Irving*. They each held my attention, in no small part because they each revealed facets of Bram Stoker's own fascinating character. In *Lair of the White Worm* and *Snakes Pass*, Bram shared the perspective of his own Irish background and Irish mythology as a basis for some interesting fiction. I could draw no definitive conclusion about the intention of *Dracula's Guest* as the missing few chapters to *Dracula*. Just as a painter

makes sketches before he sets to work on the masterpiece, it may have simply been a warm up short story, which got him in the mood to write his iconic novel. That is one of the on-going debates about *Dracula* that I will leave to the scholars.

MM When *Dracula* was first published, it received mixed reviews and was only moderately successful. Why do you think *Dracula* has stood the test of time?

STOKER: Quick answer, because Dracula is immortal!

Seriously, the character of Count Dracula, more than any other figure from Gothic horror, has been very heavily marketed since 1930. Dracula has been the central character of 160 films, only beaten by Sherlock Holmes, and there are more than 600 films that feature Dracula in the cast of characters. Dracula has appeared in countless commercials, video games, stage productions, musicals and ballets. Bram Stoker's family did not control trademarks of the character of Dracula, and after *Dracula* moved into public domain, anyone could use the character or his likeness. Derivations of Dracula as a character and a brand have been very heavily marketed. Bram Stoker's Count Dracula stands as one of the most famous villains of the 20th century, and likely will continue to be in the 21st century and beyond. All of these adaptations feature variations based on the character that Bram Stoker introduced in his novel.

Of course there are unmistakable, non-villainous elements of the original Count Dracula in *Sesame Street*'s Count von Count and the breakfast cereal Count Chocula, testimony to Dracula's success at shape-shifting. When Halloween rolls around, Count

Michael McCarty

Dracula is a perennial favorite and the costumes are displayed front and center in the shops, in children's and adult sizes. Put on pale make-up, grab a cape and a $2 set of plastic fangs, and everyone knows who you are. He lives!

"Ghosts accompany us everywhere, and the longer you live, the more of them are following you around."
—Peter Straub

THE JAZZ-MAN OF HORROR

PETER STRAUB

P ETER STRAUB HAS written within the blanket genre of speculative fiction. With literacy and critical legitimacy, pleasing fans with a sophisticated mix of style and substance, over a career spanning more than a quarter of a century, he kicked the door in without trying with such books as *Julia, Ghost Story, The Hellfire Club* and *The Talisman* (written with genre giant Stephen King). His prose is intelligent without talking down to the reader, pulling off the most difficult trick of all: keeping his stories both entertaining and exciting.

Peter Straub continues to explore dark themes, both for us and with us, reaching into mystery and suspense as he continues to lead the way. There's always new ground to be broken, which is evident with his second collaboration with Stephen King, their follow-up to *The Talisman*, called *Black House*.

At sixteen, Peter Straub knew he wanted to be a novelist. He obtained a Bachelor of Arts in English at the University of Wisconsin in 1965. He went on to collect his master's degree in contemporary literature at Columbia University.

On June 24th, 2006, Peter Straub was awarded a Lifetime Achievement Award from the Horror Writers Association. The winner of many awards including several Bram Stoker awards, he is the recipient of two International Horror Guild Awards, two World Fantasy Awards, and one British Fantasy Society Award and a Barnes and Noble's Writer's Award. His website is at www.peterstraub.net.

MICHAEL McCARTY: You recently won a Bram Stoker award for *In the Night Room*. Did you expect such recognition when you were writing the book? What does the award mean to you?

PETER STRAUB: I never waste time thinking about awards when I am writing, and I hope no one else does, either. Instead of daydreaming about "recognition," I hope I can make it to the last page without breaking my neck or otherwise injuring myself.

Winning the Stoker surprised me, because I thought I was completely out of the running. I didn't think I could win it two years in a row, and it seemed to me that Stephen King deserved every laurel he could get for coming to the end of the Dark Tower series.

MM: What inspired *In the Night Room*?

STRAUB: Initially, I was making yet another attempt

to rewrite Geoffrey Household's *Great Rogue Male*, this time with a female protagonist, Willy Patrick. Alas, after two or three months I found that I was completely bored with poor Willy's back-story and couldn't stand the thought of writing page after page about the orphanage where she had mainly grown up, so I seized the first idea that came to me, that of reaching deep inside the book and turning it inside-out.

MM: Is *The Talisman* still going to be turned into a movie? What can you tell us?

STRAUB: Steven Spielberg had a great script, and everything was set to go. Then the director quit, as did his replacement. From that point on, the project was road-kill. Maybe someday in the future, it will rise and walk again.

MM: *The Talisman* was re-released shortly before *Black House*. Both novels ended up on the best-sellers list at the same time. Were you surprised that there is still a lot of interest for *The Talisman*?

STRAUB: It was very gratifying to see that. Random House was especially gratified because they had sold a lot more copies of the new version of *The Talisman* than they had expected to, both in hardback and paperback. It was warming and rewarding the book would get a whole new audience all over again. I don't think that happens very much.

I had very mixed feelings about *The Talisman* for a long time. But when I read it in preparation for starting work again with Stephen King on *Black House*, I surprised myself on how much I liked it. I thought it was really, really a nice book.

MM: Did the internet and electronic media make the collaboration of *Black House* easier?

STRAUB: Yeah, that's right. We had one of the first modems in the early '80s. The modems were big machines with telephones on top of them. You had to dial the number. We didn't have hard disks then. The floppies were like 78 records. This was before Windows, so you had to punch in a certain DOS code. Then you could hear your computer make these digesting sounds. Grumble, click, growl. It went on for half an hour while it sent a hundred pages.

When I got the pages from Steve (King) I could see them come onto the empty floppy. Line by line down the page of my monitor. They scrolled by fast, but you could still read them.

There were all sorts of glitches in codes. He was using a Wang and I was using an IBM. They had different codes for italics, for bold, all those kinds of things. Even for paragraphing. We had to figure out little symbols to use in place of the ordinary symbols and inform the machine that those symbols were codes: italic, indent, etc.

After I wrote the whole thing, I'd then do a global search and replace for italic, quotation marks. And Steve would do a reverse global replace.

This time around, of course, it was much, much easier. It took seconds to send a hundred pages through the internet. It is vastly more convenient.

MM: *Black House* tips its hat to Charles Dickens' *Bleak House* and *The Talisman* is a tribute to Mark Twain's *Tom Sawyer*. Would you consider the series literary horror?

STRAUB: It does reflect that both of its authors have read a hell of a lot of books. We have certain tastes. *Tom Sawyer* meant a lot to both Steve and me when we were kids. *Bleak House* meant a lot to us in our adulthood. Dickens in general had a big effect on Steve and myself. The title *Black House* is a deliberate reference to *Bleak House*. We sure as hell didn't try to hide it. (Laughs) We even had one character read *Bleak House* to his best friend.

John Clute (writer and editor of *The Encyclopedias of Fantasy and Science Fiction*) discovered that the Random House edition of *Black House* contained the same number of pages as the original first edition of *Bleak House*. He was sure it was intentional. Of course, it was a wonderful coincidence.

MM: *Koko* has been a favorite of your own works. What is it about that novel that you are still fond of?

STRAUB: I'm fond of the fact that while I was writing it I knew I was going somewhere new. I had the strong feeling that my game had moved up to a new level. Nothing can be more rewarding if you write fiction all day long to feel that your work has mysteriously, internally improved. That book was emotionally richer than anything I had written before.

That had something to do with the stories "Blue Rose" and "The Juniper Tree" I wrote en route for *Houses Without Doors*. Those two stories were unlike anything I had written—I wrote them with tremendous concentration and a sense of absolute involvement. I loved them both while I was writing *Koko*. I loved the activity. Those stories are very extreme, they are unpleasant; they force the reader to look at displeasing

things very, very close-up. They are also written in such a way, to achieve a kind of transparency. I didn't want any stylistic tricks to fuzzy or interfere with the transaction of the reader on the page.

I had to bring that antiseptic into *Koko*. It is a very demanding antiseptic. I had to revise everything many, many times in order to make the prose really clean and alive. So that is another reason I like *Koko*—my writing there; although I've always been absurdly proud of my prose style, in that case it had finally grown up. I also thought my dialogue had gotten a lot better.

MM: You've written about your character Tim Underhill, the jazz-loving mystery novelist, in a number of novels, such as *Koko, The Throat, In the Night Room* and *lost boy, lost girl*. How do you keep the character interesting for yourself and your readers? Do you have any plans to bring him back in the future?

STRAUB: I'm not sure about using Underhill again, though I think I might do just that and call him by another name, as a writer invented by Underhill who writes the book Underhill was thinking about writing at the end of *In the Night Room*. I like Tim Underhill. He's a lot like me, but better at everything, more honest, braver, nicer. Unlike me, he is a gay combat veteran. Also unlike me, he seems to have been celibate for a long time. At least, he was before he met Willy Patrick.

MM: I would consider you the Jazz-Man of Horror. Who are some of the jazz musicians and artists you enjoy?

STRAUB: "The Jazz-Man of Horror." That's very nice,

I love it. The heart in my taste of jazz lies with the people I fell in love with when I first started to hear jazz. My taste has expanded a great deal, and I will get to those people in a second.

The core of my taste would sound very palatable for all those who came into the (John) Coltrane era: Paul Desmond, Chet Baker, Stan Getz, Bill Evans, Zoot Sims. From there it folds out to Lester Young, Dexter Gordon—mainly talking about tenor saxophone players. Of course, no jazz fan can't worship Charlie Parker.

When I started listening to jazz, I started listening year by year to the music being made at that time. Then we got up into the late sixties, what Coltrane was doing at that period and if you weren't attuned to it, it sounded like axe murders. It was over-blowing at the top of the horn. No underlying rhythm. No underlying harmony, simply passionate or tortured or ecstatic cries. So there was no place to go from there. You can only go back after that. You can't develop that sound. You can domesticate it, which many thousands of jazz players have done since. Domesticate Coltrane and so you can squeeze it back into the harmonic box. What I realized I had to do, I had to go back to the music I had no time for when I was younger.

Once I got into my mid-30s, I started listening backwards. Back to Ben Webster, Vic Dickenson, Duke Ellington. Ultimately, to Louis Armstrong and Bix Beiderbecke. That is generations of music and if that is what you are interested in, it's a bottomless well.

MM: Talking about Bix Beiderbecke. Have you ever attended the Bix Fest in Davenport, Iowa?

STRAUB: No.

MM: When you were writing *Ghost Story*, did you imagine it would be as successful as it was? What are your thoughts on the movie?

STRAUB: When I was writing *Ghost Story* I was very aware that I was at another level from the work I had done before that. I knew something was going to happen. I knew my life was going to change in some way. I was going to make a considerable amount of money. The book seemed so much more powerful than anything I had written. So of course, I immediately informed my agent and my publishers to get them worked up. If the book had been a dud, I would have looked like a fool. They all kind of agreed with me, and the end result was that it performed way beyond my expectations. I thought I might make about a hundred thousand dollars out of the book. To me, that was a vast amount of money. It did infinitely better than that.

When *Ghost Story* was filmed, I was very pleased to think about how the movie might be. It sounded to me like it was full of potential. I loved the cast and the director (John Irving) had done a BBC version of *Tinker Tailor Solider Spy* (from the John le Carré book), so I knew he could handle difficult, complex narratives.

The studio had promised to keep me in touch, promised to let me read the script, and offered to let me come to the set and all of that. I should have known something was wrong when the studio rigidly froze me out. They told Larry Cohen the screenwriter not to let me see the screenplay.

I hadn't known what they had done until I went to

a screening in New York. I didn't want to admit then how bad I thought it was. It was too disappointing. For me, it was a lost effort.

A lot of people liked that movie and it sold another million paperbacks, so it did me a powerful lot of good. Every now and then, I run into somebody who is very fond of that movie, and I'm glad they are. If it had been ten percent better, it would have been a hundred percent more effective.

MM: *Ghost Story* has been called "one of the finest horror novels published in this quarter of the twentieth century." The book has been around for over 25 years now. To what do you attribute to the novel's longevity and popularity and critical acclaim?

STRAUB: The book was a great pleasure to write, and I think it was also a pleasure to read. It's a novel, not merely a horror novel. At least, that was what I thought when I was having so much fun writing it.

MM: Was *Ghost Story* paying homage to such ghost story writers as Henry James, Nathaniel Hawthorne and M.R. James?

STRAUB: Yes, that was really up-front, visible to all. I inserted a version of *The Turn of the Screw*, and was going to have the characters retell stories by Hawthorne and (Edgar Allan) Poe, but the introduction then seemed to overwhelm the rest of the book, so I never went beyond the James story. Of course, my point was: horror story penetrates how deeply the ghost story permeates American fiction.

MM: What is about ghosts that attract your attention? Do you believe ghosts really exist?

STRAUB: Ghosts accompany us everywhere, and the longer you live, the more of them are following you around.

MM: *Julia, If You Could See Me Now* and *Ghost Story* have one thing in common: the past eventually becomes more important than the present. Agree or disagree?

STRAUB: In a lot of the things I've written, not just those books you mentioned, the past seeps into the present, stakes multiple claims on it, inhabits it so thoroughly that the past more or less becomes the present. In a real way, the past does not exist. What was hidden there demands to be made known, and it speaks in code, in aberrations of behavior, in repetitions of behavior, in the way people speak, the words they use, and the things they see out of the corners of their eyes.

MM: If you could be any monster, which monster would you be and why?

STRAUB: Which monster? What about Bob Evans? I bet he was a very entertaining monster in his heyday. What about Steve McQueen? I'm sure he had some super-duper monster-days. Okay, I pick Steve McQueen.

MM: You wrote about automobile accidents in both *Mystery* and *The Throat*. At the age of seven, you were struck down by a car and spent several months recuperating. Can you tell us how that incident shaped your life and writing?

STRAUB: Well, I covered this fairly thoroughly in the books you mention and on my website. Speaking generally, when I was far too young for such an experience, being struck by a car and gravely injured ("turned into a bloody rag" is how this is expressed in my inner language) stripped me of the conviction that the world was a safe place. As a result, I saw threat everywhere, and still do, more or less. Such a viewpoint is a great aid to a horror writer. In fact, it amounts to a tremendously unfair advantage over the competition.

MM: Any advice for beginning writers?

STRAUB: I think beginning writers should read their heads off. I think they should read everything they can get. I think they should read the best books they can get. The worst thing any beginning horror writer can do is to read only horror. Especially horror written by people of their generation, and mistake those people for "it." By "it" I mean achieved writing: everyone who you were forced to read in school and hated. You should go back and look at: (F. Scott) Fitzgerald, (Ernest) Hemingway, (John) Steinbeck, Charles Dickens, Wilkie Collins, George Eliot, the Brontés, John Updike, Phillip Roth, (Leo) Tolstoy, (Marcel) Proust and (Feodor) Dostoyevsky. Those are the kind of people you should be reading if you want to write. You don't want to invent the wheel. You don't want to think of the world as flat. You want writing with some dimension to it and then, while you're doing that, you just have to write, write, and write. You have to write out all the bad stuff. Every writer has within them a mountain of trash, and you have to excrete that stuff

before you can get to the good stuff. The reason you have to do it is you have to discover in that process who you are.

It took me a long time to find out what I was good at. I wouldn't have believed it when I started. I thought what I would be good at was John Ashbury post-narrative contemporary novels. I discovered what I was good at was plot, narrative, tension, and a certain subset of feelings. I didn't even want that. When I discovered I was good at it, I really wanted to expand that and develop it. I think that is one of the essential tasks of young writers, to discover their real voice and their real material. It's a hard wrestle, but it's supposed to be hard.

Writing fiction is impossible. You are trying to create a completely made-up world that can replace the real world. It has to be seamless, every detail has to have vitality in it. All the verbs have sizzle in them. When you put the perfect book down on a table, it would float on a little electrical charge of air two or three inches above the table. It would sit there humming. I keep on trying to write that book, but I can't. That is the ultimate goal.

MM: Last words?

STRAUB: Um, "fractious." No, "limpid." No, "commensurate." Damn. Okay, this is my last shot—"helplessnesslessness."

And there we are!

"I chose Egypt because it has a very vampiric feel to it. There is something connected with the vastness in time that Egyptian civilization survived and the long time that has passed since Egyptian civilization died. The enormity of their monuments. The strangeness of something that was with us for so long and was huge that could even die. There is almost the feeling that it isn't dead but rather has transformed itself into a kind of slumber being, that in itself is a sort of time-vampire. As if its presence lingers in the shadows of our world in ways we least expect and feeds off of us."
—Whitley Strieber

THE HUNGER

WHITLEY STRIEBER

STARTING IN A career in the world of advertising, Whitley Strieber moved into a very different world—that of a horror and science fiction author, writing the werewolf novel *The Wolfen* and the epic vampire book *The Hunger*. Both were #1 bestsellers and major motion pictures (*The Hunger* starred David Bowie, Catherine Deneuve and Susan Sarandon; *Wolfen* starred Albert Finney and Gregory Hines).

337

fiction account of his abduction by extraterrestrials. The book became a bestseller and a cultural sensation. Strieber found himself on still another path as a leading voice on the subject of UFOs. *Communion* was turned into a movie starring Christopher Walken.

While he may be known more for his research in alien abduction and its related subjects, Strieber continues writing novel-length fiction such as *The Forbidden Zone, Unholy Fire, Catmagic, Billy* and *Lilith's Dream*, his sequel to *The Last Vampire*.

Strieber's work in the phenomenon of aliens among us and its effects remain a deeply rooted passion, manifesting in his numerous books on the subject, including *Transformation*, *The Communion Letters*, *The Secret School*, and *Alien Hunter*.

His websites can be found at: http://www.unknowncountry.com, lilithsdream.com, and thelastvampire.com

MICHAEL McCARTY: What was the inspiration for *The Wolfen*?

WHITLEY STRIEBER: I used to walk at night in New York. I lived on the Upper West side at the time. I was in the habit of walking late at night when I couldn't sleep. When I walked to Central Park I found myself being shadowed by a pack of dogs, which was a surprising and disturbing thing. There was something about them, the way they just hung behind the trees. They had none of that weary friendliness that stray dogs often had. There was something contained and well put together about them. They weren't a bunch of

mixed breeds either—they had a look which made them look similar, like coyotes or half-size German Shepherds.

I got very interested because I didn't know what to make of them. I started asking around and a friend of mine told me about a coydog which is a mixed dog coyote. Coydogs are smart enough to live comfortably in urban areas and you absolutely never see them. They have superior hearing, eyesight and smell. The coydogs might not be any more intelligent than a chimpanzee, or even less than that. But with the superior senses to help them, they are in essence, very effective in doing what they want to do. That was the inspiration, that is where it all began.

I became very interested in wolves after that. I went out at one point to the backwoods of Minnesota in the middle of summer to track wolves, and found out you really don't do that unless you want to be basically devoured by mosquitoes. (Laughs)

MM: You never use the word "vampire" once in *The Hunger*. Why?

WHITLEY: It was a literary conceit. I was just amusing myself.

MM: Do you consider *The Hunger, The Last Vampire* and *Lilith's Dream* science fiction or horror because they are about alien vampires?

WHITLEY: They're both. I had no real awareness of the whole alien thing when I wrote *The Hunger* or *The Wolfen*. It was in my mind somewhere, because that imagery parallels things I did see in the real world later on, or what I thought I saw. Knowing that, when I

wrote *Lilith's Dream* and *The Last Vampire*, I consciously played to it.

When I wrote *The Hunger* I never heard of a blonde so called alien. I never heard of the greys when I wrote *The Wolfen.*

MM: *The Hunger* has been around for two decades now. What do you contribute to the novel's longevity and popularity?

WHITLEY: I don't think a novel survives the test of time unless it's a good story. Novels which are just good stories don't survive either. It has a good story and has some characters I was in love with. The readers also fell in love with Miriam (Blaylock), (Dr.) Sarah (Roberts) and John (Blaylock).

MM: Are there any other vampire books in the works?

WHITLEY: Not now. I have moved off of vampires at the moment. I'll get back to vampires. I think my next vampire is going to be a guy. I had been exploring the power of feminine vampire for a while. Now I'd like to write about a male vampire.

MM: You wrote about ancient Egypt as being the origins of vampirism in both *The Hunger* and *Lilith's Dream*. Why did you choose Egypt?

WHITLEY: I chose Egypt because it has a very vampiric feel to it. There is something connected with the vastness in time that Egyptian civilization survived, and the long time that has passed since Egyptian civilization died. The enormity of their monuments. The strangeness of something that was with us for so long and was huge that could even die.

There is almost the feeling that it isn't dead but rather has transformed itself into a kind of slumber being, that in itself is a sort of time-vampire. As if its presence lingers in the shadows of our world in ways we least expect and feeds off of us.

Every time someone ends a prayer in the Western world they say "Amen," that is the name of an Egyptian god associated with completion. So we're still praying to their gods.

I find all of that quite fascinating. At Abydos there is a temple, and ten years ago, there was restoration work being done on it. They found some odd cartouches—it looked for all of the world like helicopters and modern jets. I'm sure that's not what they are, but seeing that can let the imagination run really free. It made me think immediately of Philip K. Dick's idea, that the Roman Empire was actually immortal, that it still was in progress and we were sort of a dream, the reality was not this.

It's thoughts like that, that led me to set my story in ancient Egypt. When you think of Egypt and how incredible that civilization was, it has been roughly 1800 years since Egypt really disappeared as a coherent culture. It became so Hellenized and Christianized that it was no longer recognized. And yet, Egypt lasted far longer than 1800 years. 1800 years into Egyptian civilization is still young. That is how extraordinary it actually was. The United States is 200 years old—that is a comma, a semi-colon, in the vast Egyptian history.

MM: Christopher Walken portrayed you in the movie *Communion*. What did you think of his performance? Did the two of you ever meet before?

Michael McCarty

WHITLEY: Oh yeah, we met a lot. We consumed certain quantities of alcohol together. We talked a lot. I was very annoyed by his portrayal of me. I think he made me look very much like myself—except for the camera. I hate cameras—I would have never touched a camera. When he had the camera on himself—the complete self-directedness of that implied—is not me at all! I am an obsessive workaholic, I am very absent-minded. I do set things on fire in the kitchen all the time. My equipment does explode and fail mysteriously all the time—just like his did. That came because Christopher Walken actually saw that happen inside my house.

When computers first came out, they were very delicate. I had a service that came once a week to replace the motherboard in my computer because it would blow out. When it blew out, I just took a holiday. It was so frustrating. I love them because of the fact that they're so quiet compared to typewriters. I would sit there and the more excited I got, I shuffled my feet when writing, and then there would be static discharges and it would blow up.

Indeed I did get the fire department to my house one time it . . . wasn't from a duct. It was because I had put the oven on self-cleaning. I was home alone, my wife and son were down at Disney World in Florida at the time. I put a steak in the oven, and I had cleaned the oven and this caused an enormous amount of smoke and the Fire Department came. That incident in the movie actually did happen, only slightly different.

MM: Was *Billy* modeled after any real kid?

WHITLEY: I think Billy was probably modeled after a lot of real kids. I was deep into kids at the time. My son was about nine or ten then. I had little boys running all over the house all the time. Billy has bits and pieces of all of them. Probably of my friends when they were little and me—I didn't model it after any one particular individual. Not consciously.

This is how I wrote *Billy*. I got a letter from somebody, who told me that the aliens were abducting thousands of children and that these children were disappearing all over the United States, and I thought at the time, "Could this be true? Is there any reality to this?"

I got involved with various missing children groups and the FBI. And I found out what the truth was. The number of children abducted by strangers is quite small. It's a horrible crime but there aren't loads of children disappearing in the United States from strangers. But by doing this research, I got very, very interested in the whole process of stranger abduction and why someone would do that. If you could imagine yourself, going out and seeing someone else's little child and taking that somebody's precious child—how could you do that?

I got very interested in the character of Barton Royal (the novel's antagonist). I wanted to know how he could do that. So I wrote the book to try to explore it.

Billy came in the book because I love kids. It is natural that I'd want to write a character who I thought was pretty cool.

MM: If you were starting over, would you be a writer again?

Michael McCarty

WHITLEY: I wouldn't be a writer. The publishing business is consolidated and I think it is impossible to start. I wouldn't even try. Unless you are willing to be highly disciplined and write to a very specific and narrowing craft genre and be actually like what others are doing.

If you are terribly, terribly talented—so talented that you are another Jonathan France, then you should write—because there is always room for genius. But for the regular, journeyman writer who can write a good entertaining story—I don't think there is a lot of room for that.

You're typecast as a midlist author even before you start. It used to be that a writer would get five or six books before you were pulled and abandoned. They gave you a chance to build an audience. Now, if the first book doesn't build an audience, you're gone.

MM: Last words?

WHITLEY: I'm always portrayed as an eerie, extremely scary person. (Laughs) Actually I am very happy. I've lived with the same woman happily for 33 years [his wife Anne Strieber]. I live a very quiet life.

Also, I didn't lie about *Communion*. I feel I have been punished by a lot of people and a lot of reviewers who felt that I had perpetrated a literary fraud in *Communion*. I did not! The events I described in *Communion* were described with as much accuracy as I could bring to that process. They happened, pretty much the way I said they happened, and I regard both rejection of me and the rejection of the validity of this experience as being fantastic, like an outbreak of cultural insanity.

The most we can do is say, "It's aliens," "I believe that," or "I don't believe that." It's a completely inadequate response to this mystery. It's much bigger than that. It has to do with our most basic meaning. And to deny it and pretend that it isn't there is to fail fundamentally.

And please check out my web site: unknowncountry.com

"The whole Star Wars project was a huge quantum leap for me, with the possibility of vastly increasing my audience or, conversely, giving me the chance to do an incredibly high-profile belly flop."
—Timothy Zahn

HEIR TO THE EMPIRE

TIMOTHY ZAHN

BORN AND RAISED in the Chicago suburbs, Timothy Zahn earned a Bachelor of Science degree in Physics from the University of Michigan and a Masters of Science degree in Physics from the University of Illinois.

With his background in science, he became a science fiction short-story writer and won a Hugo for his novella *Cascade Point* published by *Analog* magazine in 1983. Timothy Zahn entered the book market with a militaristic space opera about cyborg soldiers in the 25th century in his novels *Cobra, Cobra Strike* and *Cobra Bargain*.

In 1991 he wrote the first spin-off book ever to be published, *Heir to the Empire*. The novel stayed on the

346

New York Times bestsellers list for twenty-nine straight weeks, becoming the best-selling Star Wars novel of all time. He has since penned two different Star Wars series, including the books *Dark Force Rising, The Last Command, Survivor's Quest* and the Hand of Thrawn series with *Specter of the Past* and *Vision of the Future*.

In the past two decades, he also has written such books as *The Icarus Hunt, Angelmass, Manta's Gift, Soulminder, Terminator Salvation: From The Ashes* and *The Green and the Gray*.

MICHAEL McCARTY: You went from studying physics to writing science fiction for a living. How did that come about?

TIMOTHY ZAHN: I used to like making up SF scenarios in my mind when I was in high school and college, usually while relaxing with colored pencil drawings, but I'd never gone any further and actually written anything down. Then, in November 1975, I was inspired by a TV show to try my hand at storytelling.

I was in grad school at the time, with an advisor who was out of town a lot and a project that was continually running into roadblocks, so I had a lot of spare time on my hands. Eventually, I started typing up some of the stories and sending them to magazines, and in December 1978, I finally sold one ("Ernie," *Analog* Magazine, 9/79). I kept writing, contemplating the possibility of taking a year off after I got my doctorate and trying to do this full time. The decision was forced on me when my advisor died suddenly in July 1979, leaving me with an unworkable project no

347

one else in the department would pick up. I tried working with a new advisor for one semester, decided I now liked writing more than I liked physics, and in January 1980, I quit school and took the plunge.

MM: Your Cobra series (*Cobra, Cobra Strike* and *Cobra Bargain*) features high-tech warriors, while your Blackcollar series (*The Blackcollar* and *The Backlash Mission*) are low-tech warriors. Was this by design and if so, why? Why do you have such a fascination for detailed military strategy and tactics in these books?

ZAHN: It was definitely by design. The other planned difference between the two series was that the Blackcollar books were to be all action/adventure, focusing pretty much exclusively on the tactics and strategies, while the Cobras would include more character/family development, politics, and world building.

My interest in tactics and combat probably stems back to my early fascination with chess (I used to play against my dad all the time when I was a boy). The chance to play both sides of the chessboard, so to speak, is both challenging and a lot of fun.

Incidentally, after twenty years, I'm finally scheduled to finish off the original Blackcollar trilogy as I had envisioned it. I just kept getting sidetracked with other projects. Baen Books will be bringing out the first two books in an omnibus in January 2006, with the third book published sometime after that. And, yes, I HAVE actually started writing the thing.

MM: What was the inspiration for *The Icarus Hunt*?

ZAHN: My one-sentence tag for *The Icarus Hunt* is "Star Wars meets Alistair MacLean." I'd always enjoyed MacLean's thrillers, particularly the early ones like *Where Eagles Dare, Ice Station Zebra*, and *When Eight Bells Toll*, and I wanted write that sort of mystery/thriller in a SF setting. Aside from the sardonic hero, I scattered lots of other little echoes and homages to MacLean's books throughout the story.

MM: Were you nervous when writing the *Heir to the Empire* that Star Wars fans might not be interested or accept the book? Were you surprised by its success?

ZAHN: Nervous? No. Terrified out of my skull? Yes.

Obviously, the whole Star Wars project was a huge quantum leap for me, with the possibility of vastly increasing my audience or, conversely, giving me the chance to do an incredibly high-profile belly flop.

Luckily, the fan reaction was generally very positive. Certainly I put as much sweat and effort as I could into making the *Thrawn* Trilogy the best books I could possibly write. In addition, my natural style of writing happens to mesh well with the flavor of George Lucas' universe in general. That meant I didn't have to concentrate on transposing, as it were, into the Star Wars key, but was free to concentrate on all the rest of the pieces required for making a book.

And yes, I was completely stunned by the trilogy's success. Pretty much everyone was, I think, except Lou Aronica, the man who got the ball rolling in the first place.

MM: What do you think sets your Star Wars books apart from the others?

ZAHN: All writers put a unique flavor into their books, and mine are no exception. My Star Wars books, therefore, are the only ones with a 'Zahn' flavor to them.

Whether that makes them better or worse than anyone else's books is, of course, a different question entirely, and there's definitely a range of opinions on that. I've had some interesting mail on the subject. Unfortunately, much as I wish I could, I can't please everyone.

MM: What went into creating your character Mara Jade? Why do you think she strikes such a chord with all the fans?

ZAHN: Mara is designed to be a foil and counterpart for Luke, in much the same way that Han plays that role for Leia. Obviously, Mara would have to be the 'scoundrel' half of that team, and in order for her to keep up with a Jedi, she would have to be powerful, competent, and smart. All the rest of her details develop from there.

As to the reasons for her popularity, my guess is that on some level female readers would like to be Mara, while male readers would like to have her at their side.

MM: Is it true you are working on a sequel to *Survivor's Quest*, a story about the Outbound Flight? If so, when do you think you'll finish the book and it will be published?

ZAHN: Outbound Flight is, in fact, completed, and is working its way through the Del Rey/Lucasfilm editorial process. Barring any unexpected problems, I believe it's scheduled for a November 2005 release.

Actually, the book is a prequel to *Survivor's Quest*, taking place fifty years earlier. All the questions and mysteries about *Outbound Flight* I raise in SQ are answered when the readers get to see what, exactly, happened to the mission.

Incidentally, I've also just signed a contract for an eighth Star Wars book, which will be set in the period after *A New Hope*. I'm still working on the outline for that one.

MM: Have you gotten any feedback from George Lucas about any of your Star Wars books?

ZAHN: I've heard nothing directly from him, since everything goes through Sue Rostoni (and Lucy Wilson before her) and the rest of the LFL marketing people. I know there were occasional questions they kicked upstairs to him, though, so he did have some direct input.

I did have a chance to meet him once, as well, though the conversation centered on the current state of movie making and didn't really touch on Star Wars at all. At that time he was still in the very preliminary work on the prequels. Very informative, and very interesting. I'd very much like to have the chance some day to just sit down and chat with him.

MM: Did Lucasfilms Ltd. ever impose any limitations on the Star Wars books you were writing?

ZAHN: Absolutely, and rightly so. Every universe has its own unique flavor and texture, and Star Wars is no exception. It would be ruined if a group of spinoff writers were allowed to do anything we wanted (so would *Star Trek, Quantum Leap, Buffy*, and everything else, for that matter).

Fortunately, for me, at least, most of the major problems and limitations were caught in the outline stage, which meant I never had to do massive amounts of rewriting. As for the smaller questions, we've always been able to work things out to our mutual satisfaction.

MM: Of all the novels you've written, which one do you feel is your best storytelling vehicle?

ZAHN: Hmm—that's a tough one. I'd have to say I especially like *The Icarus Hunt* and, more recently, *The Green and the Gray* for how close they both came to matching my original vision for the books. I'm also enjoying working on my Dragonback young-adult series, the first two of which (*Dragon and Thief* and *Dragon and Soldier*) have been published.

But certainly all of my books have been the best I could do at the time they were written. There aren't any that I would disown or even look back at and cringe.

MM: Your character Mara Jade is featured in a video game. Do you think she translates well to other medias like video games, trade cards, comic books? Would you ever consider writing an interactive book?

ZAHN: Oh, absolutely! Mara works well in other media. As far as I'm concerned, she can go pretty much anywhere she wants.

As far as interactive books—or other media—are concerned, I'm always willing to try something new. So far, though, I haven't been able to get a solid foothold in either the game or comic book worlds. Maybe someday.

MM: Considering all the books you've read, the research you've done, and ideas you've pondered in your career, what do you plan to study next?

ZAHN: Mostly, I just study whatever happens to catch my eye. I've been reading a lot about World War II lately, including William Shirer's massive *The Rise and Fall of the Third Reich*. None of this is officially research, but it's surprising how often little nuggets of this stuff will end up in a future book (Hitler's Germany, for example, is in many ways similar to Palpatine's Empire).

MM: Last question: How long were you planning on having Luke Skywalker and Mara Jade be together before they got hitched? What has been the fan response to them getting hitched?

ZAHN: Actually, I had rather hoped all along that Luke and Mara would eventually get together, but the end of the Thrawn Trilogy was way too soon for a relationship like that to work and be plausible. At that point, other authors were doing other Star Wars books, and the idea went into the might-have-been file in the back of my brain.

It came back out again in the fall of 1993 when Bantam offered me the chance to write another Star Wars book. Which later expanded into two volumes, *The Hand of Thrawn Duology*. I told them I had two requirements: I wanted to end the war between the New Republic and the Empire, and I wanted to put Luke and Mara together. Lucasfilm thought it over, and early in 1994 they gave me the green light.

For years afterward it was highly amusing to hear

the speculations as to why Luke's girlfriends kept vanishing off-stage, as well as the various self-authoritative statements by a few that they kept vanishing because Lucas would never let Luke get married. What was actually happening, of course, was that all the other writers were in on it, and were making sure to give Mara the clear path she would need when *Vision of the Future* came out. It was a wonderfully well-kept secret, and I tip my hat to all the people who kept it that way.

For the most part, the fan reaction was very positive. At least, the fan reaction I heard about was.

AFTERWORD

THE AMAZING KRESKIN

THE FIRST TIME I met Michael McCarty, he was arranging for a séance I was conducting at a private college in Eastern Iowa. Later on, he was to conduct an interview with me before my scheduled show at the Funny Bone Comedy Club. I complained that my jaw was aching on the right side of my mouth, and I wondered how his tooth was. It turns out that before the interview, he had lost a filling in his tooth and was taking a painkiller. That, combined with the séance earlier in the day, is, as far as I am concerned, an appropriate setting to be introduced to Mike McCarty, his creative work, his nonfiction writing and his interest.

One does not have to be a thought-reader or project into the future or be surprised that his works have been nominated for literary awards, including the Bram Stoker Award from the Horror Writers Association five times. Look at the authors and creative minds that have shared their thoughts with him. Marvel at the prestigious names he has

encountered who have confided in him. In both *Giants of the Genre* and *More Giants of the Genre*, Michael has assembled a remarkable cross section of special figures in the fantasy genre.

There is no doubt in my mind that, aside from his own fiction writing, his personal confabs with the 'greats' will be historically looked upon as a true time capsule to be studied and shared with envy by future generations. Let's face it, when individuals achieve a celebrity-like status in their field, one of the most valuable possessions they possess becomes their personal time. These "mythmakers" have shared time with Mike. You know a person by those with whom he associates. It would be ideal if a Michael McCarty existed in every area of the creative arts, to chronicle a given period of that field. Orson Welles and my late literary friend, Walter B. Gibson, both of whom were associated with *The Shadow*, would have been enamored with Mike's endlessly youthful enthusiasm for this craft and its contemporaries.

Of course, as would be expected, Mike has his dark side. He was once a stand-up comedian—but at least he did not practice law or enter politics! Close your eyes, and listen to him conversing. There is a touch of Vincent Price.

Michael McCarty is richly talented, not only in translating his own fantasy thoughts, but in translating those of others. I predict the day is not far in the future, when Mike's prominence will be such that he will be the subject of a major interview in the literary field—and I should know, we just wrote a book together called *Conversations With Kreskin*, available as an eBook and hardcover book.

Index

C

California 24, 107, 110, 163, 192, 214, 219, 255-256, 283, 286, 292-293, 298

Campbell Soup Can 41

Campbell, Jenny 44

Campbell, Ramsey 15, 43-51; *Ancient Image* 51; *Bride of Frankenstein* 47, 49; *Church Of High Street, The* 44; *Claw, The* 50; *Dracula's Daughter* 15, 47; *Dark Companions* 44; *Darkest Part of the Woods; Demons By Daylight* 45; *Doll Who Ate His Mother The* 46; *El Segundo Nombre* 51; *Face That Must Die* 46; *Height of the Scream, The* 45; *Hungry Moon, The* 49; *Inhabitant of Lake and Less Welcome Tenants* 44; *Los Sin Nombre* 51; *Moon-Lens, The* 51; *Midnight Sun* 47; *My Seductress* 51; *Nameless* 44, 51; *Scar, The* 46; *Night of the Claw, The* 50; *Scared Stiff* 46-47; *Spanked By Nuns* 47; *Wolfman, The* 47, 49

Camus, Albert 157; *Stranger, The* 157

Canada 191

Capote, Truman 157, 259; *Breakfast at Tiffany's* 157; *In Cold Blood* 120; *Tree Of Night, A* 259

Cal Tech 351

Campbell, Ramsey 43-51

Cambria, CA 219

Carnegie Medal in Literature 84

Cape Carnival, FL 80

Carol Burnett Show 146

Carpenter, John ix, 52-58, 96, 297; *Assault on Precinct 13* 53-54; *Black Moon Rising* 53; *Body Bags* 53, 58; *Christine* 53; *Dark Star* 53; *El Diabro* 53; *Elvis*

362

Count Dracula Society 2, 66, 69

Coydogs 339

Coyotes 339

Cozumel 196

Crabbe, Buster 292-293

Creature From The Black Lagoon, The 49

Cukor, George 31

Curtis, Dan ix, 59-64, 187-188, 192, 262, 265; *Dark Shadows* 59-61, 64; *Dead of Night* 60, 184; *Dracula* 60, 184; *Frankenstein* 60; *House of Dark Shadows* 59, 61; *Night of Dark Shadows* 59; *Night Strangler The* 59, 61-62, 184, 187-188, 262; *Norliss Tapes, The* 60, 62, 192, 262; *Scream of the Wolf* 60; *Strange Case of Dr. Jekyll and Mr. Hyde* 60; *Trilogy of Terror* 60, 62, 184, 264; *Trilogy of Terror 2* 184, 265; *War and Remembrance* 60; *Winds of War* 60

Curtis, Tony 173, 179

D

Dallas Morning News 209

Dalmatian 72

Dante, Joe 51, 96

Dark Mind, Dark Heart 44

Datlow, Ellen 311

Daughter 18-19, 23, 25, 50, 104-105, 112, 165, 191, 195, 235, 239, 252, 271, 276

Davenport, IA i, 279, 331

Dolls 47, 62, 160, 264-265

Dominio, Frank "Domino" 155-157

Doc Savage 113

Dogs 8, 38, 72, 120, 125, 297, 313-314, 338-339

Dowd, Tom 147

Dracula 6, 14-15, 17, 21, 60, 184, 198, 273, 295, 320-324

Draculon 3

Drake, Larry 145

Dreams x, 28, 38, 74-75, 129, 151, 159-160, 185, 204, 258, 301, 326, 341

Duran Duran 88-89

E

Earth ii, 34, 273, 287, 312, 314

Eastman, Marilyn 242, 252

Eastwood, Clint 271

Editor 1-2, 4, 14, 16, 18, 40, 44, 79, 90, 102, 127, 136, 171, 175, 206, 230, 304, 308-309, 312, 329

Edward 104

Egypt 35, 85, 140, 337, 340-341

Eliot, George 335

Ellington, Duke 331

Elvira (Cassandra Peterson) 2, 65-75; *Bad Dog Andy* (with John Paragon) 72; *Box of Horror* 77; *Boy Who Cried Werewolf* (with John Paragon) 72; *Camp Vamp* (with John Paragon) 72; *Elvira, Mistress of the Dark* 65-66, 70-74; *Elvira's House*

German Shepherds 339

Germany 21. 36, 142, 178, 353

Getz, Stan 331

Ghost 23, 25, 44, 47-48, 54, 63, 104, 181, 198, 208, 317, 325, 333-334

Ghostwriting 80, 82

Gibson, Walter B 356; *Shadow, The* 356

Girdler, Bill 175

God 2, 34, 57, 67, 71-71, 113, 132, 164, 193, 193, 205, 207, 246

Godzilla 227

Google 12

Gordon, Dexter 331

Gothic 48, 59, 150-152, 198, 273, 323

Grandparents 36, 152, 303, 308

Grant, Kenneth 13; *Cults of Shadow* 13; *Left-Hand Path Qahalistical* 13; *Nightside of Edge and Outer Gateways* 13; *Outside Circle of the Hecate's Fountain* 13

Grech, Amy 117

Greece 121, 199

Green Hand, The 107

Green Town 32

Greenwood Press 299

Greyhound 245

Greyhound Bus 7

Gross Point, MI 152

Guanajuato, Mexico 39

Guitar 279

H

Hill, Debra 54

Hillbilly 147

Hillenburg, Stephen 170

Hines, Gregory 337

Hinzman, Bill 194, 208, 235

Hitchcock, Alfred 139, 242

Hodgson, William 158; *Hope House of Borderland, The* 158

Holden, Gloria 15

Holland 142

Holt, Ian 320-321

Holmes, Sherlock 323

Honeymooners, The 110

Horror Channel 245

Horror Writers Association 118, 174, 256, 321, 326, 355

Horror iii, iv, v, 2, 10, 11, 12-13, 22, 24-28, 43-44, 46, 48, 52-55, 57-58, 60, 63-66, 68-69, 72, 77, 96, 98, 100-101, 104, 117-118, 120, 124, 139-141, 144, 146, 150, 156, 158, 163, 165, 167, 169-171, 173-176, 178-181, 190, 195, 197-198, 205, 208, 213-214, 217-218, 226, 230, 239, 242, 245, 249, 255, 259, 267-268, 270-274, 276, 278-279, 288-289, 292, 295-296, 302, 312, 314, 316, 322-323, 325, 328, 330-331, 333, 335, 337, 339

Hostel 144, 288

Houghton, Buck 108, 266

Household, Geoffrey 327; *Rogue Mole* 327

Howard, Robert E. 48-49

Jada, Mara 350, 352-354

James, Henry 262, 333; *Turn of the Screw* 262

James, M.R. 45-47, 333

Japan 2

Jazz 325, 330-331

Jean-Claude 99-100

Johnson, George Clayton 106-116, 192, 255, 261, 266; *All Of Us Are Dying* 106, 111, 116; *American Masters: Rod Serling: Submitted For Approval* 107; *Execution* 106, 109, 116; *Four Of Us Are Dying, The* 106, 109; *Game of Pool, A* 106; *George Clayton Johnson: Fictioneer* 107; *Kick The Can* 107-108, 116; *Kung Fu* 107; *Law and Mr. Jones, The* 107; *Logan's Run (with William F. Nolan)* 106, 112-115, 255, 259, 260-261, 267; *Man Trap* 107; *Nothing In The Dark* 106, 109, 116; *My Life With Count Dracula* 107; *Ocean Eleven* 107; *Ocean Thirteen* 107; *Ocean Twelve* 107; *Perchance To Dream* 116; *Penny For Your Thought* 106, 109, 116; *Prime Mover, The* 116; *Route 66* 107

Johnson, Judy 112

Johnson, Lola 109

Johnson, Steve 286-287

Jones, Duane 251

K

Karloff, Boris 2, 5-6, 187, 249-250

Kanal 176

Kearny, Pat 44

Lucas Films Ltd. 350-351, 353
Lucas, George 349, 351, 354
Lugosi, Bela 2, 6
Luther, Bobbi Sue 284

M

Maberry, Jonathan 311
Machen, Arthur 45
MacLean, Alistair , *Ice Station Zero; When Eight Bells Toll ; Where Eagles Dare*
Mad Magician, The 65
Magazine of Fantasy & Science Fiction, The 186
Magic 2, 18, 28, 47, 84-85, 111, 114, 141, 181, 183, 311, 319
Maine 219, 306
Malibu Beach, CA 115
Mansfield, OH 214
Mansion 6, 152, 219
Marin, Cheech 289-290
Mars 33, 36, 41
Marshall, E.G. 77
Martin, Dean 167
Martin, George R.R. 223; *Fevre Dream* 223
Marvel Comics 66, 355
Marycrest College v
Massachusetts 45
Masters of Horror 54, 91, 96, 163, 184

184; *Richard Matheson's Uncollected Volume 2* 184, *Morning After* 187; *Night Killers, The (with William Nolan)* 184, 187, 262; *Path, The* 190; *Shrinking Man, The* 21, 184, 186, 189, *The; Somewhere In Time* 184, 187, 189; *Stir of Echoes, A* 184; *To Live* 187; *Trilogy of Terror* 60, 62, 184, 264; *Trilogy of Terror 2* 184, 265; *What Dreams May Come* 184, 187

Mathews, Dan 74

Matrix 113, 260

Maxim 278

Mayflower Books of Black Magic Stories 47

McCarty, Michael iii-vii, 14, 23, 43, 52, 83, 97, 106, 117, 139, 150, 194-195, 207, 229, 241, 249, 254, 279, 311, 355-357, 393; *Bloodless (with Jody LaGreca)* 393; *Conversations with Kreskin (with The Amazing Kreskin)* vi, 356, 393; *Dark Duets* 393; *Giants of the Genre* vi, vii, 356, 393; *Hell Of A Job, A* 393; *Laughing in the Dark* 393; *Little Help From My Fiends, A* 393; *Liquid Diet and Midnight Snack: 2 Vampire Satires* 14, 393; *Lost Girl of the Lake (with Joe McKinney)* 195, 207, 393; *Modern Mythmakers* viii, x, 149, 393; *More Giants of the Genre* 356, 393; *Night of the Scream Queen (with Linnea Quigley)* 279, 286, 393; *Partners in Slime (with Mark McLaughlin)* 83, 393; *Return of the Scream Queen (with Linnea Quigley)* 279, 286, 393; *Rusty the Robot's Holiday Adventures (with Sherry Decker)* 393

McCauley, Kirby 49

McKinney, Joe 194-212, 393; *Apocalypse of the Dead*

Native American 306

Navajo 306

NBC 56, 74, 267

Near Dark 223

Nebula Award 84

New England 121

New Jersey 121

New World Pictures 70

New York, NY 3, 7, 49, 71, 110, 181, 206, 265-267, 302, 308, 333, 338

New York Stock Exchange 73

New York Times 224

New York Times Best Seller 84, 101, 213, 276, 311, 347

Newberry Award 84

Newt 19

Nicholas, Martin Allen 292, 294

Night of the Living Dead 141, 185, 194, 207-208, 210-211, 215, 229-238, 240-254, 313

Nolan, William 255-269; *Ceremony, The; Dark Universe; Halloween Man, The; Dreamflight; He Kilt With A Stick; Just Before Dawn; Kansas City Massacre; Kincaid: A Paranormal Casebook; Logan Trilogy, The; Logan's Return; Logan's Run (with George Clayton Johnson); Logan's Search; Logan's World; Lonely Train A Comin'; Max Brand: The Man and His Work; Melvis Purvis: G-Man; Nighthawk Rides, The; Night Killers (with Richard Matheson)* 184, 187, 262; *Norliss Tapes, The* 60, 62, 192, 262; *Nolan on Bradbury: Sixty*

O

Q

Robbins, Tim 217

Rodgers, Charlee 216

Rodriguez, Robert 289

Roman Empire 35, 341

Romberg, Nina 16

Romero, George 23-25, 96, 186, 199, 207, 208, 210, 229-230, 239, 251, 254, 297

Roosevelt University 142

Rose Parade 73

Rostoni, Sue 351

Rottweiler 72

Royal, Barton 343

Ruins, The 155

Russia 11, 20-21, 36, 272

Russo, John ix, 194, 208, 229-240, 250-251; *Children of the Living Dead* 239; *Heartstopper* 237; *Majorettes, The* 230, 237; *Midnight* 230-231; *Return of the Living Dead* 215, 239, 278, 280-281, 284; *There's Always Vanilla* 239; *Russo, John Movie Academy* 230, 240

S

Said, Tina 154

Salinger, J.D. 154; *Catcher in the Rye* 158

San Antonio Police Department 194-185, 199, 205-206

San Francisco, CA 46, 71, 116, 213-214, 220, 225

San Francisco State College 299

San Marcos, CA 286

Sandler, Adam 134

Sands, Mavis 222

Santa Barbara, CA 214

Sarandon, Chris 223

Sarandon, Susan 337

Satan 16, 57, 135, 180

Saturn Award 2

Saul, John 298-310; *Black Lightning* 299; *Blackstone Chronicles, The* 299; *Creature* 302; *God Project, The* 301, 306; *Guardian* 299; *Homing, The* 310; *House of Reckoning* 299; *In the Dark of Night* 299-300; *John Saul: A Critical Companion* 299; *Midnight Voice* 302; *Manhattan Hunt* 302; *Nathaniel* 299, 308-309; *Nightshade* 303; *Perfect Nightmare* 298-299; *Presence, The* 309; *Punish The Sinners* 299; *Right Hand of Evil, The* 299; *Second Child* 299; *Sleepwalk* 306; *Suffer the Children* 298, 303-305 *Warning, The* 299

Savalas, Telly 295

Saville Theatre 177

Savini, Tom 2, 194, 208, 239-240, 244, 246

Saw 144, 288

Schon, Kyra 200, 210, 229, 235, 241-248, 252

Schow, David 49

Scott, Cameron 284

Scott, Ridley 51

Scott, Tony 51

Science Fiction iii, v, vii, 1-2, 4-5, 28, 33-35, 37-38, 53, 57-58, 67, 100-101, 106, 124, 185, 190, 195, 214, 226, 255-256, 267, 292, 337, 339, 346-347

T

X

Y

Z

About The Author

Michael McCarty has been a professional writer since 1983 and the author of over thirty books of fiction and nonfiction, including *Laughing In The Dark, A Hell of A Job, A Little Help From My Fiends, Giants of the Genre, More Giants of the Genre, Dark Duets, Partners in Slime* (co-written with Mark McLaughlin), *Lost Girl of the Lake* (co-written with Joe McKinney), *Conversations With Kreskin* (co-written with The Amazing Kreskin), *Night of the Scream Queen* (co-written with Linnea Quigley), *Rusty The Robot's Holiday Adventures* (kid's book co-written with Sherry Decker) *Bloodless* (co-written with Jody LaGreca) and *Liquid Diet & Midnight Snack: 2 Vampire Satires.* He is a five-time Bram Stoker Finalist and in 2008 David R. Collins' Literary Achievement Award from the Midwest Writing Center. He lives in Rock Island, Illinois with his wife Cindy and pet rabbit Latte.

Michael McCarty is on Twitter as michaelmccarty6.

His blog site is http://monstermikeyaauthor.wordpress.com

Facebook! Like him on his official page: http://www.facebook.com/michaelmccarty.horror.

Or snail mail him at:
Michael McCarty
Fan Mail
P.O. Box 4441
Rock Island, IL 61204-4441

Connect with Crystal Lake Publishing

Website (be sure to sign up for our newsletter):
www.crystallakepub.com
Facebook:
www.facebook.com/Crystallakepublishing
Twitter:
https://twitter.com/crystallakepub

I hope you enjoyed this title. If so, I would be grateful if you could leave a review on your blog or any of the other websites and outlets open to book reviews. Reviews are like gold to writers and publishers, since word-of-mouth is and will always be the best way to market a great book. And remember to keep an eye out for more of our books.

Crystal Lake Publishing also publishes novels, short story collections, poetry collections, non-fiction books on writing, and novellas. If you're a big fan of non-fiction books related to the Dark Fiction genre (or whichever genre you write in), then be sure to pick up *Horror 101: The Way Forward*.

THANK YOU FOR PURCHASING THIS BOOK

Printed in Great Britain
by Amazon